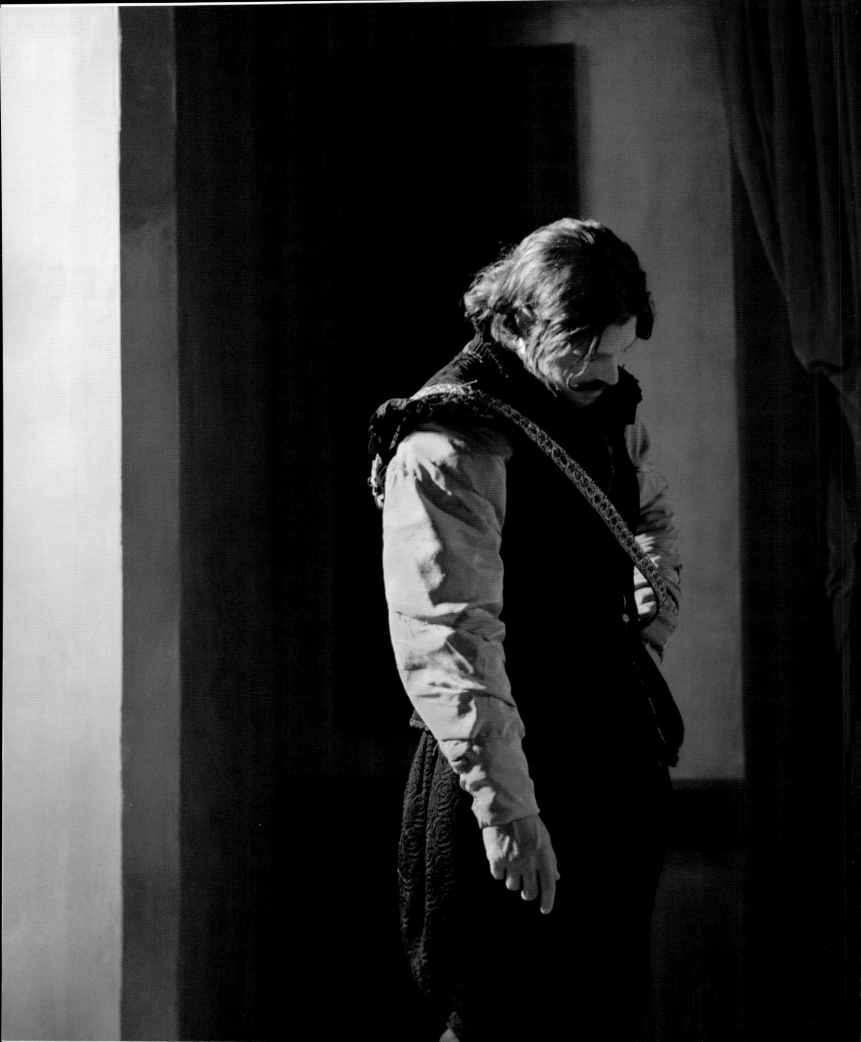

acting the part

PHOTOGRAPHY AS THEATRE

Edited by

Lori Pauli

With essays by

Lori Pauli

Marta Weiss

Ann Thomas

Karen Henry

National Gallery of Canada

MERRELL
LONDON · NEW YORK

First published 2006 by Merrell Publishers Limited

Head office:
81 Southwark Street
London SE1 0HX

New York office:
49 West 24th Street, 8th Floor
New York, NY 10010

merrellpublishers.com

in association with the

National Gallery of Canada
380 Sussex Drive
POB 427, Station A
Ottawa, Ontario K1N 9N4

national.gallery.ca

NATIONAL GALLERY OF CANADA

Chief, Publications Division: Serge Thériault
Editors: Usher Caplan, Susan McMaster, Stéphanie Moreau
Picture Editor: Andrea Fajrajsl
Translators: Marie-Josée Arcand, Danielle Chaput, Sylvie Chaput

Published on the occasion of the exhibition
Acting the Part: Photography as Theatre
organized by the National Gallery of Canada,
and presented in Ottawa 16 June – 1 October 2006

British Library Cataloguing-in-Publication Data:
Acting the part : photography as theatre
1.Staged photography – History – Exhibitions 2.Composition
(Photography) – Exhibitions
I.Pauli, Lori
778.8

ISBN 1 85894 328 0 (hardcover)
ISBN 0 88884 818 8 (softcover)
Publié aussi en français sous le titre *La photographie mise en scène.
Créer l'illusion du réel*

Designed by Empire Design Studio, New York
Printed and bound in Italy

Front cover
Gregory Crewdson, *Untitled*, 2001 [fig. 136, detail]

Back cover
Anne Ferran, *Scenes on the Death of Nature, II*, 1986 [fig. 44]

Details
Page 2: Eve Sussman and The Rufus Corporation, *The King Sleeps*
 (Jeff Wood as Philip IV, King of Spain), 2004 [credit as for fig. 48]
Page 6: William H. Rau, *Mr. and Mrs. Turtledove's New French
 Cook* ("Well, I Am Caught Sure Enough."), 1902 [fig. 72]
Pages 10–11: Duane Michals, *The Mirror*, 1972 [fig. 74]
Page 12: Hippolyte Bayard, *Self-Portrait as a Drowned Man*, 1840
 [fig. 1]
Page 80: Lewis Carroll, *Saint George and the Dragon*, 1875 [fig. 85]
Page 100: Man Ray, *Larmes (Tears)*, 1930–1933 [fig. 110]
Page 132: Jeff Wall, *The Vampires' Picnic*, 1991 [fig. 144]
Page 169: *The Artistic (?) Studio*, published in *Punch*, 1870

CONTENTS

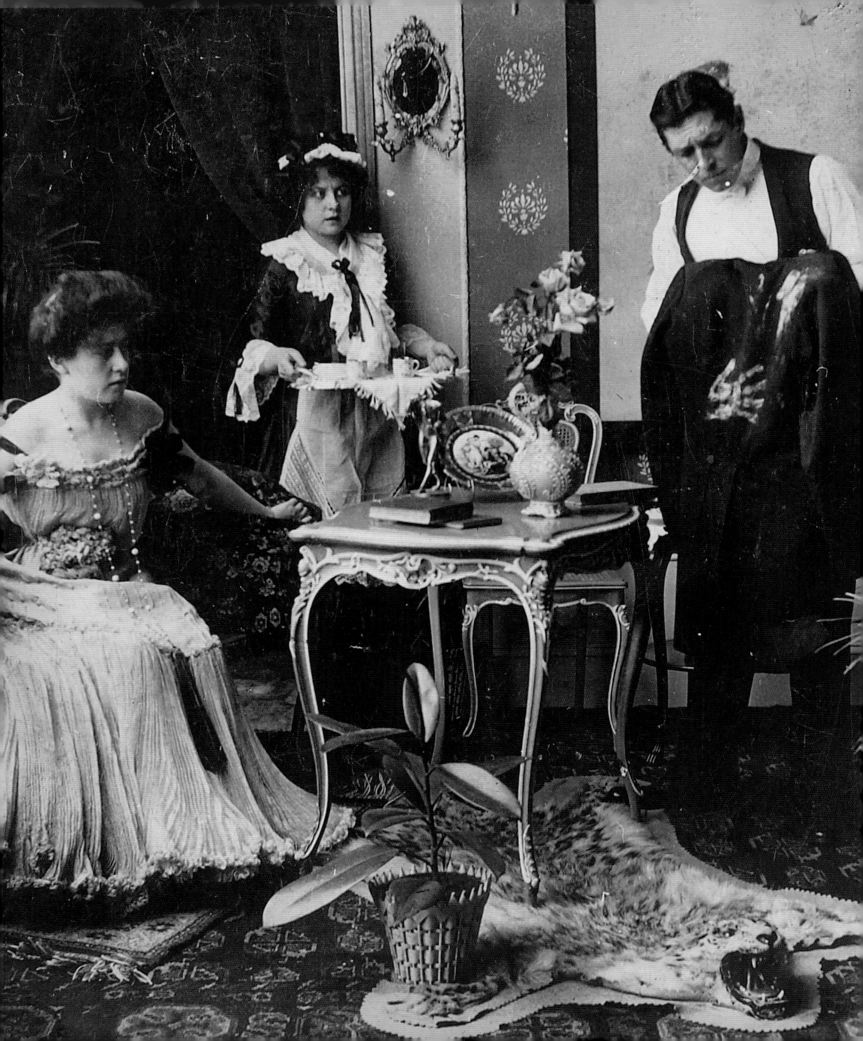

DIRECTOR'S FOREWORD

Photographers have been telling stories through their art ever since the medium was first invented, staging scenes of one kind or another and directing the "actors" posing before their cameras. The theatrical photograph has assumed an enormously varied range of forms over the past century and a half, and its interactions with the related arts of theatre, film, and video, and the realms of advertising and journalism, have taken fascinating directions. One can only wonder why such a rich vein of photographic history has been so little studied. This book and exhibition make a strong case not only for the historical interest of this enduring branch of photography but also for its intrinsic artistic value.

Yet there are so many significant examples of dramatic photography that it is beyond the scope of any single presentation to cover the entire spectrum. Lori Pauli's selection of works for *Acting the Part* constitutes a thought-provoking and remarkably representative survey that is likely to stimulate further elaboration by other scholars and curators over the years to come. I am proud to say that our own considerable collection of photographs at the National Gallery of Canada proved to be a rich source of material. Our contributions encompass a range that allows viewers to appreciate the resonance of subject matter and photographic styles over generational and cultural divides.

It would have been impossible, however, to assemble such a comprehensive overview without the unstinting participation of many professionals and institutions. I would like to thank all those involved in this project, in particular the lenders to the exhibition, both public and private. Deserving of our gratitude are Gregory Crewdson, Jakub Dolejš, Adad Hannah, Vicki and Kent Logan, Richard and Ronay Menschel, John and Amy Phelan, Robert and Jane Rosenblum, Michael Snow, and Alan and Susan Solomont. We are likewise indebted to the generosity of the Ackland Art Museum; the Amon Carter Museum; the Angell Gallery; the Art Gallery of South Australia; the Canadian Museum of Contemporary Photography; the Centre Pompidou; China Avant-Garde; George Eastman House; Hans P. Kraus, Jr.; the Harry Ransom Humanities Research Center; the International Center of Photography; the J. Paul Getty Museum; the Jack Shainman Gallery; the Laurence Miller Gallery; the Library of Congress; the Los Angeles County Museum of Art; Luhring Augustine; The Metropolitan Museum of Art; the Modern Art Museum of Forth Worth; Moderna Museet; The Museum of Contemporary Art, Los Angeles; the Museum of Contemporary Art San Diego; The Museum of Modern Art, New York; the National Museum of Photography, Film and Television; the Pace/MacGill Gallery; Ronald Feldman Fine Arts; the San Francisco Museum of Modern Art; the Scottish National Portrait Gallery; the Société française de photographie; the Vancouver Art Gallery; the Walker Art Center; and the Yevonde Portrait Archive.

The impulse to tell stories through pictures lies at the very heart of the visual arts. The narratives presented here in theatrically constructed photographs and videotapes are informative, entertaining – and often profoundly moving. I invite you to share a fascinating journey.

Pierre Théberge, O.C., C.Q. *Director* National Gallery of Canada

ACKNOWLEDGEMENTS

The preparation of an exhibition and book requires the skills and talents of a number of people, and I am grateful for the assistance and generosity of everyone involved. I would especially like to thank the Director's Program Committee and Merrell Publishers for their support and enthusiasm for this project.

The cornerstone of a project such as this is the creativity and cooperation of the artists themselves. Along with outstanding works by artists of the past, I am honoured to be able to include so many contributions from contemporary artists, including Eleanor Antin, Tina Barney, Karl Beveridge, Carole Condé, Gregory Crewdson, Jakub Dolejš, Evergon, Anne Ferran, Adad Hannah, Eikoh Hosoe, Les Krims, Duane Michals, Yasumasa Morimura, Adi Nes, Cindy Sherman, Yinka Shonibare, Michael Snow, Eve Sussman, Bill Viola, Jeff Wall, Wang Qingsong, Carrie Mae Weems, and Anne Zahalka.

I am also deeply indebted to the authors who contributed essays for the book. Marta Weiss, Ann Thomas, and Karen Henry have each provided thoughtful and illuminating discussions of the various periods and issues that surround the genre of theatrical photography. Katherine Stauble prepared the excellent artist biographies.

The initial concept for *Acting the Part* was shaped and refined in conversation – both verbal and electronic – with a number of people, notably Ann Thomas, Marta Braun, Roger Taylor, Geoffrey Batchen, Mitchell Frank, Nancy Keeler, and Marc Mayer.

The publication team that worked on this book, headed by Merrell's Joan Brookbank and our Publications Chief, Serge Thériault, deserves special mention. Both Joan and Serge displayed an unflagging

excitement for the book that was infectious. In particular, I am grateful for the careful attention and valuable advice given by editor Usher Caplan as the manuscript was taking shape. Along with editor Susan McMaster and freelancers Didi Pollock, Marcia Rodriguez, and Jennifer Wilson, Usher worked in partnership across the ocean with the project editor for Merrell, Claire Chandler, and her colleagues art director Nicola Bailey and production controller Sadie Butler in London. Together they were committed to producing the best possible book. The French edition is a fine example of its kind, thanks to the dedication and skill of National Gallery editor Stéphanie Moreau and an elegant French translation by freelancers Danielle Chaput, Sylvie Chaput, and Marie-Josée Arcand. National Gallery picture editor Andrea Fajrajsl performed miracles in her efforts to obtain, prepare, and document illustrations for the book. At the last, crucial stage of production, I would like to thank designers Gary Tooth and Brian Hennings at Empire Design Studio in New York for a lovely book.

The private and institutional lenders to the exhibition, thanked above by the Gallery's Director, Pierre Théberge, are the other essential element in a project like *Acting the Part*, and I join my sincere thanks to his. I would especially like to express my gratitude to those who, in various ways, facilitated the loan of objects from these collections. Debbie Armstrong, Quentin Bajac, Ann Behan, Laura Bentes, Toni Booth, Linda Briscoe-Meyers, Tatiana Chetnik, Monica Chung, Julian Cox, Verna Curtis, Malcolm Daniel, Frances Dimond, Caroline Dowling, Mary Engel, Howard Farber, Mia Fineman, Jane Fletcher, Barbara Galasso, Lawrence Hole, Brian Liddy, Barbara London, Ann Lyden, Natalia Mager-Sacasa, Catherine Mahoney, Mark Mann, Karen Marks, Anne Morra, Jennifer Parkinson, Tania Passafiume, Vicki Petrusevics, Alix Rici, Judy Sagal, Heather Scanlan-Walker, Eve Schillo, Berta Serrano, Claude Simard, Carole Trouffleau, Amy Via, Callie Morfeld Vincent, and Carolyn Wood went out of their way to make the process smooth, and answered my many questions with patience and good cheer.

The support and enthusiasm afforded me by all my curatorial colleagues here at the National Gallery of Canada is much appreciated, particularly that offered by Erika Dolphin, Josée Drouin-Brisebois, David Franklin, Martha Hanna, Graham Larkin, Michael Pantazzi, Kitty Scott, and Jonathan Shaughnessy. I am grateful also to the many other professionals directly involved with *Acting the Part*, including Daniel Amadei, David Bosschaart, Louise Chénier, Karen Colby-Stothart, Julie Hodgson, Guy Lacroix, Sue Lagasi, Julie Levac, John McElhone, David Monkhouse, Mark Paradis, Ellen Treciokas, Lise Villeneuve, Jacqueline Warren, and Diane Watier. In addition, the Photographs Department has benefited from the work of interns over the past few years and I would like to thank Valérie Boileau-Matteau, Judy Dittner, and Helen Parkinson for their contributions to this exhibition and book.

Finally, I would like to thank my husband Bruce and my sons Griffin and Owen for their patience.

Lori Pauli *Assistant Curator, Photographs* National Gallery of Canada

THE TMARERORMIRROR

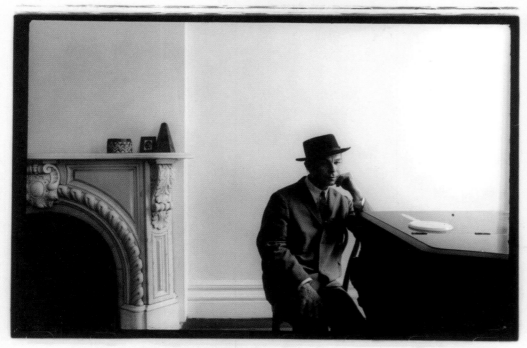

the mirror 1972

2

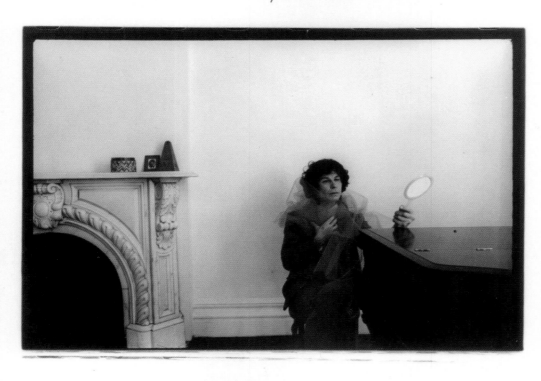

4

5

In 1840 Hippolyte Bayard created a highly unusual self-portrait: a photograph depicting himself as a suicide by drowning. We see the "corpse" from the knees up, his tanned hands crossed in his lap, his torso bare, and his damp hair combed back. A large-brimmed straw sunhat hangs on the wall behind him and a vase sits on a table to his left. The photograph is accompanied by a text lamenting, in piteous terms, the failure of the French government to recompense Bayard adequately for his role in the invention of photography.

Bayard's *Self-Portrait as a Drowned Man* (see figs. 1 and 7), with its theatrical props and implied narrative, reminds us that the creation of fictitious images or "staged" photographs has been a part of photographic practice from the very beginning. Indeed, theatricality and narrative are the defining features of all the works that have been selected for this book and its accompanying exhibition.

These works, ranging from the earliest salted paper prints and daguerreotypes right up to today's digitally manipulated photographs, have been grouped under three major themes: "Actor,"

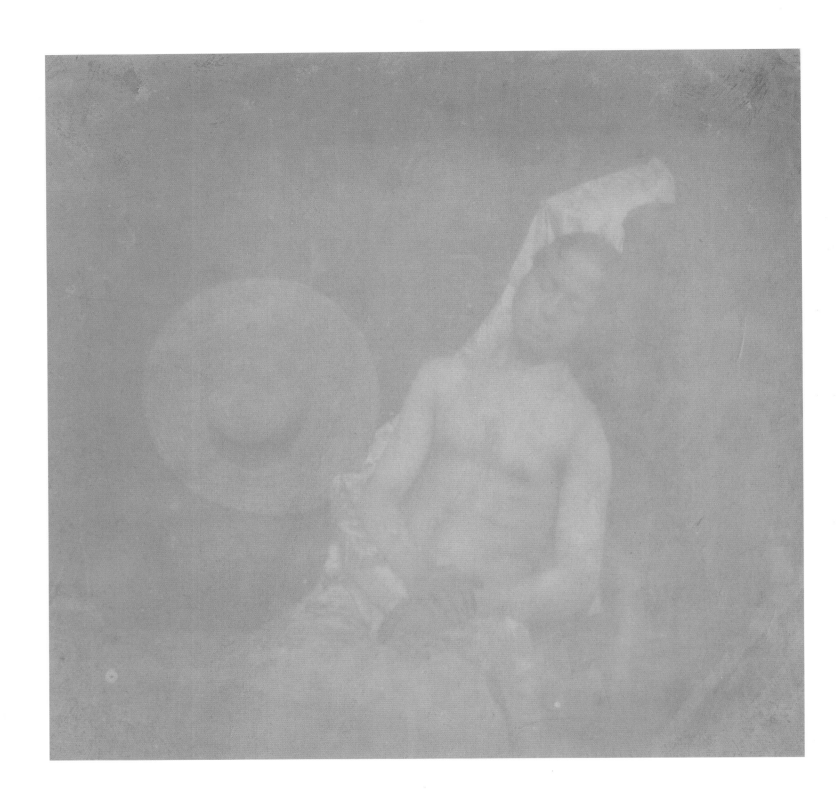

Fig. 1
Hippolyte Bayard, *Self-Portrait
as a Drowned Man*, 1840,
Bayard direct-positive
process print. Société française
de photographie, Paris

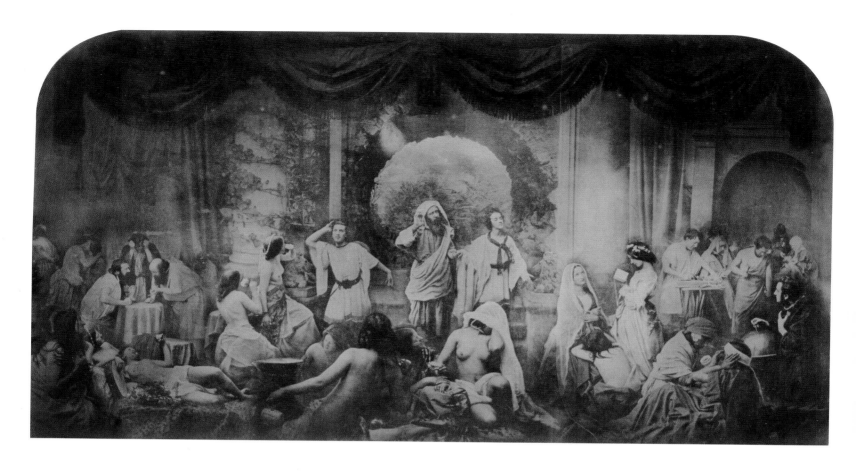

"Artist," and "Storyteller." The themes are not intended as rigid or exclusive categories: they are all interconnected, and many individual photographs could be considered from different angles. Bayard's *Self-Portrait* reveals him as both "Storyteller" and "Actor." Similarly, the contemporary Japanese photographer Yasumasa Morimura is "Actor" as well as "Artist," casting himself as the principal player in a series of photographic re-enactments of famous paintings. In *Portrait (Futago)* (fig. 131) he poses boldly as Manet's *Olympia* and puts in a second appearance as the black servant leaning toward the reclining figure (*futago* means "twin" in Japanese). Like Bayard, Morimura defies simple categorization.

There has been a tendency to overlook the historical continuum that links the work of these two photographers, separated by more than a century and a half. At one end of the continuum are those photographs that are deliberately staged, with every detail and gesture being determined by the photographer. Works that would fall into this category include Oscar Gustave Rejlander's *Two Ways of Life* (fig. 2) and Yinka Shonibare's *Diary of a Victorian Dandy* (fig. 132). At the other end of the continuum are such works as Weegee's *The Critic* (fig. 123) or Ruth Orkin's *American Girl in Italy* (fig. 125), in which the scene has been anticipated or pre-visualized but only a limited number of elements are actually "set up," so that the photograph seems more spontaneous than staged.

While some attention has been paid to the practice of staging in contemporary photography,[1] the study of theatricality in art has typically been confined to an examination of painting and sculpture.[2] This omission is partly explained by the mistaken belief that theatricality in art was primarily a feature of the eighteenth and nineteenth centuries. But a consideration of the work of Bayard and Morimura shows us that theatricality has always been a part of photography. The origins of photography, as Roland Barthes observes, can be seen as more closely allied to acting than to painting.[3] What is more, this aspect of photography is part of our everyday experience: we all tend to strike a pose when we are aware that our picture is being taken.

All of the photographic images that form the core of this book, and are featured in the exhibition,

Fig. 2
Oscar Gustave Rejlander, *Two Ways of Life*, c. 1857, albumen silver print. Moderna Museet, Stockholm (FM 1965 001 777)

are of people posing or performing in some way for the camera, either as actors in a staged scene, or as recognizable stereotypes, or simply as persons other than themselves. Straightforward portraiture has therefore been placed only at the periphery of the present discussion, along with staged photographs of animals or objects, as well as "constructions" or "fabrications" – photographs that are concerned with the setting of the scene rather than with a performance by actors or models.[4]

In addition to the element of theatrical performance, narrative content is the other essential characteristic of all the photographs featured here. This too has been part of staged photographs from their inception to the present day. Bayard and Morimura are not only actors; they are also the directors, choosing the sets, props, and costumes, determining the lighting, and establishing the gestures in order to tell a dramatic story.

In many nineteenth-century staged photographs, the narrative element is entirely explicit, as in Julia Margaret Cameron's series illustrating Tennyson's *Idylls of the King.* Henry Peach Robinson's *Fading Away* (fig. 81) seeks to tell a complete story in one image, as does Rejlander's *Two Ways of Life.* In these photographs, as in many others from the Victorian era, we can see the influence of the theatre, with the figures arrayed as if frozen in place on a horizontal line across a shallow stage. Rejlander commented directly on this connection, declaring, "It is upon this stage that I have lifted up the curtain to introduce you to the dramatis personae."[5] There was another source for the linear, horizontal, frontal composition of many Victorian photographs: the tableau vivant. In this popular drawing-room entertainment, family members and their guests would dress in costume and arrange themselves in a pose based on a famous painting or sculpture or a scene from literature or history. The overall effect was rather stilted: although the object was to create the appearance of a living painting, the ability to hold still was more important than a talent for expressing natural emotion.

Just as live theatre and the tableau vivant were major formal influences on staged photography in the Victorian period, so popular entertainment has continued to exert an influence on the medium to the present day. Following the invention of cinematography around the turn of the century, photographers became less concerned with trying to tell the whole story in one picture and began to take an interest in serial images, such as those designed to be viewed in the hand-held stereoscope. These stereographic images became the most popular format for staged photographs in the early years of the twentieth century.

Advertising was another area in which staged photography remained in the mainstream. The earliest advertising photographs were mainly intended to show the product in the framework of a pleasing composition or design. From the late 1920s on, however, photographs with a strong narrative line, such as *The Coffee Drinkers* (fig. 3) by Paul Outerbridge, Jr., began to play an important role in advertising. By the 1950s, staged or "set up" photographs had become the norm.

Despite the popularity of the stereograph and the ubiquity of advertising images, the staged photograph was in many respects out of favour during the heyday of mid-twentieth-century cinema. It is now generally agreed that the art of the staged photograph was, in effect, superseded by cinematography, a medium that is more powerfully able to convey the narrative dimension of time.[6] But another factor in this decline was the very "staginess" of the staged photograph.

It seems likely that in the earliest years of photography, viewers would have been relatively untroubled by this staginess. In fact, all early photographs were arranged by the photographer to a greater or lesser degree. Most cameras were bulky and heavy, and exposure times were long, requiring sitters to hold a steady pose for up to several minutes, sometimes with their heads steadied by a metal brace. Thus technical limitations meant that all early photographs were, in a sense, staged. In the later years of the nineteenth century and the early years of the twentieth, hand-held cameras, faster film, and easily produced prints made candid snapshots widely popular, and therefore it became possible to think of staged photography as a distinct genre and ultimately an inferior one for being artificial and less "truthful." To the extent that the camera was seen as a witness to truth in news reporting, in scientific studies, and in all aspects of daily life, the practice of staging photographs was increasingly regarded with a mixture of skepticism and suspicion.

Yet it was this very artificiality that made the staged photograph especially interesting to a new generation of artists. By the early 1920s, it had become

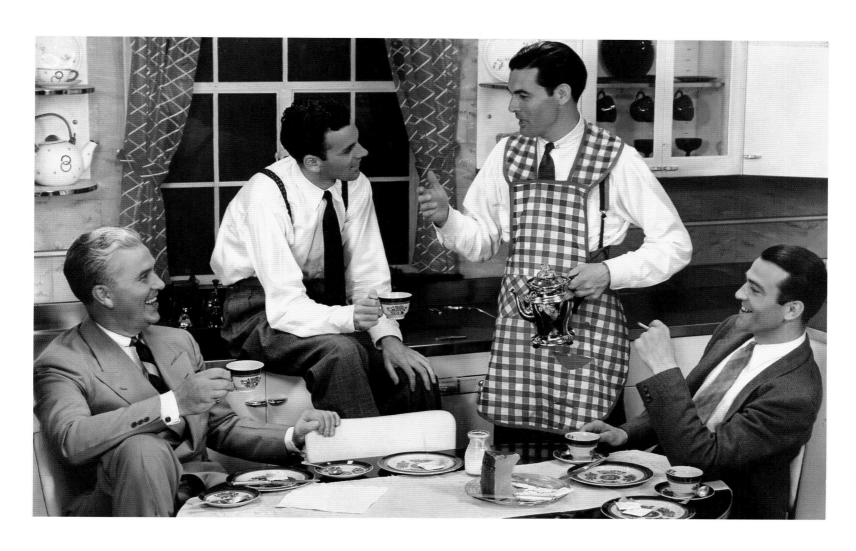

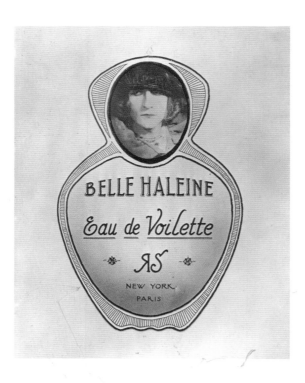

Fig. 4
Man Ray, *Belle Haleine*, 1921,
gelatin silver print. J. Paul
Getty Museum, Los Angeles
(85.XM.386.3)

Fig. 5
Man Ray, *Rrose Sélavy*, 1923,
gelatin silver print. J. Paul
Getty Museum, Los Angeles
(84.XM.1000.80)

one of the favourite photographic genres used by such avant-garde artists as Man Ray and Marcel Duchamp, who collaborated on *Belle Haleine* (fig. 4) and *Rrose Sélavy* (fig. 5). Both pictures show Duchamp in drag, sporting a stylish hat and jewellery, in what can be regarded, at one level, as a parody of a fashion photograph.[7] Claude Cahun's self-portrait in male clothing (fig. 6) is another exploration of cross-gender identity from the same period. By the 1960s, the possibilities of this genre had been re-conceptualized to encompass the realm of fantasy, as in the work of Duane Michals and Eikoh Hosoe. In the late 1970s Cindy Sherman produced an influential series of staged photographs called *Untitled Film Stills* (see fig. 129); their ambiguous and arrested narratives, derived mainly from Hollywood films, examine a variety of female stereotypes – the ingenue, the femme fatale, the housewife – with Sherman herself acting the parts.

The artist Duane Hanson also used photography in the late 1970s, "staging" scenes that incorporated live models as well as lifelike sculptures of ordinary people in ordinary settings. Hanson would often instruct his models to pose as if they were in a state of deep concentration. While completing a sculptural work entitled *Self-Portrait with Model*, he posed himself in a series of photographs as a way of determining the best positions and gestures for the two models (see fig. 11). Although these photographs originally functioned simply as "sketches" for the artist (Hanson would sometimes produce scores of them for a given project), the resulting images also stand on their own as an engaging blend of fact and fiction.

The strong resurgence of staged photography from the early 1960s to the present can be seen as a kind of reaction against the predominance of documentary or "straight" photography from the first half of the twentieth century. Artists working with the staged photograph after the 1960s may have favoured still photography over cinematography precisely because it is a medium that represents stories episodically, in fragments. Contemporary photographers appreciate the way that staged photography, like painting – or probably more accurately, like the film still – leaves the completion of the narrative up to the viewer. The staged photograph has become once again a dramatic moment frozen in time.

THE ACTOR

There seem to have been few early photographers who could resist the temptation to place themselves in front of the lens of their own camera.[8] In most cases, they were content with a faithful rendering of their physical appearance, staying well within the parameters of conventional self-portraiture.

Hippolyte Bayard's *Self-Portrait* was, as we have seen, far from conventional. A self-taught photographer, Bayard was a civil servant in the French ministry of finance, but his social circle included a wide range of artists and printmakers. In 1851 he was appointed to the prestigious Mission héliographique, the mandate of which was to photograph important historical and architectural sites. Bayard's very earliest known

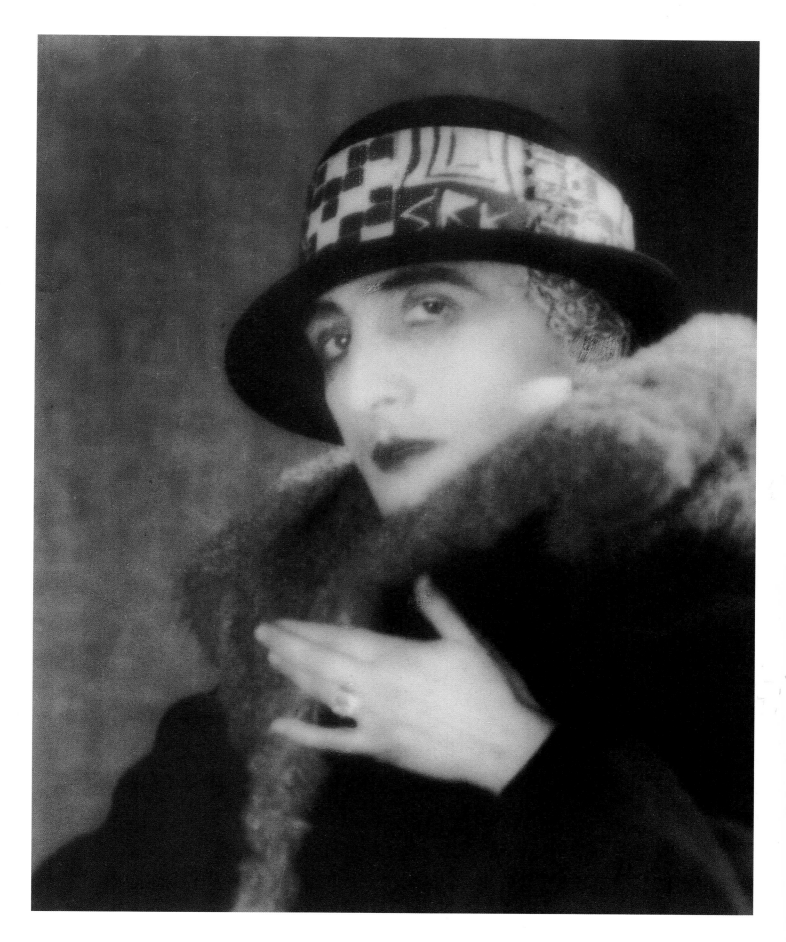

Fig. 6
Claude Cahun, *Self-Portrait*,
1920, gelatin silver print.
Collection of Richard and
Ronay Menschel, New York

photographs, however, are self-portraits, notably the 1840 picture of himself as a drowned man. Bayard experimented with this image, producing three different versions with slightly different poses and camera angles. Posing lifeless for the camera was an ingenious idea since it took advantage of the slow exposure times of that era, which demanded an unnatural stillness on the part of the sitter. In the best-known rendering (fig. 1) – the only version with an accompanying text – a white cloth covers the lower part of Bayard's body and extends behind him, as a clever way of providing a contrasting backdrop. In another version (fig. 7), the drapery is pulled a little higher on his torso, and his hands fall loosely in his lap rather than being crossed.[9] In this second version, the camera has also been moved a little further back, revealing a statuette at Bayard's feet.

Bayard's sense of the theatrical is always evident. For other early self-portraits his props included gardening implements and plaster casts of bas-reliefs. In *Bayard Attending a Patient* (fig. 8), he holds the wrist of a young child as if playing the part of the ministering physician. Two other ingenious self-portraits (figs. 9 and 10) show him as if in conversation with his double.[10] We can only speculate as to Bayard's intentions in setting up these scenes. It is known that he was a friend of the artist and actor Edmond Geffroy, and that his circle of acquaintances included performers at the Comédie-Française.[11] Whatever his purpose may have been, it is obvious that Bayard was quick to grasp the potential of the photograph as a kind of virtual stage.

Bayard was not the only early photographer to exploit the new medium in this manner. In an impressive series of daguerreotype self-portraits made around 1855, the American photographer Warren Thompson chose his props and costumes with care in order to adopt such personas as *Thinker* (fig. 12), *Arab* (fig. 13), *Hunter* (fig. 14), and *Artist* (fig. 15). The guises in which Thompson presented himself were typical for the period. In conventional portraiture, however, one would have assumed that the person holding his palette and brush actually was an artist and that the hunter shown with his spoils actually was a hunter, whereas here all of the characters are the photographer himself. It seems likely that these very elaborate self-representations were intended to be used by Thompson in promoting his daguerreotype business.

An interest in Oriental subject matter, as evinced in Thompson's Arab costume, was widespread throughout the art world by the time of photography's invention, and the customs and costumes of the exotic East continued to exert a strong attraction throughout the remainder of the nineteenth century. In 1855 the British photographer Roger Fenton photographed himself as a Zouave (fig. 16), and in 1858 he dressed in Middle Eastern costume for the camera together with the painter William Grundy (fig. 17).[12] Even as late as 1901, the fascination with Oriental garb can be seen in photographs by Frederick H. Evans of F. Holland Day wearing Algerian robes (figs. 18 and 19).

Role-playing for the camera was also an important part of the work of the Victorian photographer Oscar Gustave Rejlander.[13] Rejlander himself appears as the central figure of the Sage in the first of two versions of *Two Ways of Life* (fig. 2). For the other models, Rejlander hired actors from a travelling tableau vivant group.[14] The photograph is set up with the performers arranged across the picture plane as if placed on a conventional proscenium stage. Behind them hangs a backdrop painted with a landscape, and the entire scene is framed by large curtains at either side and a scalloped valance along the top. *Two Ways of Life* was an ambitious project in several respects. First, it had a serious moral purpose, with the figures to the left of the Sage representing a life of vice and those to the right representing a life of virtue.[15] Second, it had an equally serious artistic purpose, signalled by its imitation of the composition and Classical details of Raphael's *School of Athens*. Third, it was technically challenging, an elaborate composite of about thirty separate negatives, photographed individually and assembled into a final montage. This technique allowed Rejlander to play another role as one of the gamblers on the left of the picture.

Rejlander's skill as a performer was required on a number of other occasions during his career. When Charles Darwin asked him to provide several photographic illustrations for his forthcoming book *The Expression of the Emotions in Man and Animals* (published in 1872), Rejlander himself posed for some of the images (see figs. 20 and 21). To our eyes, the emotions seem highly exaggerated, but the gestures are those of Victorian melodrama and would have been familiar to most readers of the time.[16] Like Bayard, Rejlander had

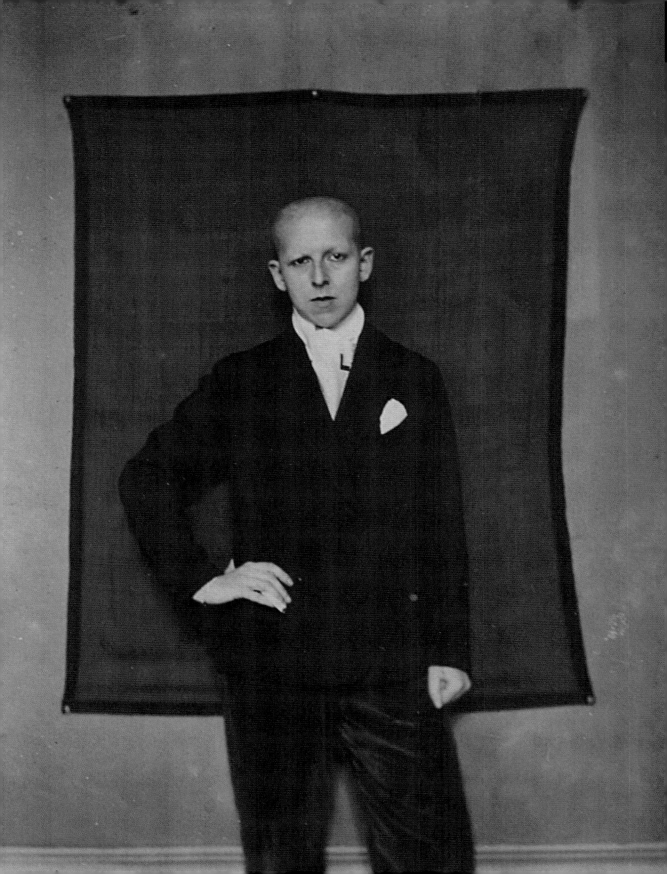

Fig. 7
Hippolyte Bayard, *Self-Portrait as a Drowned Man*, 1840, Bayard direct-positive process print. Société française de photographie, Paris (24.6)

Fig. 8
Hippolyte Bayard, *Bayard Attending a Patient*, c. 1840, salted paper print. Société française de photographie, Paris (24.301)

Figs. 9 & 10
Hippolyte Bayard, *Double Self-Portrait* (two versions), albumen silver prints. Château-musée municipal de Nemours,

Fig. 11
Duane Hanson, *Self-Portrait with Model*, 1979, Instant Prints (Kodak). Courtesy Laurence Miller Gallery, New York

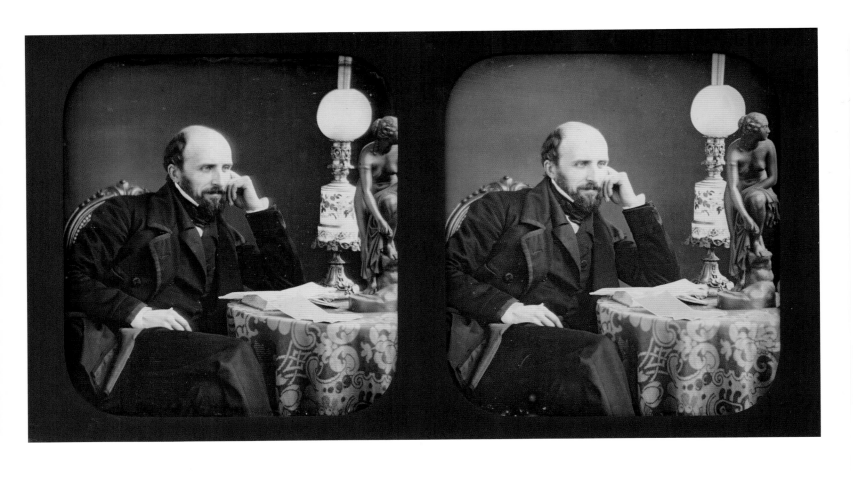

Fig. 12
Warren Thompson, *Self-Portrait as Thinker*, c. 1855, stereo daguerreotype. George Eastman House, Rochester, Gift of Eastman Kodak Company, ex-collection Gabriel Cromer (1976:0168:0115)

Fig. 13
Warren Thompson, *Self-Portrait as an Arab*, c. 1855, stereo daguerreotype. George Eastman House, Rochester, Gift of Eastman Kodak Company, ex-collection Gabriel Cromer (1970:0011:0004)

Fig. 14
Warren Thompson, *Self-Portrait as a Hunter*, c. 1855, stereo daguerreotype. George Eastman House, Rochester, Gift of Eastman Kodak Company, ex-collection Gabriel Cromer (1976:0168:0154)

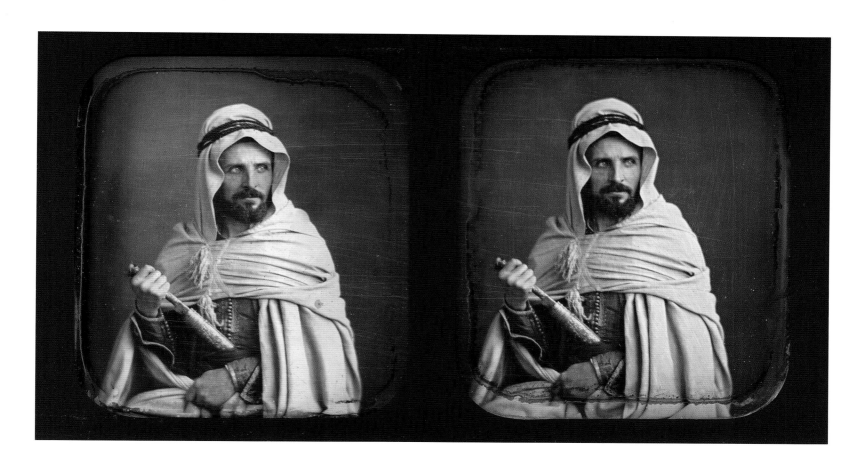

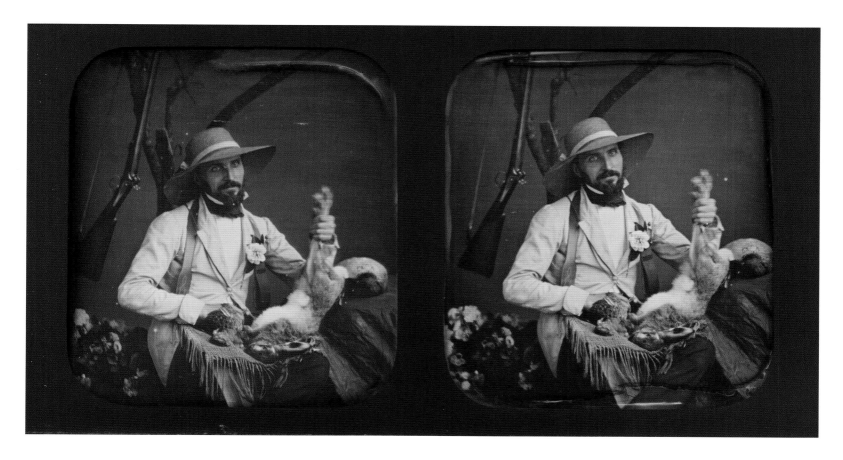

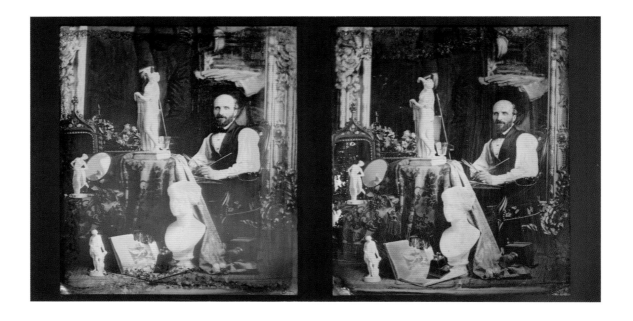

connections in the theatre; he was evidently a close friend of the British tragedian John Coleman, who may have posed for the second gambler in *Two Ways of Life*.[17]

In another, more humorous photograph from about the same period, Rejlander appears as both a military volunteer and an artist – a double self-portrait (fig. 24). But unlike Thompson, who had no apparent connection with the roles he assumed for his photographs, Rejlander really had served as a volunteer marksman and had indeed been a painter and lithographer before taking up photography. Clearly he still thought of himself as an artist even though his preferred medium was now photography. Perhaps it was his military career that inspired him to pose as the Italian revolutionary Giuseppe Garibaldi (fig. 22). The Victorian public was intensely fascinated by Garibaldi, and Rejlander undoubtedly shared this interest as a result of the years he himself had spent in Rome (and perhaps also because the two men bore a startling resemblance to one another). The stance and costume assumed by Rejlander in this fictional portrait suggest that he was familiar with a true portrait of Garibaldi from 1864 made by John Clarck (fig. 23).

Sometimes photographs of artists performing for their own camera provoked a surprising degree of public outrage. In the summer of 1898 F. Holland Day produced his *Seven Last Words of Christ* (fig. 25) and a large number of images of the Crucifixion (see fig. 26). In total, Day made approximately two hundred and fifty photographs of this subject. Depictions of Christ on the Cross have a long and rich tradition in the history of art, as do Passion plays in the theatre. There is little reason to doubt that these works were conceived with the utmost respect. Evidently aiming for a faithful, even naturalistic, evocation of the biblical account of Christ on the Cross, Day let his hair grow long and starved himself to the point of emaciation before posing for the photographs. But despite his intentions, the result stirred up controversy.

What was it about Day's photographs that prompted such outrage from the members of the public who first viewed them? James Crump suggests that the attacks were sparked by Day's public identification as an aesthete linked to Oscar Wilde and other known homosexuals.[18] But something more may have been at work. While the public was accustomed to painters adopting an alternative persona for a self-portrait, the expectations for photography were evidently different. Like Day posing as Christ, Rejlander had experienced a hostile reaction to his photographic impersonation of Garibaldi. He had also encountered some negative responses to the nude figures in *Two Ways of Life*, even though the depiction of nudes was familiar in painting.[19] Likewise some viewers were troubled by the fact that *Two Ways of Life* was a combination print, which meant that the actors had not all posed simultaneously for the scene.

Henry Peach Robinson's *Fading Away* (fig. 81) also disturbed viewers, but for two opposing reasons. At first it aroused the uncomfortable suspicion that the photographer had actually witnessed the death of a young woman surrounded by her anguished family. Then there was consternation at the revelation that he had seen no such thing, that the episode had been invented and that this picture too was staged and put together by means of combination printing. Because photography

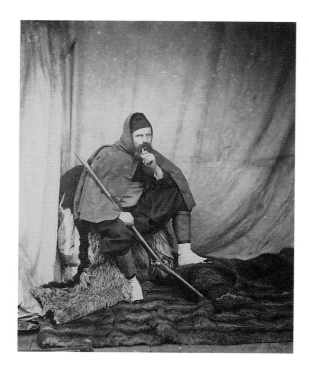 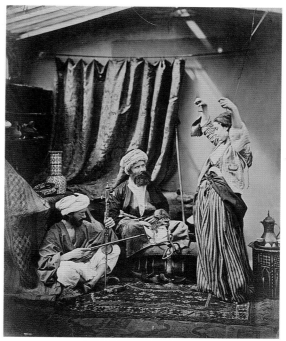

reflects the physical world more directly than does painting, manipulation of the image may seem tantamount to deception. The photographic portrayal may appear all too real, or it may be insufficiently real, making it hard for viewers to suspend their disbelief and accept the representation of fiction in a photograph.

THE ARTIST

The practice of copying great works of art has long been the traditional way for students to learn from the Old Masters. Given the difficulty of always working directly from originals, generations of students have relied on reproductions. Drawing courses such as the one developed in the nineteenth century by Charles Bargue in collaboration with the French painter and sculptor Jean-Léon Gérôme, for example, required that students copy works reproduced in the *Cours de dessin*, a book of lithographed drawings. Similarly, plaster-cast reproductions served as models for aspiring sculptors.

Photographic pioneers such as William Henry Fox Talbot understood the usefulness of photography as a tool in art education. Talbot outlined his proposals in a groundbreaking publication, *The Pencil of Nature* (1844–1846), one of the first books with photographic illustrations.[20] This was soon followed by the first photographically illustrated book of art history, William Stirling's *Annals of the Artists of Spain* (1848). Talbot's invention of the paper negative, which facilitated the making of reproductions, helped to place copies of fine paintings within easy reach of art students.

Rejlander saw yet other innovative possibilities. An artist himself, he had worked in Spain and Italy copying paintings for lithographic reproduction. In 1853 he learned the rudiments of photography from Talbot's assistant, Nicholas Henneman.[21] The camera now offered him a completely original way to "copy" works of art – by photographing staged tableaux of paintings. Initially, Rejlander's purpose was educational. He believed that the capability of photography to render the human form with great accuracy would help teach artists to become better draftsmen.[22] His *Two Ways of Life*, as we have seen, restages the composition of Raphael's *School of Athens*, though its subject is different. His *Young Woman in Prayer* (fig. 27) is a carefully arranged re-creation of *The Virgin in Prayer* by the seventeenth-century Italian painter Sassoferrato (fig. 28). It is likely that this photograph is identifiable as the "Madonna alla Sassoferrato" praised by the critic George Wharton Simpson in a review of the Berlin International Photographic Exhibition of 1865. The "Madonna" and similar photographs, Simpson says, "form a weighty argument for maintaining the view that photography should be regarded as an art in the highest sense."[23] As Simpson recognized, Rejlander's ultimate intention in his photographed tableaux was not just to pay homage to artists he admired or to facilitate the teaching of art, but to show that photography could match the high seriousness of drawing and painting.

Somewhat in the same vein, Rejlander also made a number of humorous images, among them one called *The First Negative* (fig. 29), inspired by Pliny's story of the origins of drawing and painting. Although the subject had been depicted in paintings since the eighteenth

Fig. 16
Roger Fenton, *Zouave, 2nd Division*, 1855, salted paper print. Los Angeles County Museum of Art, The Audrey and Sydney Irmas Collection (AC1992.197.52)

Fig. 17
Roger Fenton, *Pasha and Bayadère*, 1858, albumen silver print. J. Paul Getty Museum, Los Angeles (84.XP.219.32)

Fig. 18
Frederick H. Evans, *F. Holland Day in Algerian Costume*, 1901, platinum print. George Eastman House, Rochester, Museum Purchase, ex-collection Gordon Conn (1981:1198:0083)

Fig. 19
Frederick H. Evans, *F. Holland Day in Arab Costume*, 1901, platinum print. Los Angeles County Museum of Art, The Audrey and Sydney Irmas Collection (AC1992.197.40)

Figs. 20 & 21
Collotypes by Oscar Gustave
Rejlander illustrating Disdain,
Disgust, Indignation, and
Helplessness in Charles Darwin's
*The Expression of the Emotions
in Man and Animals* (London:
John Murray, 1872, 1st ed.).
National Gallery of Canada,
Ottawa (PSC76:183:5;
PSC76:183:6)

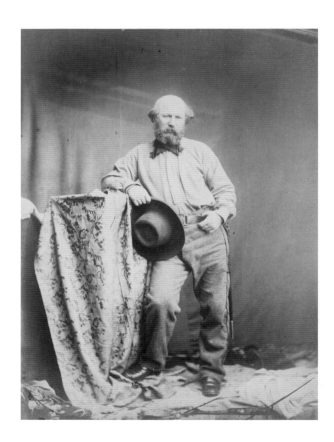

Fig. 22
Oscar Gustave Rejlander,
Rejlander as Garibaldi,
c. 1864, albumen silver print.
Royal Photographic Society
Collection, National Museum
of Photography, Film and
Television, Bradford, England

Fig. 23
John Clarck, *Giuseppe Garibaldi*,
1864, albumen silver print, with
applied colour. National Portrait
Gallery, London

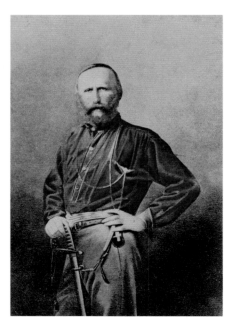

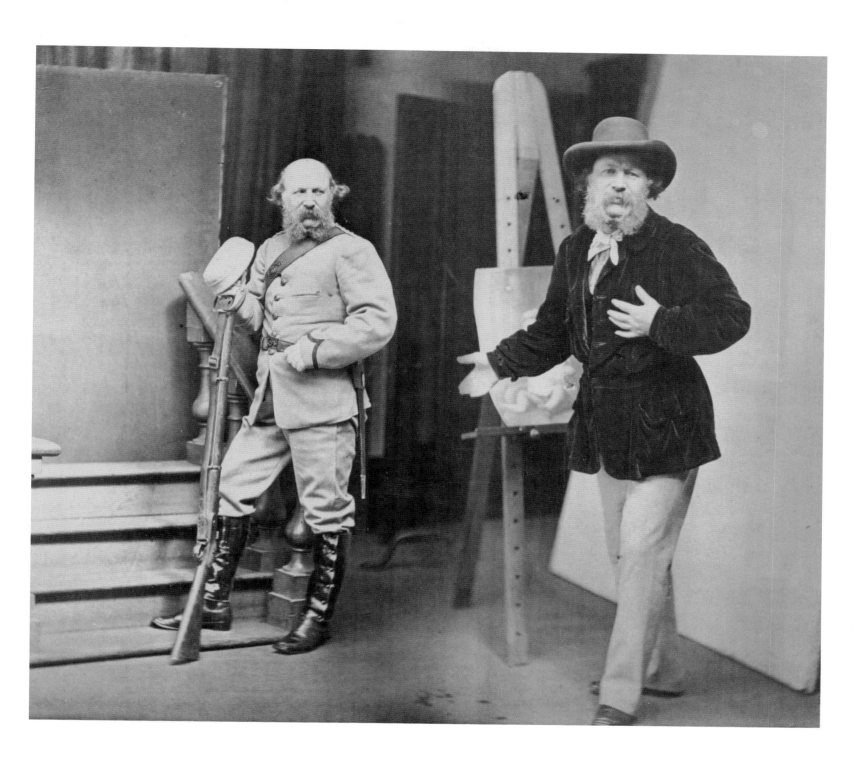

Fig. 24
Oscar Gustave Rejlander,
The Artist Introduces O.G.R.
the Volunteer, c. 1871, albumen
silver print. National Museum
of Photography, Film and
Television, Bradford, England

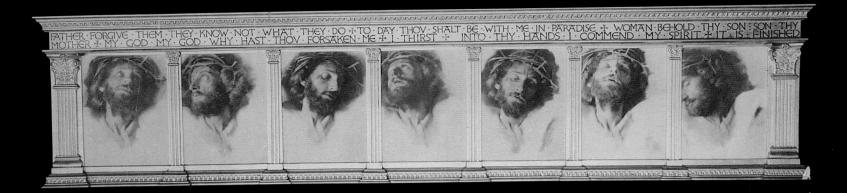

FATHER FORGIVE · THEM · THEY · KNOW · NOT · WHAT · THEY · DO ✝ TO · DAY · THOV · SHALT · BE · WITH · ME · IN · PARADISE ✝ WOMAN · BEHOLD · THY · SON : SON · THY
MOTHER ✝ MY · GOD · MY · GOD · WHY · HAST · THOV · FORSAKEN · ME ✝ I · THIRST ✝ INTO · THY · HANDS · I · COMMEND · MY · SPIRIT ✝ IT · IS · FINISHED

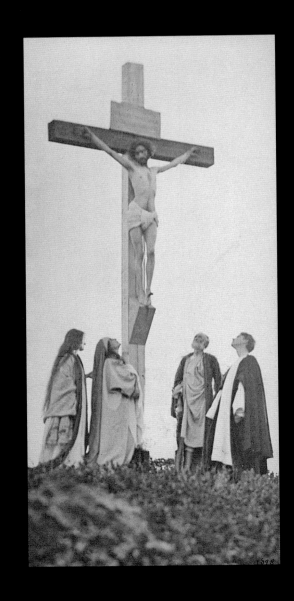

century,[24] Rejlander's staged scene was the first attempt to tell the story in a photograph. A young actress, costumed as the "Corinthian Maid," kneels next to a man, probably the actor John Coleman, shown likewise on bended knee and in profile.[25] The young woman is tracing the outline of the man's shadow – the result being the first drawing, according to the traditional version of the story. Built into the picture now is the witty allusion to the shadow as "the first negative."

While *Two Ways of Life* and *The First Negative* make reference to the Classical period through costume or narrative, other Victorian staged photographs are directly modelled on Classical works of art. A particularly exciting source of inspiration was offered by the Elgin Marbles, that potent symbol of nineteenth-century British imperialism. (Lord Elgin, at the dawn of the nineteenth century, had planned on making plaster casts and drawings of the Parthenon sculptures, to be displayed at his home in Scotland. He ended up returning with some of the original marble friezes, which he sold to the British Museum, where they quickly became a popular attraction, especially among art students who gained practice by copying them.) Julia Margaret Cameron, at one time a pupil of Rejlander, re-created a section of the marbles, with two of her housemaids, Cyllena Wilson and Mary Hillier, posing as Aphrodite and Dione, figures in the frieze that are thought to be from the eastern portion of the pediment of the Parthenon. There are two versions of the scene, differing from one another only in the positioning of the heads (figs. 30 and 31).[26]

The practice of photographing scenes inspired by works of art continued into the twentieth century, becoming one of the hallmarks of Pictorialism. This photographic style, which flourished from about 1880 to 1920, strove to establish a place for artistic photography, making it distinct from commercial work through its emulation of more established art forms such as painting or etching. The Italian Guido Rey and the Netherlander Richard Polak both produced photographs styled in the manner of paintings by Johannes Vermeer, Pieter de Hooch (see fig. 32), and other Dutch painters. *The Letter* by Rey, from 1908 (fig. 33), shows the influence of seventeenth-century Dutch painting, down to the detail of the black-and-white tiled floor.[27] Polak is known only for the one book he produced, entitled *Photographs from Life in Old Dutch Costume*, showing domestic scenes staged in imitation of Dutch painting. Rey also arranged scenes based on his research into the art of ancient Pompeii (see fig. 34). The photography of Rey and Polak, with its uncritical, unselfconscious references to paintings from the past, seems quaint to modern viewers, who are familiar with more recent work that is deliberately and unabashedly contrived in its staging. In their day, however, Rey and Polak were greatly admired; Rey's work was frequently featured on the pages of Alfred Stieglitz's Pictorialist quarterly, *Camera Work*.

Some Pictorialists continued to look to paintings for their subject matter even into the 1930s. As late as 1935, the American photographer William Mortensen still delved into seventeenth-century Dutch painting for images such as *Flemish Maid* (fig. 96).[28] But Pictorialism was on the wane, its painterly qualities perceived as artificial. Photography that relied on painting for either its artistic effect or narrative content was suspect: it was seen as a denial of the medium's unique ability to record the "real" world. At the same time, the Great Depression created a demand for documentary photography relating to the social and political issues of the time, in all their harshness. The aesthetic climate favoured what is known as "straight" photography, which avoids darkroom manipulation intended to make the result look more like a painting or an etching. In 1932 a group of photographers calling themselves Group f/64 issued a manifesto stating that "photography, as an art form, must develop along lines defined by the actualities and limitations of the photographic medium, and must always remain independent of ideological conventions of art and aesthetics that are reminiscent of a period and culture antedating the growth of the medium itself."[29]

Rebuffed by the proponents of this Modernist aesthetic, many Pictorialist photographers found a more enthusiastic welcome in Hollywood. Several of them, including Karl Struss, Ralph Steiner, Paul Outerbridge, Jr., and William Mortensen, moved to Hollywood in the 1920s and 1930s, and their work there had a strong impact on the development of cinematography. The Pictorialist photographer Karl Struss, for example, who had trained at the Clarence White School in New York, was hired by a filmmaking company in California for his ability to encapsulate a story in a single image and for his skill at creating atmospheric lighting. Hollywood in turn influenced the direction of still photography, most

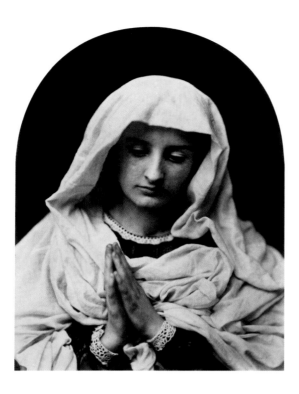

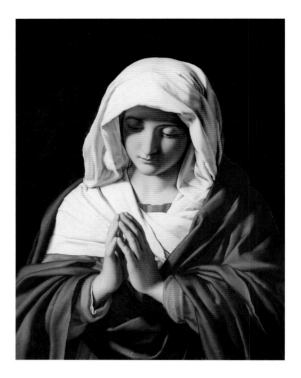

noticeably in the work of William Mortensen and Arthur F. Kales, whose sense of glamour and melodrama could be traced back to the era of the silent film.

The influence of cinematography on still photography can be seen even in Mortensen's *Flemish Maid,* where the strong artificial light that carves the figure out of the dark background owes as much to the movies as to Vermeer. Hollywood glamour is at the very heart of many of Erwin Blumenfeld's photographs. Blumenfeld began as a Dadaist and later did commercial work for *Vogue* and *Harper's Bazaar.* In a photograph that may have been intended for a fashion magazine (fig. 35), Blumenfeld, like Mortensen, drew his inspiration from art history, actually reproducing part of Renoir's *La Loge* directly in the scene but replacing the central figure with a glamorous model.

Horst P. Horst's *Electric Beauty* (fig. 122) also uses elements appropriated from painting to add elegance and sophistication to an image made for commercial purposes. A detail from *The Temptation of Saint Anthony* by Hieronymus Bosch provides the background for this macabre scene, showing a woman snarled in the cords of various grooming appliances. In its unmasking of the darker side of glamour, the image subverts the conventions of fashion photography. Furthermore, the ambience of psychological ambiguity and threatened violence seems to anticipate film noir.

Outside the commercial arena, a few avant-garde artists continued to work with staged photography, expanding the conceptual framework of the genre. The boundary between commercial and art photography was not always sharply drawn, as can be seen in Horst's *Electric Beauty.* In the first half of the twentieth century, staged photography was influenced not just by movies themselves, but also by movie magazines such as *Photoplay, Silver Screen,* and *Motion Picture,* the covers of which regularly featured close-ups of famous actresses or stills from films. A good example is Man Ray's *Tears,* from the early 1930s, with its close-up of a woman's tear-stained face looking imploringly upward (see figs. 109 and 110). The artist's *Self-Portrait with Dead Nude* (fig. 36), from a slightly earlier period, combines sex and violence in a sensationally melodramatic image reminiscent of the lurid cover art of the pulp magazines that flourished from the 1930s to the 1950s.

By the 1950s, staged fictional scenes were the dominant mode in advertising photography. A theatrical style was used, so that the article or service being sold could be incorporated into an engaging story. In Paul Outerbridge's *The Coffee Drinkers* (fig. 3), made for a 1939 advertisement for Eight O'Clock Coffee, we are afforded a glimpse into a suburban kitchen in which a group of men are enjoying an animated conversation over coffee. The particular brand of coffee they are drinking is not identified anywhere in the image, and so the picture by itself does not reveal its true intent. While advertisements earlier in the century had employed a direct, unadorned, Modernist approach, highlighting the actual product and its benefits, here we are lured by the appeal of something larger and less tangible: friendship and conviviality. The "fictional situations" developed by such photographers as Outerbridge and Ralph Bartholomew, Jr., were often

Fig. 29
Oscar Gustave Rejlander,
The First Negative, 1857,
salted paper print. Hans
P. Kraus, Jr., New York

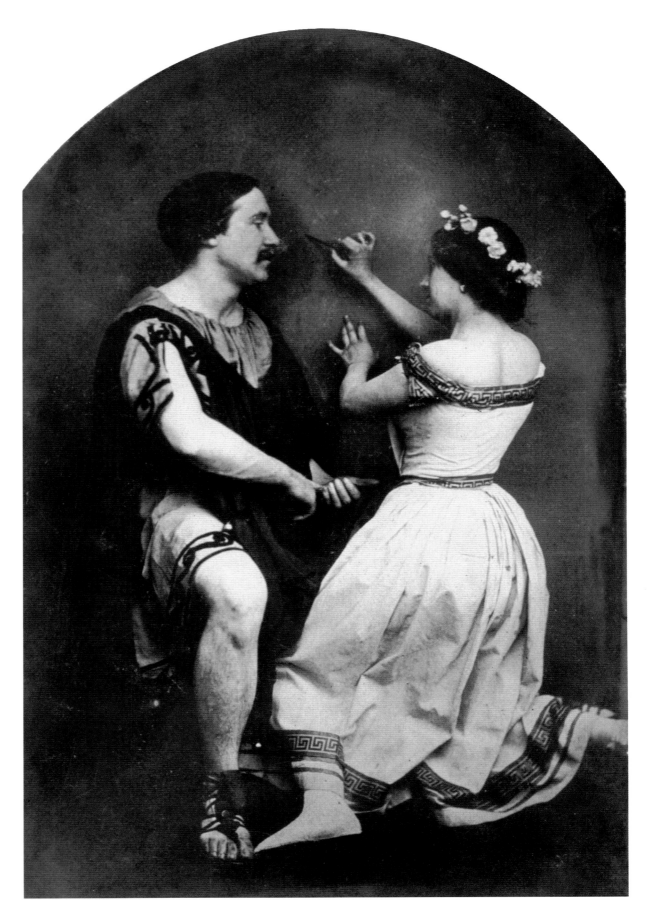

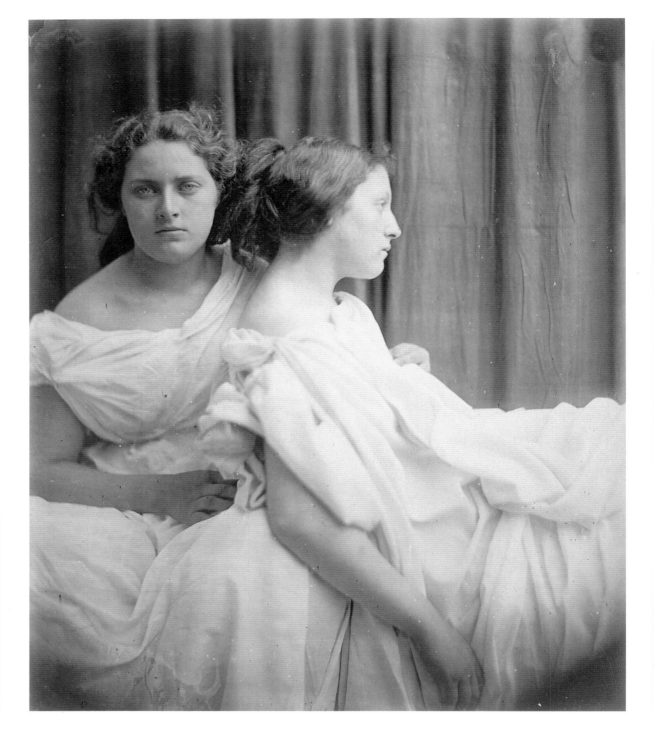

Fig. 30
Julia Margaret Cameron,
Teachings from the Elgin Marbles,
1867, albumen silver print.
National Museum of Photography,
Film and Television, Bradford,
England

Fig. 31
Julia Margaret Cameron, *After
the Manner of the Elgin Marbles,*
1867, albumen silver print.
The Victoria and Albert Museum,
London, The Nevison Bequest
(E.2745-1990)

Fig. 32
Pieter de Hooch, *An Interior,*
with a Woman Drinking with
Two Men, and a Maidservant,
probably 1658, oil on canvas.
The National Gallery, London,
Bought with the Peel Collection,
1871 (NG834)

Fig. 33
Guido Rey, *The Letter*, 1908,
platinum print. J. Paul Getty
Museum, Los Angeles
(85.XP.314.7)

Fig. 34
Guido Rey, *Four Figures in Classical Robes*, c. 1895, platinum print. J. Paul Getty Museum, Los Angeles (94.XM.9.1)

Fig. 35
Erwin Blumenfeld, *Untitled*, c. 1936–1940, gelatin silver print. National Gallery of Canada, Ottawa, Gift of Rodney and Cozette de Charmoy Grey, Geneva, 1979 (20883)

directly modelled on scenes from films, introducing a new dramatic style to the burgeoning field of advertising photography. A photograph made for Eastman Kodak in 1954 (fig. 38) reveals the extent to which Bartholomew was influenced by cinematography, and especially by the film noir genre.

Beyond the world of advertising, the staged photograph as an art form continued to decline through the 1940s and 1950s. Often the disdain for the staged photograph was so intense that photographers would claim that their images were spontaneous even when they had actually been set up. Weegee's *The Critic* (fig. 123) and Robert Doisneau's *The Kiss at the Hôtel de Ville* (fig. 124) both have the look of a casual photo snapped by chance on a busy street. More than forty years later, Doisneau admitted publicly that his picture had been staged. (Even in the nineteenth century, photographers sometimes portrayed scenes that would seem to have been spontaneous occurrences in the street but which we now know could only have been achieved through a deliberate, choreographed approach [see fig. 37].)

Beginning in the 1960s, the work of Duane Michals, Les Krims, Eikoh Hosoe, and others signalled a revival of the staged photograph. Among these photographers, it is only Hosoe who has made use of famous works of art from the past, incorporating them as backdrops or overlays (see fig. 117).[30]

Generally speaking, art history provided little inspiration to the postwar generation of photographers until the advent in the 1980s of Postmodernism, with its characteristic practices of quotation and appropriation. At first glance, it would seem that Japan's Yasumasa Morimura has stepped in exactly where Rejlander left off, creating images that are clearly modelled on familiar paintings. But closer examination reveals that his interests and those of his contemporaries are far removed from Rejlander's goals of instructing artists or elevating the status of photography. In photographs such as *Portrait (Futago)* (fig. 131), Morimura is, as Donald Kuspit has argued, both "a reconstructive archaeologist" and "a deconstructive parodist," in that he reconstructs a version of an earlier work of art while at the same time probing its layers of cultural assumptions.[31]

Cindy Sherman, one of the best-known contemporary practitioners of the staged photograph, looks to the history of art in her *History Portraits* series of 1989–1990. The photographs in this series occasionally refer to specific paintings; *Untitled #224* (fig. 39), for example, is a re-enactment of Caravaggio's *Sick Bacchus* (fig. 40). Photographs such as *Untitled #223* (fig. 41) work in a more complex way, combining stylistic elements from several different artists or else details from different paintings by the same artist. These juxtapositions leave the viewer with an uncanny sense of recognizing the sources of Sherman's restagings but not being able to pinpoint them.

By the late 1990s, Sherman's work had itself become sufficiently recognizable that an artist such as Morimura could begin to appropriate it in turn. *Untitled #96* (fig. 42), from Sherman's *Centerfold* series, is restaged by Morimura in *To My Little Sister: For Cindy Sherman* (fig. 43). Like Sherman in the original, Morimura is lying on a reddish-brown floor patterned in fake tiles. Wearing an orange tee-shirt and pleated skirt, Morimura/Sherman clutches a piece of paper that might have been torn from a newspaper, novel, or telephone book. Yet *Little Sister* is not an exact replica of Sherman's photograph: the lettering on the piece of paper is in Japanese, the pattern and colour of the skirt are slightly different, and the facial features are obviously Asian. Morimura's consciousness of the differences between the two works is indeed essential to the meaning of his photograph. Transmitting the dissonances inherent in a Japanese upbringing heavily influenced by Western culture, Morimura's photograph constantly reminds us that he is an Asian man posing as a young American woman. As Morimura himself has observed, it is an image about things "gone amiss."[32]

In making *Little Sister*, Morimura built and painted the sets himself, performed for his own camera, and even digitally edited the final image, using a multiplicity of skills and arts to convey his message. However, it is his own body that serves as literal and metaphorical canvas, permitting him to examine issues of gender, authenticity, originality, race, and culture. Through his restaging of Sherman's photograph, Morimura embraces the traditions of art history while simultaneously rejecting them.

Sherman and Morimura, as well as such other contemporary photographers as Jeff Wall, Evergon, Anne Ferran, Anne Zahalka, Jakub Dolejš, and Adi Nes, have restored the staged image to a position of prominence in the photographic canon (see figs. 44-47, 51, 127, 128, 143,

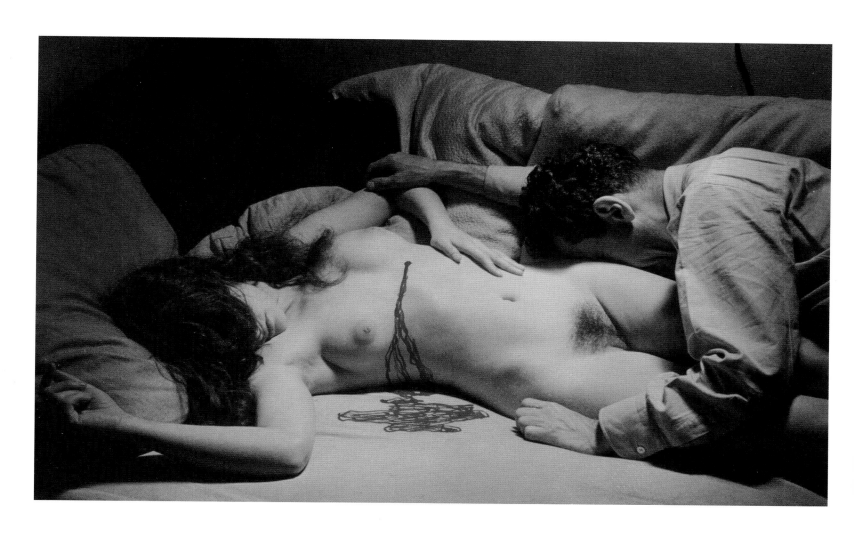

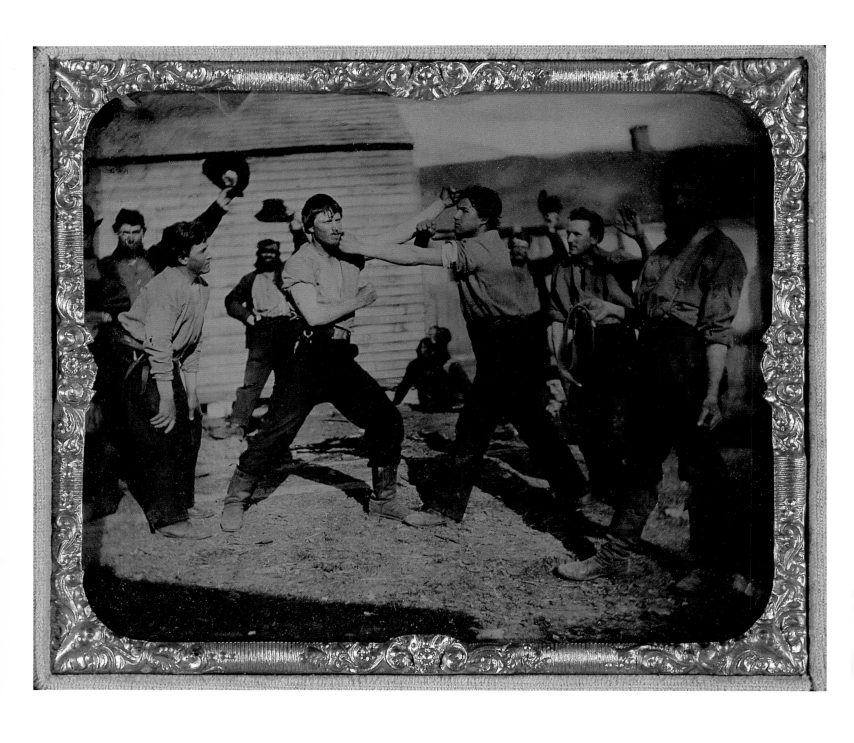

Fig. 37
Unknown photographer, *Soldiers
in a Staged Fight*, c. 1863,
ambrotype, with applied colour.
Amon Carter Museum, Fort
Worth, Texas (P1989.7.1)

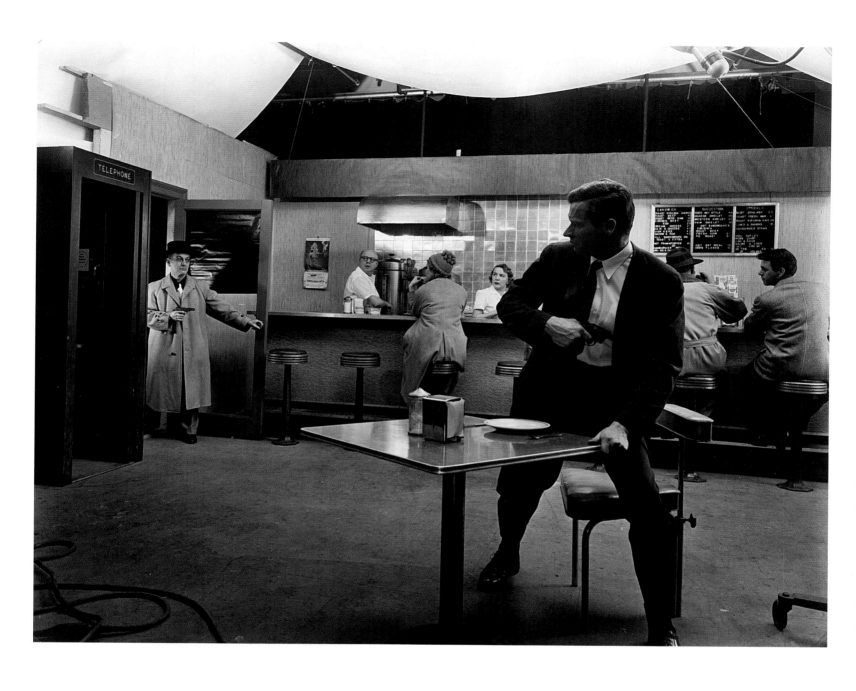

Fig. 38
Ralph Bartholomew, Jr., *Untitled*,
1954, gelatin silver print. Los
Angeles County Museum of Art,
Gift of the Bartholomew Family,
Courtesy Keith de Lellis Gallery,
New York (AC1998.1.6)

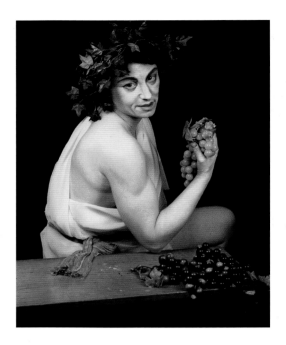

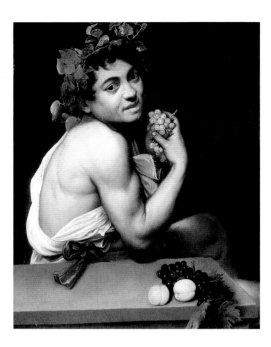

Fig. 39
Cindy Sherman, *Untitled
#224*, 1990, dye coupler print.
Courtesy of the artist and Metro
Pictures Gallery

Fig. 40
Caravaggio (Michelangelo
Merisi), *Sick Bacchus*,
1593–1594, oil on canvas.
Galleria Borghese, Rome

Fig. 41
Cindy Sherman, *Untitled
#223*, 1990, dye coupler print.
The Museum of Contemporary
Art, Los Angeles, Partial
and promised gift of Beatrice
and Philip Gersh (97.162)

and 144). Employing large-sized prints that bear a greater affinity to painting than to photography, and addressing subjects that are often drawn from works of art, these photographers speak with a new vocabulary derived from art history but informed by other elements of visual culture such as advertising and film.

The Canadian artist Jeff Wall restages elements of well-known paintings in a modern idiom. His photographs are mounted as transparencies in the light boxes commonly used for advertising displays. Wall's *Destroyed Room* echoes Delacroix's *Death of Sardanapalus*. His *Stereo* reminds us of Manet's *Olympia*. It is harder to find a direct connection between *The Vampires' Picnic* (fig. 144) and any particular painting, although it has been compared both to Manet's *Luncheon on the Grass (Déjeuner sur l'herbe)* and to Géricault's *Raft of the Medusa*.[33] Wall himself cites German and Flemish Mannerist painting and also horror films as influences on this work.[34]

The way in which the staged tableau is used in still photography also has a parallel in a number of films and videos of the past few decades. Peter Greenaway's *A Zed & Two Noughts* (1985) pays homage to Vermeer's *Girl with a Red Hat*, and Derek Jarman's biographical film *Caravaggio* (1986) makes reference to many of that artist's paintings. Bill Viola's video *The Greeting* stages Jacopo da Pontormo's *The Visitation* (see figs. 140 and 141). While in some of these works the connection to historical art is merely fleeting or only vaguely hinted at, in others the reference is quite explicit. For example, in Eve Sussman's *89 Seconds at Alcázar* (fig. 48), a twelve-minute looped video, there are a few seconds in which the actors pose so as to mimic the scene represented in Velázquez's *Las Meninas*, triggering the viewer's memory of the original painting. Both Viola and Sussman make interesting use of slow-motion as a way of forcing our attention.

The intersection of filmmaking and staged photography is explored by the Canadian artist Michael Snow in a work from 2001 entitled *Flash! 20:49, 15/6/2001* (fig. 49). In this large colour photograph, a man and a woman sit across from each other at a dinner table, seemingly oblivious to the chaos of the moment – wine-filled glasses tip over, dinner rolls fly across the table, and a plate spins toward a wall. The "flash" of the work's title seems to precipitate the explosion of activity even as it arrests it, and the "decisive moment" is captured as if stroboscopically. The true subjects of Snow's staged image are time and movement.

Over the past three years, the Canadian artist Adad Hannah has created a series of installations/projections that explore the boundaries between the still image and the staged photograph through the use of modern technologies. In *Cuba Still (Remake)* (fig. 50), a work that also probes the issue of artistic quotation and appropriation, Hannah begins by posing actors in a tableau that restages a photograph made in the 1950s. He then videotapes or photographs each element of the tableau separately. The moving and still images are displayed through six projectors equipped with masking devices that serve to isolate particular parts of the projected montage. The result brings combination photography full circle: the practices of Robinson and Rejlander have now been transposed into the twenty-first century.

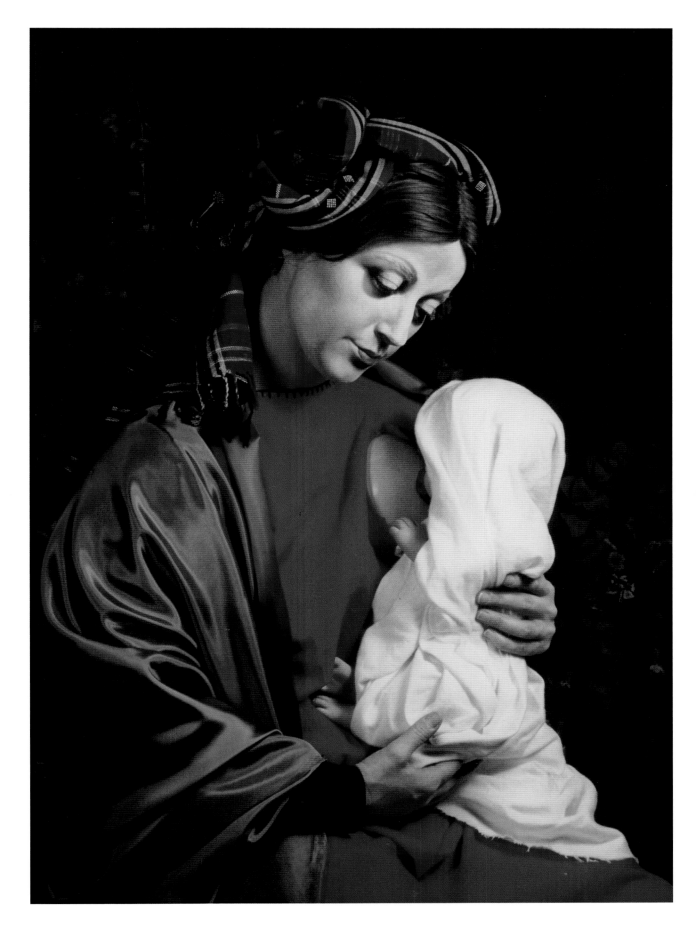

Fig. 44
Anne Ferran, *Scenes on the
Death of Nature, I and II,*
1986, printed 1989, gelatin
silver prints. George Eastman
House, Rochester, Museum

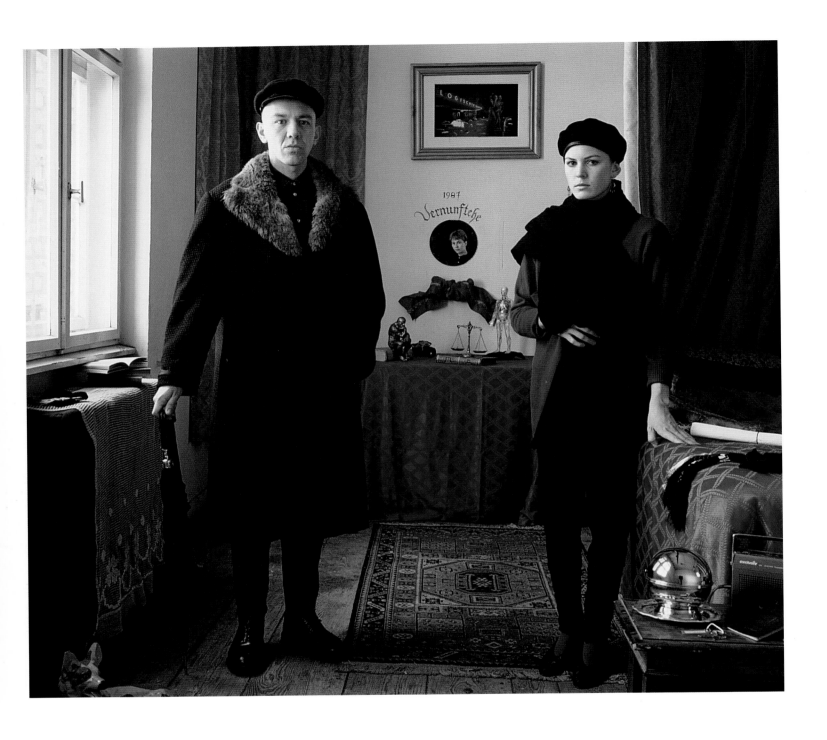

Fig. 45
Anne Zahalka, *The Marriage
of Convenience*, from the series
Resemblance I, 1987, azo dye
print (Cibachrome). Art Gallery
of South Australia, Adelaide,
South Australian Government
Grant, 1989

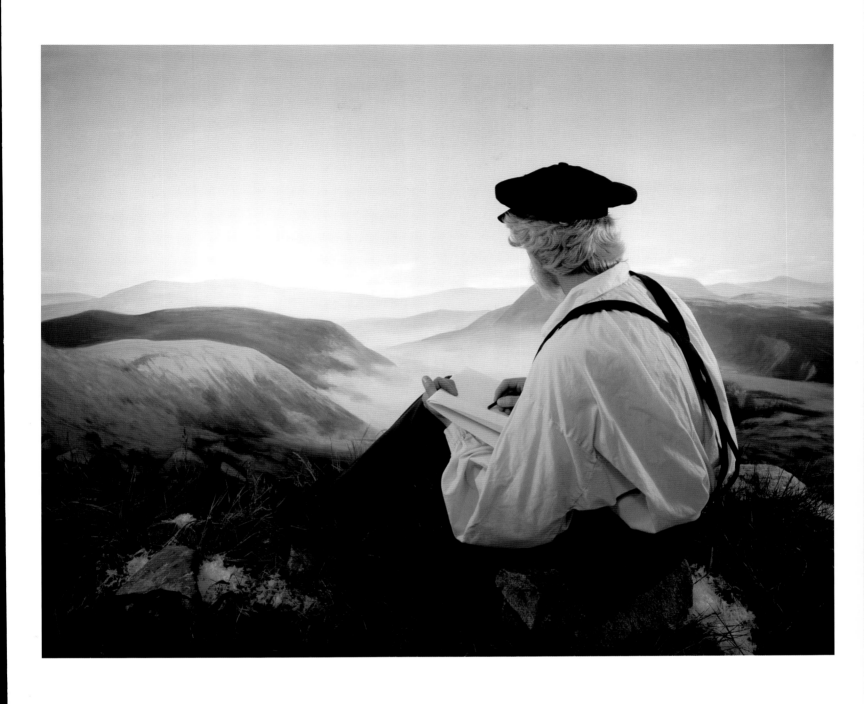

Fig. 46
Jakub Dolejš, *Caspar David Friedrich Sketching My Homeland, 1810*, 2003, dye coupler print. Courtesy of the artist and Angell Gallery, Toronto

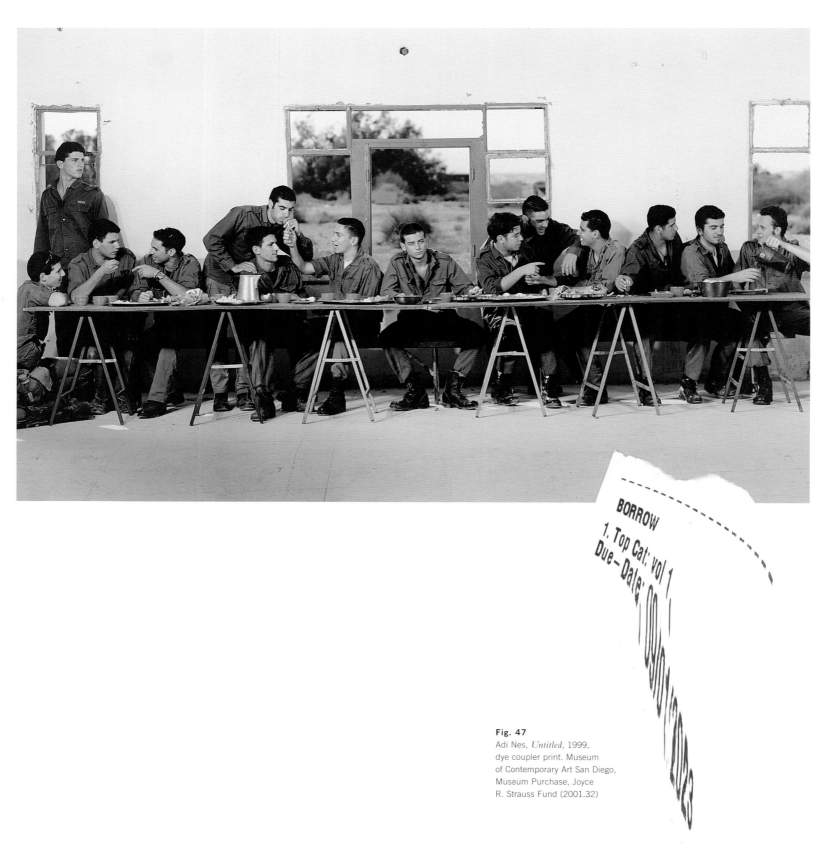

Fig. 47
Adi Nes, *Untitled*, 1999,
dye coupler print. Museum
of Contemporary Art San Diego,
Museum Purchase, Joyce
R. Strauss Fund (2001.32)

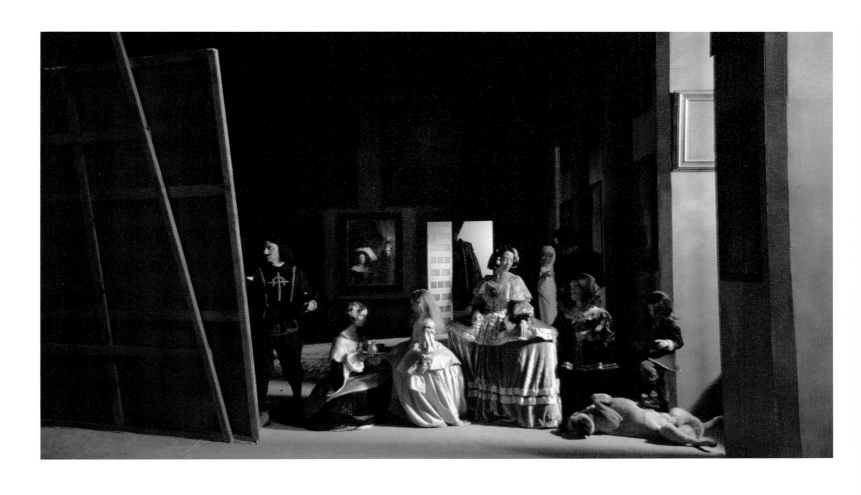

Fig. 48
Dog Rolls, production still from
89 Seconds at Alcázar (video),
Eve Sussman and The Rufus
Corporation, 2004. Photograph
by Benedikt Partenheimer.
The Museum of Modern Art,
New York

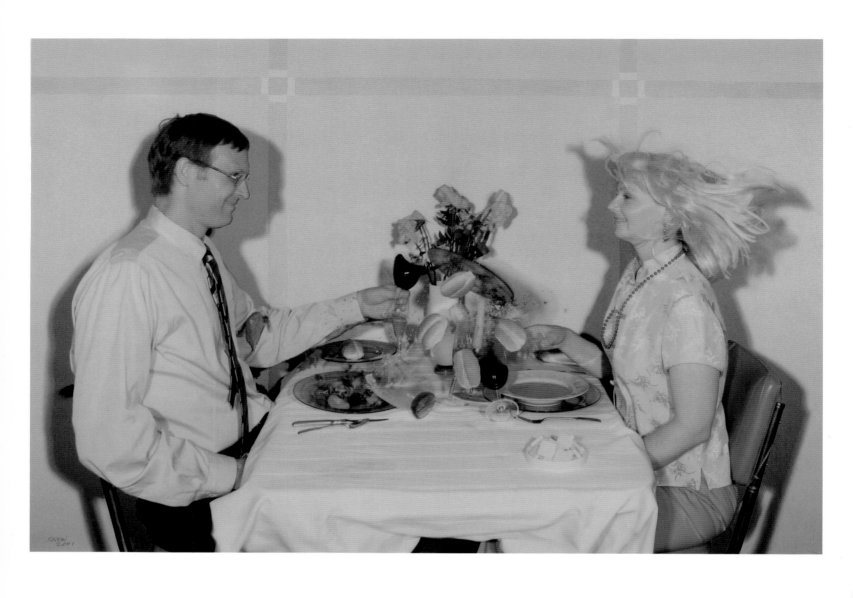

Fig. 49
Michael Snow, *Flash! 20:49,
15/6/2001*, 2001, dye coupler
print. Courtesy of the artist and
Jack Shainman Gallery, New York

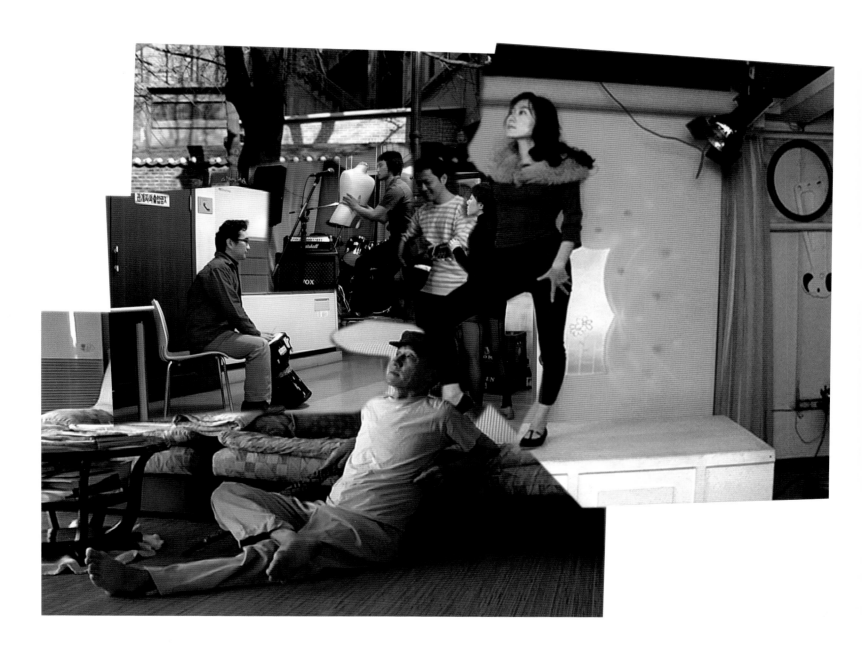

Fig. 50
Adad Hannah, *Cuba Still
(Remake)*, 2005, video
installation. Collection
of the artist, Montreal

THE STORYTELLER

One of the earliest known photographic group portraits is *The Fruit Sellers* (fig. 54), which has long been attributed to William Henry Fox Talbot. Made in 1845, it is an outdoor scene showing four men and two women re-enacting an everyday event: fruit sellers offering their wares to the ladies of the house.[35] The photograph was made in the grounds of Lacock Abbey, Talbot's family home.[36] Like all of the earliest photographs, it is anything but spontaneous. Slow exposure times and the lack of flash meant that the outdoor setting was a necessity. It was usually the photographer who would arrange the scene and suggest poses for the sitters to adopt. Like the painting of a portrait, the process took time and required preparation. Moreover, *The Fruit Sellers* is not just a straightforward documentary account of reality; it tells a fragment of a story, and the sitters are playing roles.

In their subject matter, many early photographs adopted the conventions of painting and drawing that were popular at the time, even extending to the frequent moralism. For the Victorians, the expectation that a painting should tell a story or provide moral instruction was something deeply ingrained. In Ford Madox Brown's painting entitled *Work* (fig. 52), showing a busy street scene crowded with robust and industrious workmen, there is a lesson about the nobility of labour and the dignity of the common worker. In the background, a pair of well-dressed women appear to be handing out temperance leaflets, providing the viewer with yet another lesson. William Holman Hunt's *The Awakening Conscience* (fig. 53), another popular painting in its day, shows a young woman starting up from the lap of a young man as they sit at the piano. She is evidently seized by misgivings about her past behaviour and has "awakened" to the realization of a nobler path.

The Victorians were not always this earnest, of course. An early example of humour in a staged photograph is *The Morning After ("He, Greatly Daring, Dined")* by David Octavius Hill and Robert Adamson (fig. 55). This witty double portrait of Hill and the surgeon James Miller shows Hill slumped at a small table, his shirt undone and hair tousled. Miller holds Hill by the wrist: the calm and sober doctor checks the pulse

of his dissolute friend. Behind Miller is a large bust entitled *The Last of the Romans* by the Scottish sculptor John Stevens. The title of the photograph plays on a line from Ovid's *Metamorphoses*, the inscription on the grave of Phaeton "who sought to guide / His father's steeds, and, greatly daring, died."[37] Since Miller was known as a temperance reformer and an orator, we are presumably meant to discern a serious purpose underlying the joke, a warning about the evils of overindulgence.[38]

It is harder to know what led Hill and Adamson to make a series of photographs illustrating passages from Sir Walter Scott's *The Antiquary*. The photographs were taken on the estate of Lord Cockburn near Bonaly, in Scotland, sometime between 1843 and 1847 (see fig. 56). Hill seems to have visited the estate several times, which makes it difficult to attach a precise date to the photographs. The fact that the sitters are dressed in the same costumes or clothing in many of the pictures suggests that they were all taken on the same day. Were they produced in anticipation of their being exhibited as illustrations to Scott's text? Or are they just an example of a tableau vivant, one of the parlour games that filled the leisure hours of upper-class Victorians?

Scenes from literature or history were popular subjects for other Victorian photographers. William Lake Price, for example, illustrated *Don Quixote* in 1857 (fig. 57). In 1858 Henry Peach Robinson retold the tale of *Red Riding Hood* in a sequence of four photographs (fig. 58), believed to be his first attempt at a picture narrative.

The story of King Arthur gave Robinson the inspiration for at least two photographic illustrations, *The Lady of Shalott* (fig. 59) and *Elaine Looking at Lancelot's Shield*. Perhaps his most celebrated staged photograph is *Fading Away* (fig. 81), which shows a dying young woman surrounded by her family. It is made from five studies photographed separately and then assembled for the final print. The study of the young woman was published on its own with the title *"She Never Told Her Love"* (fig. 82), a quotation from Shakespeare's *Twelfth Night*:[39]

She never told her love,
But let concealment, like a worm i' the bud,
Feed on her damask cheek: she pined in thought,
And with a green and yellow melancholy
She sat like patience on a monument,
Smiling at grief. Was not this love indeed?

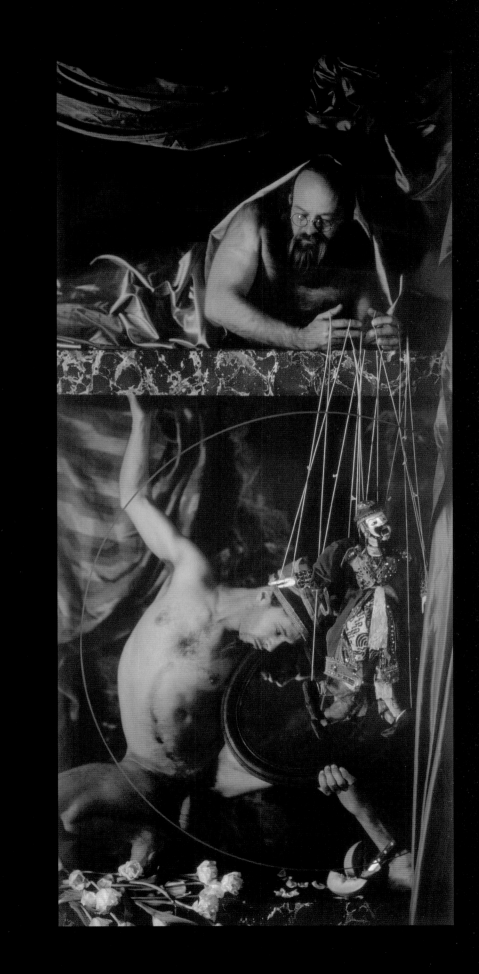

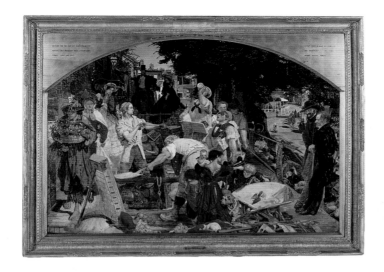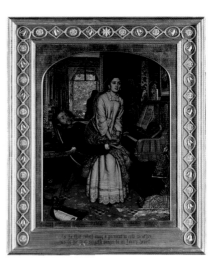

Fig. 52
Ford Madox Brown, *Work*,
1852–1863, oil on canvas.
Manchester Art Gallery

Fig. 53
William Holman Hunt, *The
Awakening Conscience*, 1853,
oil on canvas. Tate Britain

While the title is a reference to the lines in *Twelfth Night*, the image is certainly not an illustration of the play. Even less clearly tied to a specific text are other photographs by Robinson such as *Preparing Spring Flowers for Market* (fig. 60) and *Dawn and Sunset* (fig. 61), yet their allegorical or metaphorical element is suggestive of narrative.

Julia Margaret Cameron may be best known for her insightful portraits, but she also produced some memorable narrative photographs. *Go Not Yet (The Fisherman's Farewell)* (fig. 62) and *Pray God Bring Father Safely Home* (fig. 63), for example, were inspired by Charles Kingsley's 1851 poem "The Three Fishers."[40] In 1874 Alfred Tennyson, who was Cameron's neighbour on the Isle of Wight, asked her to illustrate his *Idylls of the King*, a retelling of the story of King Arthur. It might have been expected that the combined efforts of these two highly esteemed Victorian artists would garner both popular and critical acclaim, but the *Idylls* was neither a critical nor a financial success in its own time.

Today, we still consider Cameron's *Idylls* to be among her lesser works. Unless the modern viewer happens to be familiar – as the Victorian public would have been – with Tennyson's poetry and the tales of King Arthur, the gestures and props and even the titles of the photographs become fairly obscure.[41] Occasional amateurishness is a problem as well. In *Vivien and Merlin* (fig. 65), for example, the curtain is meant to contain the scene, but there is a gap that allows the viewer to see the furniture behind it, a glaring reminder that this is just play-acting for the camera. The models, usually members of Cameron's family and household staff, sometimes pose awkwardly, breaking the narrative spell. The self-

consciousness entailed in posing for the camera – in "acting the part" – is explicitly recognized by the titles of two of Cameron's photographs, *Acting the Lily Maid of Astolat* (fig. 66), from the *Idylls*, and *Acting Grandmama*, a picture of a young girl dressed as an older woman.

While Cameron's portraits remain easy to enjoy, the overwrought theatricality of her narrative photographs, and those of her contemporaries, often makes them less accessible today. We find it hard to view the earnest narratives with the seriousness their creators intended. Paradoxically, however, those same theatrical elements – the props, lighting, costumes, and gestures – were carefully chosen to make the images more believable, more "real." For nineteenth-century photographers such as Cameron, Robinson, and Rejlander, the desire for naturalism was not at odds with the objective of telling a story through images. Even the combination photographs, assembled from many negatives, were a way for Robinson and Rejlander to inject a sense of "realism" into their allegorical scenes.[42]

The last decade of the nineteenth century saw the introduction of motion pictures. Their influence on the practice of still photography is reflected in the popularity of the stereoscope, a hand-held viewer into which a sequence of stereographic cards could be inserted. Each card contained two images, one presented to each eye, giving the effect of a three-dimensional picture. In some sets of stereographs, captions were used to help construct narratives – often humorous domestic tales with a slightly risqué tone (see fig. 72). Travel pictures were also popular. In the form of stereographs, staged photographs remained popular into the early years of the twentieth century. *The Seven Last Words of Christ*

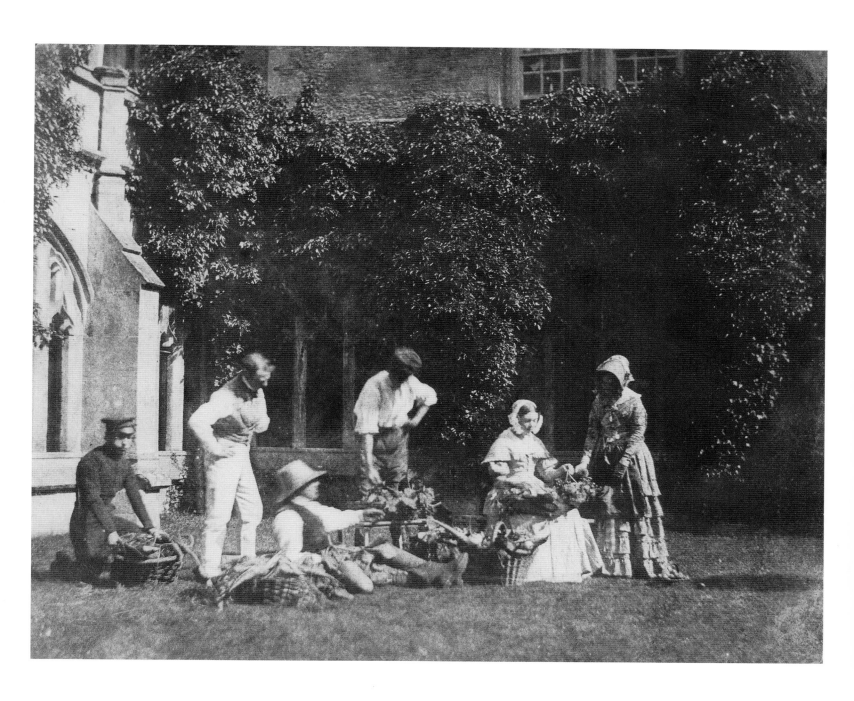

Fig. 54
William Henry Fox Talbot,
The Fruit Sellers, 1845, salted
paper print. National Gallery
of Canada, Ottawa (33487.35)

(fig. 25), F. Holland Day's controversial photographic series from 1898, is not unlike a set of stereographic cards, in that the sequence of facial expressions accompanied by text provides a kind of narrative arc. It might be regarded as both the apogee of the pre-cinematic period of staged photography and also the harbinger of the serial form of visual narrative.

Over the past half-century, narratives in staged photographs have become less realistically structured. We can discern strong elements of fantasy in the work of Ralph Eugene Meatyard and Les Krims. Meatyard's *Romance (N.) from Ambrose Bierce #3* (fig. 75) shows a group of children sitting on a battered wooden staircase, their relaxed posture at odds with the grotesqueness of their oversized Halloween masks. In another series, Meatyard photographs his family and friends disguised in masks, enacting the life and times of his fictional heroine Lucybelle Crater. Les Krims similarly poses his own family and friends in a series of fictional photographs from the early 1970s called *The Incredible Case of the Stack O' Wheat Murders*. In a photograph from the same period titled *The Nostalgia Miracle Shirt* (fig. 73), Krims shows a young man standing in a living room gazing calmly at his outstretched arm, which is inexplicably on fire.

A similar use of fantasy can be seen in a photographic sequence by Duane Michals entitled *The Mirror* (fig. 74). Michals, who began his career as a commercial photographer, was strongly influenced by the Surrealist artist René Magritte. Michals's sequences of staged photographs invariably display some kind of narrative structure, but the content of his images is often pure fantasy, rich in symbolism and sexual innuendo. His work is more episodically dreamlike than its earlier stereographic counterparts, and clearly rooted within the format of the film sequence.

More recently, Yinka Shonibare has used staged photographs to form a serial narrative in at least two works, *Diary of a Victorian Dandy* (see figs. 132a–132e) and *Picture of Dorian Gray*. Originally produced as a series of posters for the London Underground, Shonibare's *Diary* follows the tradition of Hogarth's *A Rake's Progress*, tracing episodes in the life of a wealthy gentleman. Hogarth's underlying message is a moral one, that vice and reckless behaviour result inevitably in a fall from grace. Shonibare, however, draws our attention to issues of race and class by posing himself, a black man, in the starring role of the hedonistic dandy. Reversing the usual stereotypes, white servants cater to the powerful black man.

Storytelling with an overtly political message can be seen in the collaborative work of the Canadian photographers Carole Condé and Karl Beveridge. Their series *Oshawa – A History of Local 222*, based on interviews conducted by the artists with individual autoworkers, recounts the story of a union local's struggles from 1937 to 1984. The six scenes that make up the second part of the series (fig. 76) deal with specific incidents illustrating the fragility of the union, the role of working women, and management's resistance to settling grievances.

In the last twenty years, the role of narrative in staged photography has remained strong. Evergon's *Le Pantin* (fig. 51), Jakub Dolejš's *Escape to West Germany, 1972* (fig. 77), Eleanor Antin's *Death of Petronius* from the series *The Last Days of Pompeii* (fig. 78), and Wang Qingsong's series *Another Battle* (see fig. 79) all present photographic tableaux of pure fantasy, with the narrative pared down to a single image. In a very different vein, Tina Barney's *The Son* (fig. 134) and Carrie Mae Weems's *Kitchen Table* series (see fig. 80) employ the staged photograph as a way of probing fictional domestic dramas in which the narrative is again more suggestive than literal.

Jeff Wall uses single images to convey narrative. Wall considers the "constructed" photograph – he prefers that term to "staged" – to be complete, its meaning independent and self-contained, like that of a painting. Unlike the documentary photograph, which Wall sees as relying on an aesthetic of the "fragmentary,"[43] the staged photograph is a completed visual statement. Gesture, pose, set design, and lighting are all highly controlled, as would happen in preparing a scene for a motion picture. Wall, in fact, frequently refers to his work as "cinematographic," but in his constructed photographs the narrative resides entirely within a single image.

For Gregory Crewdson, the challenge of the limited narrative capacity of the single image is one of the primary strengths of staged photography. The narratives in his photographs are not easily deciphered. Looking as if they could be stills from a David Lynch film, Crewdson's photographs have an uncanny, mysterious feeling. In an untitled photograph often called *Ophelia* (fig. 135), a woman lies floating in water that fills an otherwise ordinary living room. In another untitled

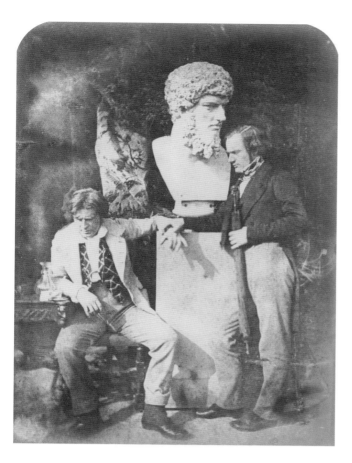

Fig. 55
David Octavius Hill and Robert
Adamson, *The Morning After*
(*"He, Greatly Daring, Dined"*),
c. 1845, salted paper print.
George Eastman House,
Rochester, Gift of Alden Scott
Boyer (1981:2389.0001)

Fig. 56
David Octavius Hill and Robert
Adamson, *Mrs. Elizabeth
Cockburn Cleghorn and John
Henning as Miss Wardour
and Eddie Ochiltree from Sir
Walter Scott's "The Antiquary,"*
1846–1847, salted paper print.
J. Paul Getty Museum, Los
Angeles (88.XM.57.21)

Fig. 57
William Lake Price, *Don Quixote
in His Study*, 1857, albumen
silver print. The Metropolitan
Museum of Art, New York, Gift of
A. Hyatt Mayor, 1969 (69.635.1)

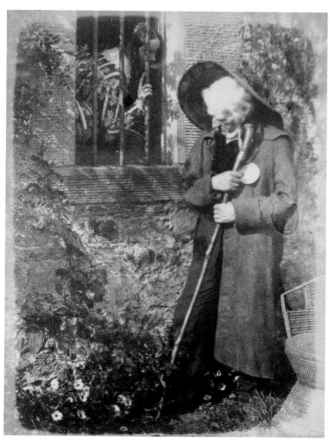

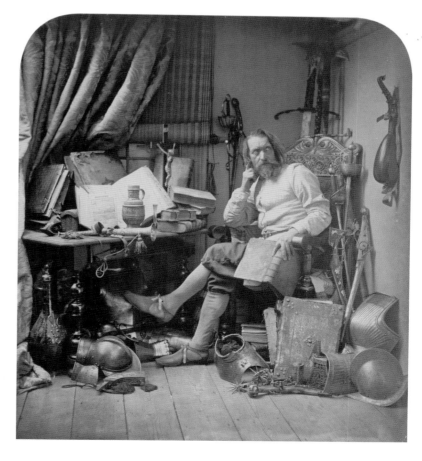

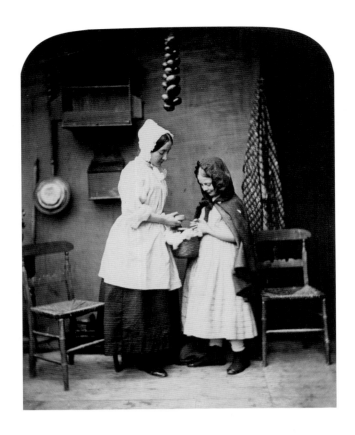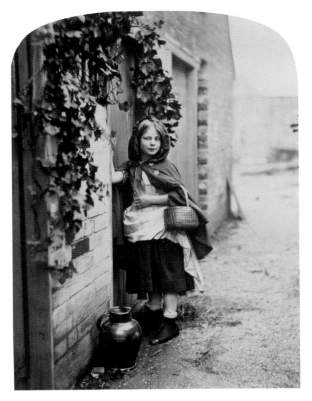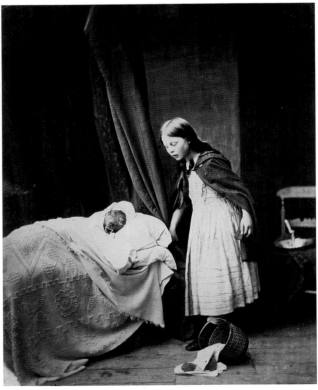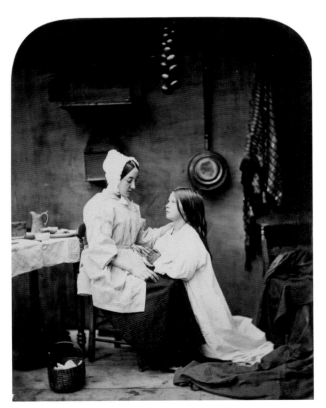

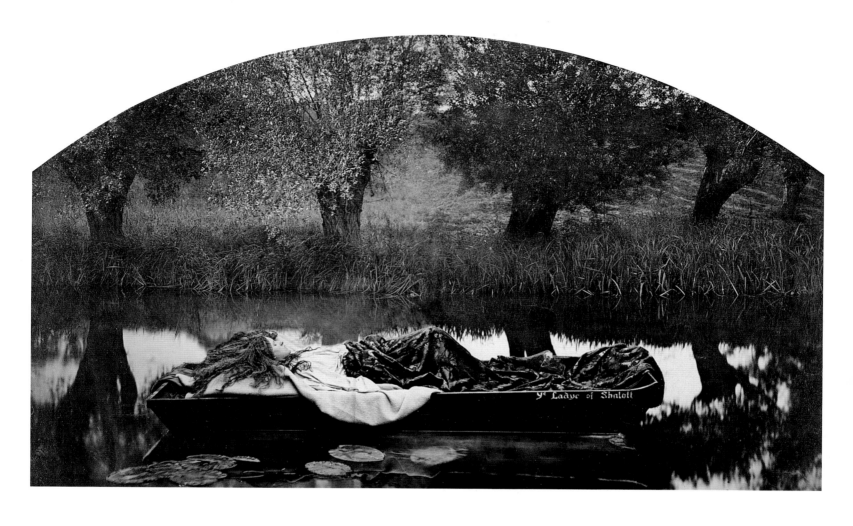

Fig. 58
Henry Peach Robinson, *Red Riding Hood*, 1858, albumen silver prints. National Museum of Photography, Film and Television, Bradford, England

Fig. 59
Henry Peach Robinson, *The Lady of Shalott*, 1861, albumen silver print. Harry Ransom Humanities Research Center, The University of Texas at Austin, Gernsheim Collection (964:0661:0002)

Fig. 60
Henry Peach Robinson and
Nelson King Cherrill, *Preparing
Spring Flowers for Market*, 1873,
albumen silver print, with applied
colour. J. Paul Getty Museum,
Los Angeles (86.XM.603)

Fig. 61
Henry Peach Robinson, *Dawn
and Sunset*, 1885, platinum
print. Harry Ransom Humanities
Research Center, The University
of Texas at Austin, Gernsheim
Collection (964:0661:0007)

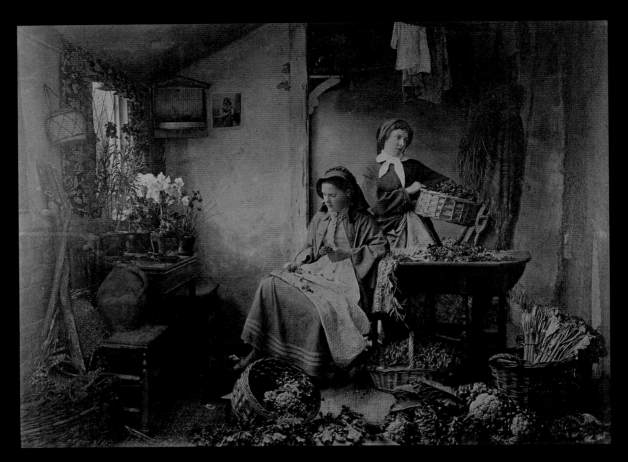

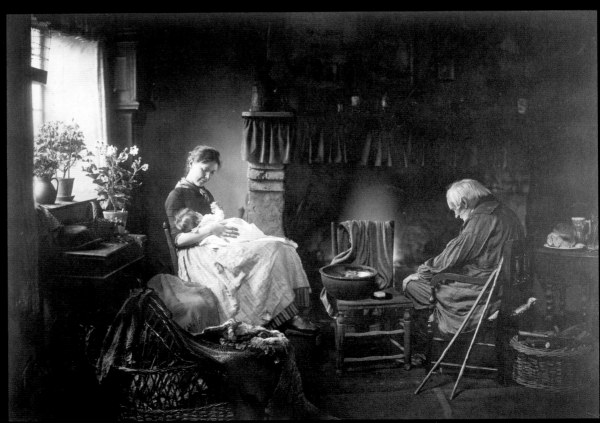

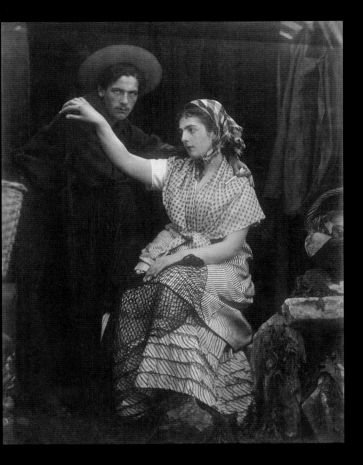

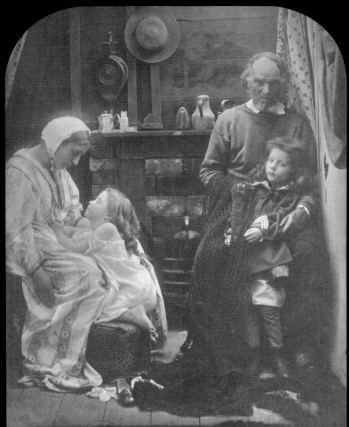

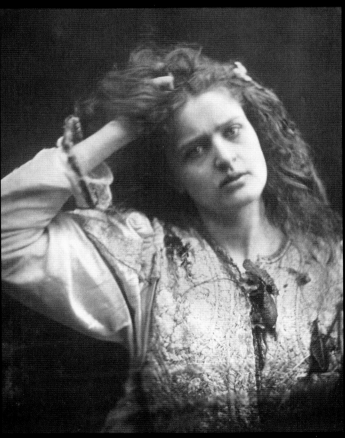

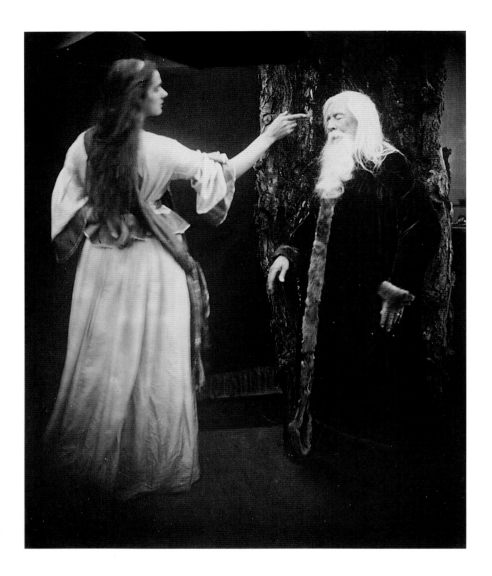

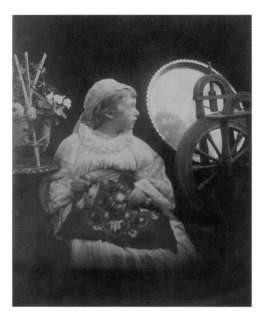

Fig. 65
Julia Margaret Cameron, *Vivien and Merlin*, 1874, albumen silver print. J. Paul Getty Museum, Los Angeles (84.XO.732.2.6)

Fig. 66
Julia Margaret Cameron, *Acting the Lily Maid of Astolat*, 1874, albumen silver print. National Gallery of Canada, Ottawa (21279)

work, sometimes referred to descriptively as a "boy with hand in drain" (fig. 136), a young man reaches down the drain of a shower that appears to be part of a stage set representing a bathroom in a house. Three-quarters of the image is devoted to the familiar scene of an ordinary domestic bathroom, while the bottom quarter reveals a darker, stranger place. The unusual composition and Crewdson's skilful use of lighting direct the narrative. Sunlight appears to pour into the upper-left portion of the image, creating an illusion of domestic warmth, while in the lower section a bluish light turns the young man's dangling arm into a lifeless, surreal object.

———— ◆ ————

Many histories of photography have tended to ignore the staged photograph, glossing over it as little more than a quaint and fleeting aberration within the evolution of the medium. But as this survey demonstrates, staged photography has had its own lively, ongoing tradition, influenced by and in turn influencing other areas of visual culture, most notably the fields of advertising, cinematography, and video art. From their early associations with fiction and the theatre through to their current links with film and video, staged photographs have filled a space described by Lewis Baltz as "a narrow deep area between the novel and the film." It is, above all, their deployment of narrative – through a series of images or in a single image – that would account for their enduring and universal appeal. Staged photographs now occupy a prominent position in the broader world of contemporary art, along the borders that have traditionally separated photography from other creative media. As we observe the nineteenth-century tableau vivant providing a model for today's latest experiments in slow-motion video, we can easily imagine that staged photography, far from having exhausted itself, will remain a vital and continually evolving mode of artistic expression.

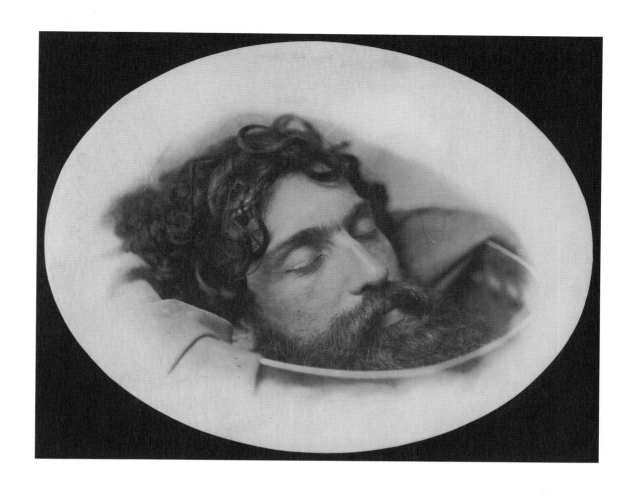

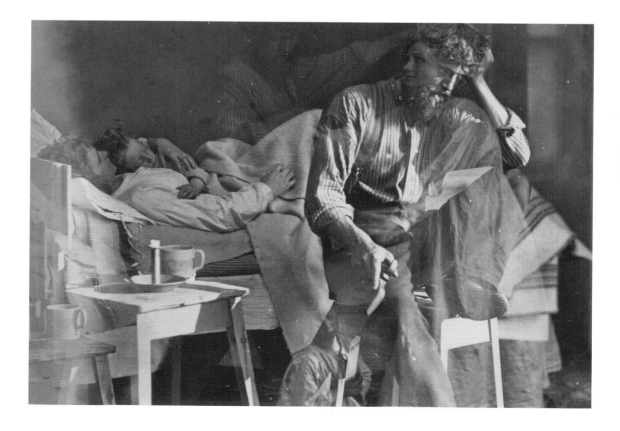

Fig. 67
Oscar Gustave Rejlander, *Head of Saint John the Baptist in a Charger*, c. 1858, albumen silver print. George Eastman House, Rochester, Museum Purchase, ex-collection A.E. Marshall (1981:1791:0003)

Fig. 68
Oscar Gustave Rejlander, *Hard Times*, c. 1860, albumen silver print. George Eastman House, Rochester, Museum Purchase, ex-collection A.E. Marshall (1972:0249:0042)

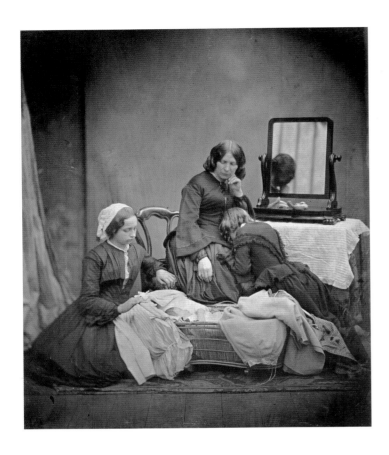

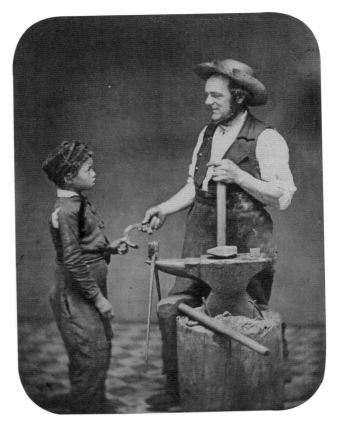

NOTES

1 See, for example, Anne H. Hoy, *Fabrications: Staged, Altered, and Appropriated Photographs* (New York: Abbeville Press, 1987); Michael Köhler, ed., *Constructed Realities: The Art of Staged Photography* (Zurich: Edition Stemmle, 1995); and Kathleen Edwards, *Acting Out: Invented Melodrama in Contemporary Photography* (Iowa City: University of Iowa Museum of Art, 2005). The only publication to examine this subject with specific regard to nineteenth-century photography is Quentin Bajac's *Tableaux vivants: Fantaisies photographiques victoriennes (1840–1880)* (Paris: RMN, 1999).

2 See Michael Fried, *Absorption and Theatricality: Painting and Beholder in the Age of Diderot* (Berkeley: University of California Press, 1980).

3 Roland Barthes, *Camera Lucida: Reflections on Photography*, trans. Richard Howard (New York: Hill & Wang, 1981), p. 31.

4 Examples of constructed or fabricated staged photographs include Thomas Demand's *Space Simulator* (fig. 142), James Casebere's *Venice Ghetto* (1991), and Laurie Simmons's *Study for a Long Red House (Red Suitcase)* (2003).

5 Oscar Gustave Rejlander, "On Photographic Composition: With a Description of 'Two Ways of Life,'" *Journal of the Photographic Society of London*, 21 April 1858, reprinted in *The Photography of O.G. Rejlander: Two Selections*, ed. Peter C. Bunnell (New York: Arno Press, 1979), p. 192.

6 David A. Cook, *A History of Narrative Film*, 4th ed. (New York: W.W. Norton, 2004), p. 13.

7 In the *Rrose Sélavy* series, Germaine Everling, the wife of the painter Francis Picabia, assisted Duchamp and Man Ray with the staging. It is her arms and hands we see delicately clasping the fur collar around Duchamp's neck and shoulders.

8 William Henry Fox Talbot and Julia Margaret Cameron are two of the most famous photographers who have not left us self-portraits.

9 A third version of the image, in the collection of the Société française de photographie (24.282), appears to vary only in the proximity of the camera to the entire *mise en scène*.

10 Bayard may have been the first to create a photographic double self-portrait, but it is a device that has been employed by other photographers as well. Examples include Oscar Gustave Rejlander's *The Artist Introduces O.G.R. the Volunteer* (c. 1871, fig. 24), Hannah Maynard's *Multiple Exposure* (c. 1895), and Jeff Wall's *Double Self-Portrait* (1979). An on-line exhibition presented by the American Museum of Photography titled *Seeing Double: Creating Clones with a Camera* (http://www.photography-museum.com/seeingdouble.html) shows several other such portraits or self-portraits from the nineteenth century.

11 There is a salted paper print at the Société française de photographie by Bayard of a man believed to be Geffroy. See Jean-Claude Gautrand, *Hippolyte Bayard: Naissance de l'image photographique* (Amiens: Trois Cailloux, 1986), plate 67.

12 Gordon Baldwin, *Roger Fenton: Pasha and Bayadère* (Los Angeles: J. Paul Getty Museum, 1996).

13 It is believed that Rejlander was born in Sweden, though he worked in England, first in Wolverhampton, in the West Midlands, and later in London.

14 Edgar Yoxall Jones, *Father of Art Photography: O.G. Rejlander, 1813–1875* (Newton Abbot: David & Charles; Greenwich, Conn.: New York Graphic Society, 1973), p. 22.

15 An advertisement offering reproduction prints of Rejlander's *Two Ways of Life* featured in the *Liverpool and Manchester Photographic Journal* of 15 June 1857 indicates that the title of the photograph was *Two Ways of Life: Or, Hope in Repentance*.

16 The Victorian fondness for both theatrics and allegory is mocked in an 1870 *Punch* cartoon by John Leech entitled *The Artistic (?) Studio: A Stereoscopic Scene from Fashionable Life*. It shows three figures posing histrionically in a photographer's studio for a photograph to be called "Love, Pride, Revenge" (see p. 169). No longer content to sit for a mere family portrait, the fashionable Victorian wants to be cast as a character in a domestic melodrama.

17 Edgar Yoxall Jones was the first to note that Rejlander was a friend of Coleman, and he suggests that it is Coleman who acts the part of a gambler in *Two Ways of Life* (Jones, *Father of Art Photography*, p. 7).

18 James Crump, *F. Holland Day: Suffering the Ideal* (Santa Fe, N. Mex.: Twin Palms, 1995), p. 7.

19 Exasperated by this criticism, Rejlander informed Robinson on 25 January 1859 that he intended to resign himself to making pictures of "ivied ruins and landscapes forever – beside portraits – and then stop" (Henry P. Robinson, "Our Leaders," *Practical Photographer* 6, no. 63 [March 1895], p. 70). The critic A.H. Wall defended Rejlander against the charges levelled at him by fellow photographer Thomas Sutton. In his article, Wall quotes Sutton: "There is not impropriety in exhibiting such works of art as Etty's *Bathers Surprised by a Swan*, or the *Judgement of Paris*; but there is impropriety in allowing the public to see photographs of nude prostitutes, in flesh and blood truthfulness and minuteness of detail" (*The British Journal of Photography*, 16 February 1863, p. 74).

20 See, for example, Talbot's photographs of works of art in plates 5, 11, 17, and 23 of *The Pencil of Nature*.

21 Jones, *Father of Art Photography*, pp. 9–11.

22 Ibid., p. 15.

23 George Wharton Simpson, in *Photographische Mitteilungen* (Berlin), June 1865.

24 For the most complete discussion of this subject, see Robert Rosenblum's essay "The Origin of Painting: A Problem in the Iconography of Romantic Classicism," *Art Bulletin* 39, no. 4 (December 1957), pp. 279–290.

25 In the photograph, the man appears to be speaking to the maid and emphasizing his point by tapping his right index finger in the palm of his left hand. For a fuller discussion of the photograph and of the meaning behind the gesture, see Lori Pauli, "The First Negative" in *Oscar Gustave Rejlander 1813(?)–1875*, ed. Leif Wigh (Stockholm: Moderna Museet, 1998), pp. 25–29.

26 I want to thank Geoffrey Batchen for bringing this work and the photographic diptych by Anne Ferran to my attention.

27 It is odd that Rey's concern with fidelity to the paintings did not affect his decision to cast a woman in the role of the male suitor who stands behind the seated woman.

28 Mortensen's work is discussed more fully in Ann Thomas's essay below, pages 104 to 108.

29 Group f/64 manifesto (1932), reprinted in *Seeing Straight: The f/64 Revolution in Photography*, ed. Therese Thau Heyman (Oakland: Oakland Museum, 1992), p. 53.

30 See Ann Thomas, *Eikoh Hosoe: Killed by Roses*, National Gallery of Canada Journal, no. 45 (January 1984).

31 Donald Kuspit, "Art's Identity Crisis: Yasumasa Morimura's Photographs," in *Daughter of Art History: Photographs by Yasumasa Morimura* (New York: Aperture, 2003), p. 9.

32 *Daughter of Art History*, p. 114.

33 Scott Watson, "Apocalypse Now," *Canadian Art* 10, no. 4 (Winter 1993), p. 43.

34 Thierry de Duve, Arielle Pelenc, and Boris Groys, *Jeff Wall* (London: Phaidon, 1996), p. 21.

35 *The Fruit Sellers* follows the tradition of the eighteenth-century "conversation piece," an informal family group that includes elements that make it interesting enough to inspire a conversation. The photograph, with its arrangement of figures in a landscape setting that also includes architectural elements, is also typical of the British taste for the picturesque.

36 Although the photograph was long attributed to Talbot, the staging or "choreography" of the image leads Larry Schaaf to suspect that it is not by Talbot but rather by his friend the Reverend Calvert Jones. See *William Henry Fox Talbot: Photographs from the J. Paul Getty Museum* (Los Angeles: Getty Publications, 2002), pp. 133–136.

37 The phrase "greatly daring dined" is traceable to Alexander Pope's *Dunciad*, 4.318. See Sara Stevenson, *The Personal Art of David Octavius Hill* (New Haven, Conn., and London: Yale University Press, 2002), pp. 138–139.

38 For an example of Miller's temperance writing, see his *Labour Lightened, Not Lost* ([Edinburgh?]: privately published, c. 1870).

39 *Twelfth Night* 2.4.115–120. The first three lines are inscribed on the back of the matte of the print of *"She Never Told Her Love"* in the collection of the National Museum of Photography, Film and Television, Bradford, England. The reverse of the exhibition print of *Fading Away* is inscribed with a quotation from Shelley's *Queen Mab*, 1.12–17.

40 Lines from Kingsley's poem are written on the back of each of these two photographs from the J. Paul Getty Museum. See Julian Cox and Colin Ford, *Julia Margaret Cameron: The Complete Photographs* (Los Angeles: Getty Publications; London: Thames & Hudson, 2003), p. 465.

41 The title on the back of the print reproduced here as figure 64 identifies the subject as Ophelia, but since we know that Cameron was working at the same time on the *Idylls* series, it seems more plausible that the figure shown is actually Elaine, the "lily maid of Astolat." Both dead (or dying) maidens floating down a river. Elaine and Ophelia are often represented in the visual arts in a very similar way, with branches and river weeds entangled in their clothes and hair.

42 Robinson's concern about realism is noted by Margaret Harker in her monograph on the artist: "In later years Robinson regarded his [photograph of] Richelieu as 'desperately bad,' not because of the photographic qualities but because the costume was not authentic, a mistake he was careful to avoid thereafter." Margaret Harker, *Henry Peach Robinson: Master of Photographic Art, 1830–1901* (Oxford: Basil Blackwell, 1988), p. 25.

43 Duve, Pelenc, and Groys, *Jeff Wall*, p. 9.

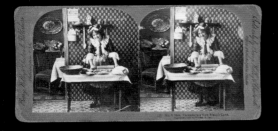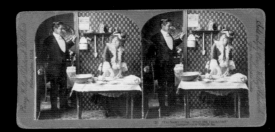

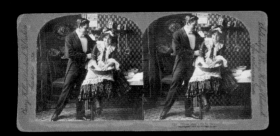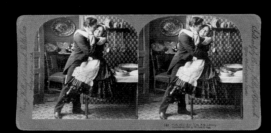

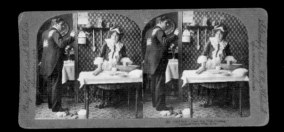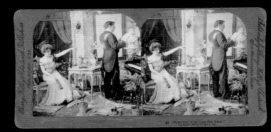

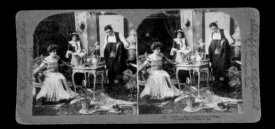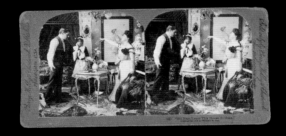

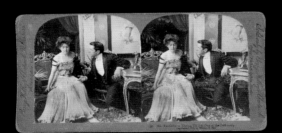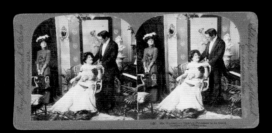

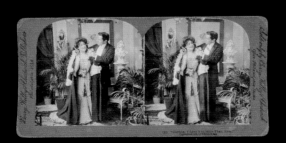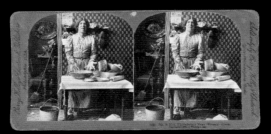

Fig. 72
William H. Rau, *Mr. and Mrs. Turtledove's New French Cook*, 1902, gelatin silver prints (stereographs). National Gallery of Canada, Ottawa (32617.1–12)

Mr. and Mrs. Turtledove's New French Cook

"You Sweet Thing, When Did You Arrive?"

"Now Don't Be So Shy!"

"Oh My! But You Are Lovely."

"Sh! Sh!! I Hear My Wife Coming."

"Heavens! What Does She Mean?"

"Well, I Am Caught Sure Enough."

"She Must Leave This House at Once."

Mr. Turtledove Trying to Get Out of the Difficulty

Mr. Turtledove Making Promises to Be Good

"Darling, I Love You More than Ever."

Mr. and Mrs. Turtledove's Next "French" Cook

Fig. 73
Les Krims, *The Nostalgia Miracle Shirt*, 1971, gelatin silver print. National Gallery of Canada, Ottawa (31310)

Fig. 74
Duane Michals, *The Mirror*, 1972, gelatin silver prints with hand-applied text. Courtesy Pace/MacGill Gallery, New York

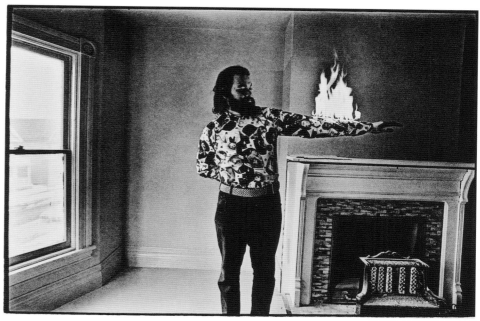

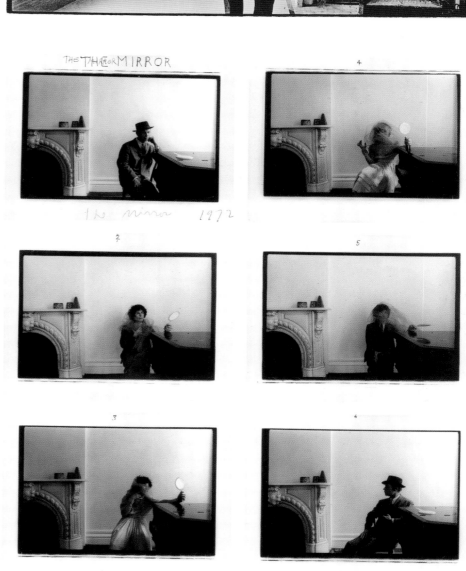

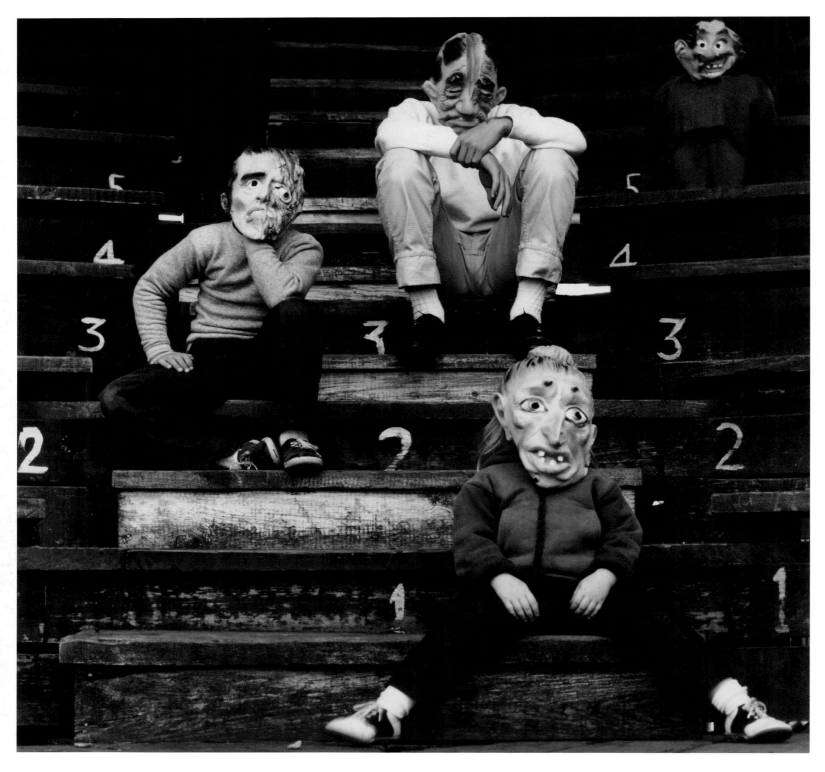

OSHAWA
(Part 2)
938 - 1945

by
arole Con... and Karl Beveridge

Direction
Gay Bell

with
Cynthia Grant, Simon Harwood, Chris Reed.

Typesetting
Gay Bell

...ed on interviews with members of
...awa), United Auto Workers of America, CLC

In the wake of the 1937 strike victory everything in Oshawa turned union. In the 1938 municipal elections, Union members won the majority of seats on the city council, and everything had to carry the union label.

But the weight of the depression still bore down so that by the end of 1938, Union membership had fallen from well over 2,000 to less than 400. People were either reluctant to pay Union dues or were afraid of management retaliation.

Desperate, the Union started a re-organizing drive, but it was the war, with its year-round full employment, that set the stage for the Union's consolidation. By the end of the war, the Union not only had full membership, but had clearly established itself as the bargaining representative of the workers.

Strikes were illegal and wages were frozen during the war years. All grievances and wage demands were arbitrated by provincial and national Labour Review Boards. Several walkouts took place in Oshawa, but were settled before a major confrontation developed.

It was also during the war that married women were first hired at General Motors. The majority of them worked at non-traditional jobs. In aircraft assembly women accounted for between a half and three-quarters of the workforce.

It is important to note that immediately after the war the Canadian UAW won dues check-off (the Rand formula) in a major strike against the Ford Motor Co. in Windsor.

...e in the plant. You'd try and get them before they went home on Friday night, or ... scared the Union might fall through again.

We punched in at 7:00. I walked home everyday to see the kids got a good lunch. I would do the washing on Monday night, Tuesday, damp down the clothes and iron on Wednesday. I had my whole life mapped out.

...ettled we just sat down. A manager got so angry once he hit the table and said, ...

After the war the aircraft department was just closed down. The single girls were transferred to Cutting and ...

Fig. 77
Jakub Dolejš, *Escape to West Germany, 1972*, 2002, dye coupler print. Courtesy of the artist and Angell Gallery, Toronto

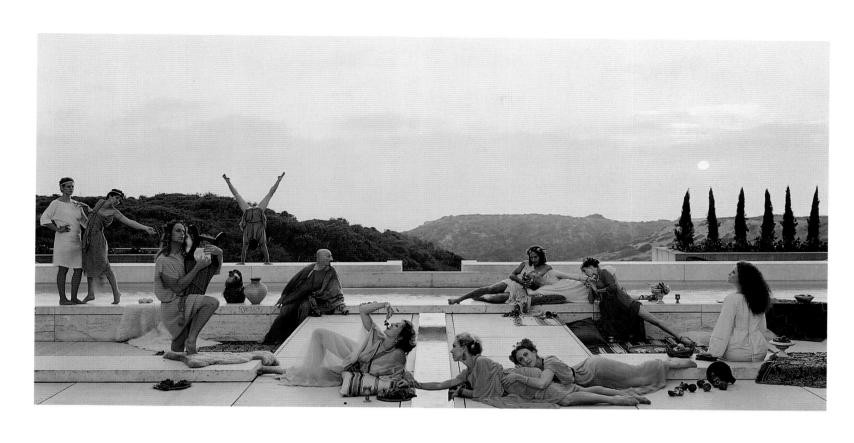

Fig. 78
Eleanor Antin, *Death of Petronius,* from the series *The Last Days of Pompeii,* 2001, dye coupler print. Courtesy Ronald Feldman Fine Arts, New York

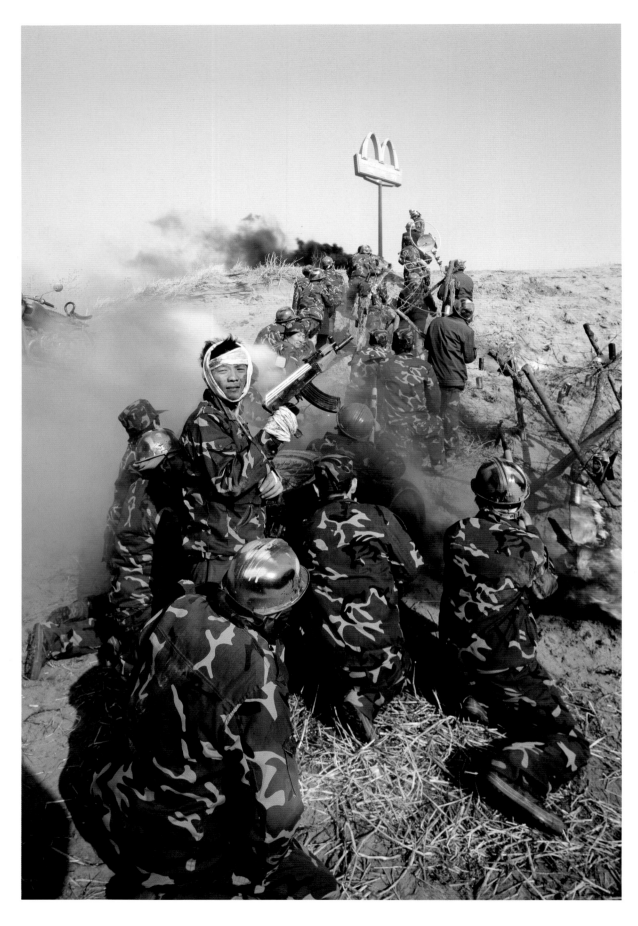

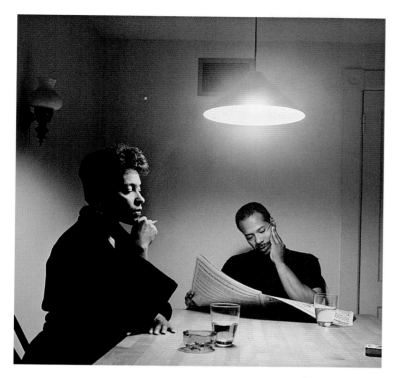

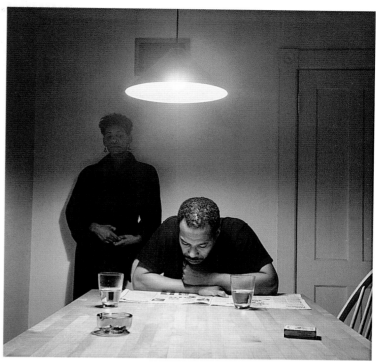

Fig. 79
Wang Qingsong, *Number 6,*
2001, from the series *Another*
Battle, 2001, dye coupler print.
The Farber Collection, New York,
Courtesy China Avant-Garde Inc.

Fig. 80
Carrie Mae Weems, *Untitled,*
1990, gelatin silver prints,
5 text panels. Walker Art Center,
Minneapolis, Rollwagen/Cray
Research Photography Fund,
1991 (1991.101.1–8)

Almost a hundred and fifty years after Henry Peach
Robinson first exhibited it, *Fading Away* remains —
despite its title — one of the most vivid examples
of nineteenth-century staged photography.
A depiction of the final moments of a graceful
young consumptive surrounded by her family,
Fading Away (fig. 81) illustrates the notion that
photography is capable not only of recording
facts, but also of representing fiction. For Victorian
viewers, the image of a contemporary girl dying
of tuberculosis evoked the distressing reality of
a disease that posed a constant threat. At the same
time, the sentimentality of the picture suggested
the romantic associations of consumption, which
was linked in the Victorian imagination with
artistic creativity and unrequited love. In fact,
Robinson exhibited a study of *Fading Away*'s
central figure under the title *"She Never Told
Her Love"* (fig. 82). Although some viewers were
disturbed to see such an intimate and morbid
scene represented in a medium as realistic as
photography — one critic complained, "'Fading
Away' is a subject I do not like ... it is a picture

no one could hang up in a room, and revert to with pleasure"[1] —Victorian audiences recognized that Robinson had photographed a model acting a part, not an actual dying girl.[2] The overtly theatrical nature of the composition, with its frieze-like arrangement of figures framed by parted curtains, signalled that this was a staged scene.[3] The quotation from a poem by Shelley that accompanied the exhibition print further reassured viewers that this was not an unmediated representation of reality, but rather an elevated artistic expression.[4] The mixture of staged artifice with photographic truthfulness led another contemporary reviewer to describe *Fading Away* as "an exquisite picture of a painful subject."[5]

Fading Away is an iconic staged photograph of the Victorian period: the sentimental subject matter, the deliberately theatrical composition, and the use of a literary quotation to assert high art aspirations are characteristic of the genre. Many historians of photography have cited *Fading Away* as the prime example of overly sentimental tableau photography of the mid-nineteenth century.[6] It is not, however, entirely representative of Victorian staged photography, which was a more widespread practice than the study of individual examples such as *Fading Away* would suggest. Many staged photographs made their way into albums, compiled either by collectors or by photographers, in which they were presented not in isolation, but surrounded by other types of photographs. Albums, which traditional histories of photography dismiss as low, domestic, or feminine, are in fact rich sources of staged photographs, preserving them as they were originally seen and offering clues to the social context in which they were made.

This essay considers the particularly informative example of an 1864 album that includes both conventional portraits and fictional scenes photographed by Victor Prout at Mar Lodge, a Scottish country house. A close reading of this album demonstrates how Victorian staged photographs were strongly influenced by amateur theatrical pursuits, which were enjoyed by the same social groups that collected, arranged, and displayed photographs in albums. Before turning to a discussion of the Mar Lodge album, it is first necessary to consider staged photography in general and then to address related Victorian theatrical practices.

In his essay "The Directorial Mode: Notes toward a Definition," A.D. Coleman differentiates between photographers who regard the world as "given" and those who approach it as "raw material" to be manipulated.[7] Those in the former camp make seemingly fact-filled pictures that reveal little evidence of the photographer's presence, while those in the latter work in the "directorial mode," in which "the photographer consciously and intentionally *creates* events for the express purpose of making images thereof."[8] When these criteria are applied to nineteenth-century photography, a carte-de-visite portrait, the primary function of which is to convey the likeness of a sitter, falls into the first category (see fig. 83), while a staged photograph such as *Fading Away* fits squarely in the second.

Although Coleman's distinction provides a useful starting point for any discussion of staged photography, it proves insufficient for a broader consideration of the practice in mid-Victorian Britain. First, it was not as natural an assumption in the nineteenth century as it is today that a photograph that documents an existing aspect of the world is incompatible with one that records a deliberately set up scene. As Douglas Nickel has pointed out, reviews of photographic exhibitions in the 1860s and 1870s describe allegorical subjects displayed alongside portraits and landscapes, suggesting that Victorians did not share our inclination to segregate photographs of real and imaginary subject matter.[9] The arrangement of photographs in Victorian albums confirms this lack of differentiation. By studying albums, today's viewers can begin to comprehend how, for Victorians, "directorial" photographs could comfortably co-exist with more documentary ones.

Coleman's definition of the directorial mode of photography is also insufficient in that it does not allow for the possibility of a sitter (the photographer's "raw material") exerting any control over the photograph. For Coleman, the "directorial mode" flows in only one direction, from photographer to subject. However, many nineteenth-century staged photographs were made in social situations in which the sitters were not necessarily passive models in the hands of the photographer, but were more likely to have been active participants in an exchange of ideas.

It therefore seems more useful to consider Victorian staged photographs along a spectrum of

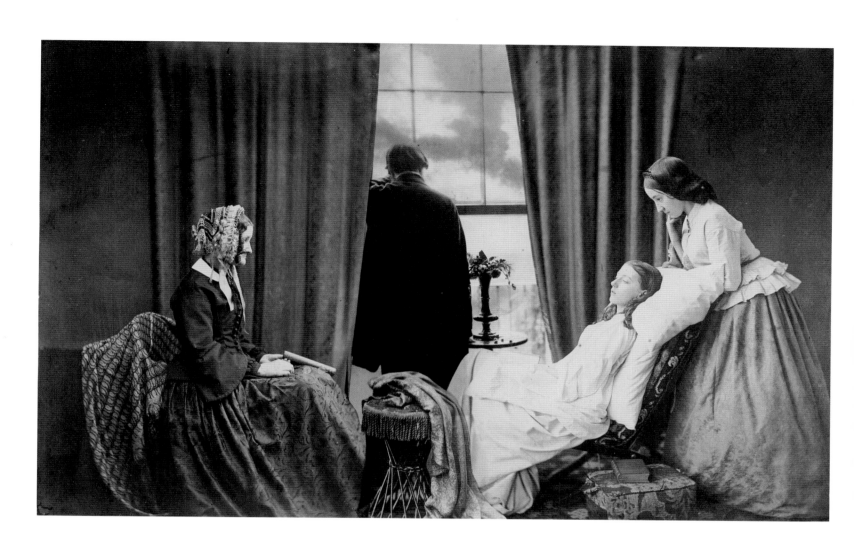

directorial control, ranging from those in which the photographer poses a hired model in accordance with his or her vision, to those in which the subject initiates the sitting, as in the case of a guest at a fancy-dress ball who commissions a photographer to document his or her costume. In the staged photographs that fall in the middle of this spectrum, the relationship between the photographer and sitter is the most fluid, allowing for a shifting, complex collaboration in which neither the photographer nor the subject has sole control. These pictures were generally made by amateurs for whom taking and posing for photographs was a form of social interaction.[10] The occasions on which such photographs were made sometimes included other performative activities that called for dressing up and posing, such as charades, tableaux vivants, and amateur theatricals. Even when such theatrical pursuits were not actually combined with photographic sessions, the middle- and upper-class predilection for dramatics and dress-up left its mark on staged photographs.

Cuthbert Bede's 1854 novel *The Further Adventures of Mr. Verdant Green, an Oxford Under-graduate* offers a fictional account of the intermingling of amateur performance and photography in social contexts. During a visit to a friend's house over Christmas, the title character both acts in a charade of the word "calotype" and meets a young lady who expresses her romantic interest photographically:

> Miss Fanny Bouncer was both good-humoured and clever, and besides being mistress of the usual young-lady accomplishments, was a clever proficient in the fascinating art of photography, and had brought her camera and chemicals, and had not only calotyped Mr. Verdant Green but had made no end of duplicates of him, in a manner that was suggestive of the deepest admiration and affection.[11]

Another popular form of amateur theatrical entertainment that, as Martin Meisel maintains, "in polite society gave the respectable an opportunity to taste the pleasures of impersonation and display," was the tableau vivant, which requires performers to arrange themselves into a picture, sometimes after a well-known work of art, and hold their position for several minutes.[12] Emma Hamilton is often credited with introducing the fashion

to European society in the late eighteenth century with her "attitudes," in which she imitated the figures depicted by the Classical sculpture and vases collected by her husband, Lord Hamilton, the British ambassador to Naples. In *Italian Journey,* Goethe wrote of one her performances:

> She lets down her hair and, with a few shawls, gives so much variety to her poses, gestures, expressions, etc. that the spectator can hardly believe his eyes. He sees what thousands of artists would have liked to express realized before him in movements and surprising transformations – standing, kneeling, sitting, reclining, serious, sad, playful, ecstatic, contrite, alluring, threatening, anxious, one pose follows another without a break.[13]

Although many members of "polite society" did not consider Lady Hamilton "respectable" (she is best remembered as Lord Nelson's mistress), both her "attitudes" and the tableaux vivants that the Victorians enjoyed performing were socially acceptable ways of flaunting one's beauty and flouting convention. The artistic nature of such performances sanctioned women's appearance before an audience with loose hair and bare feet, and in more revealing costumes than were normally acceptable. For both sexes, the freedom to dress up temporarily as a character from another historical period or social class was a way of asserting the stability of one's own social position.

Throughout the nineteenth century, tableaux vivants were performed in private drawing-rooms as well as in public theatres such as the Adelphi, which in 1837 presented a program of tableaux representing the "Passions."[14] Tableaux were also integrated into the staging of some plays: at the end of each act, the actors would group themselves into a picture-like arrangement and suspend motion. More generally, according to Michael Booth, "to look at the stage as if it were a picture was by 1850 an automatic response in audiences, and to make performances resemble painting was a habit of managers and technical staff."[15] The mutual influences between painting, theatre, and tableaux vivants are exemplified by David Wilkie, a painter of highly theatrical narrative genre scenes, who in 1833 was hired by the Marchioness of Salisbury to design

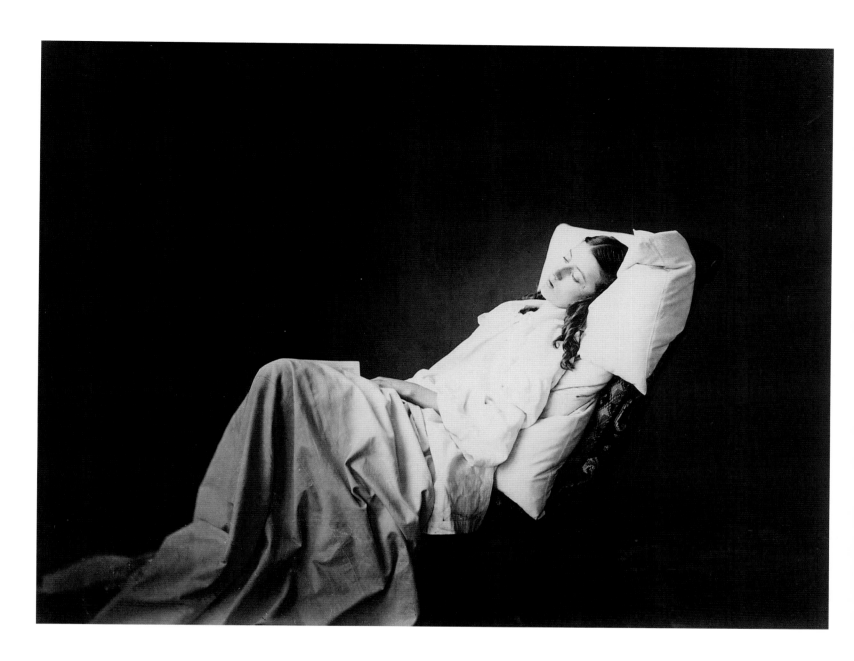

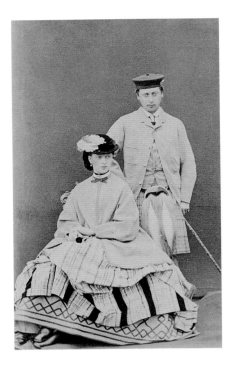

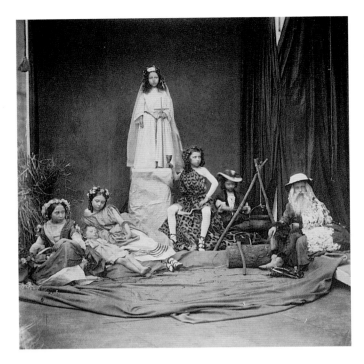

the tableaux vivants performed at a ball at Hatfield
House in Hertfordshire. Wilkie made numerous
preparatory sketches for the tableaux, which represented
scenes from Walter Scott's novels and were not based on
any existing paintings. As Sara Stevenson points out, the
episode demonstrates that "tableaux had developed from
a reproductive into an original art form."[16]

By the time the invention of photography
was announced in 1839, the tableau vivant was an
established form and it quickly became an obvious
photographic subject, growing in popularity during
the 1850s and 1860s, when indoor exposure times were
still fairly long. Martin Meisel argues that the tableau
vivant and the dramatic tableau were each "a readable,
picturesque, frozen arrangement of living figures; but
the dramatic tableau arrested motion, while the *tableau
vivant* brought stillness to life."[17] A staged photograph,
in turn, restored stillness to a picture that had been
animated by living models.

Seven years after Mr. Verdant Green had
matriculated at a fictional version of Oxford, Lewis
Carroll found inspiration at the actual university during
the performance of tableaux vivants that followed a
dinner for the undergraduate Prince of Wales. In a letter
to his family, Carroll wrote:

> The tableaux vivants were *very* successful.... One of
> the prettiest was Tennyson's *The Sleeping Princess*, acted
> entirely by the children.... I shall try and get them to
> go through it by daylight in the summer. It would
> make a beautiful photograph.[18]

Although he evidently never photographed that
particular scene, Carroll did produce many pictures
of children wearing exotic costumes and acting out
narrative scenes. In *Saint George and the Dragon* (fig. 85),
for instance, Xie Kitchin (one of Carroll's favourite
sitters) and her brothers use the paraphernalia of the
nursery to stage an allegory of the triumph of good
over evil in which England's patron saint slays a dragon
as he rescues a captive princess.

Amateur staged photographs such as *Saint George
and the Dragon* were often displayed in albums, which
were themselves an accoutrement of drawing-room
sociability.[19] Today, these albums preserve the context in
which staged photographs were originally presented and
often contain details about the social settings in which
the pictures were made. Victor Prout's Mar Lodge album
is an especially revealing example.

In August 1863, during the first official visit to
Scotland by the Prince and Princess of Wales, the recently
married couple attended the Braemar Gathering, an
annual Scottish athletic competition held in the grounds
of Mar Lodge, the estate of the Earl and Countess of
Fife.[20] At the celebrations that followed, the prince was
treated once again to a performance of tableaux vivants.
They were designed by Prout and Lewis Wingfield,
a young aristocrat who was himself an amateur
photographer and who also acted in several of the
tableaux. The following year, Prout produced an album
of the photographs he had taken of the royals and
aristocrats in attendance, posing for formal portraits
and enacting the tableaux vivants as well as scenes from

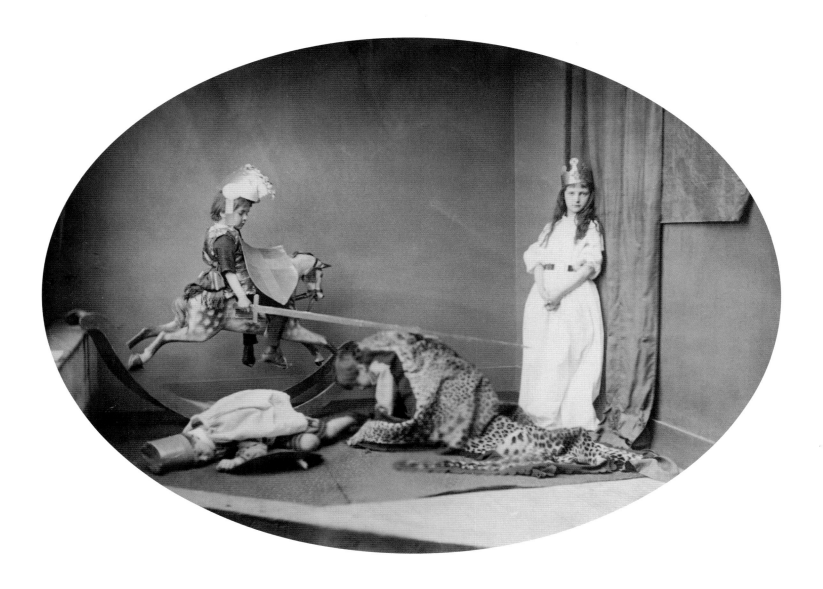

Fig. 85
Lewis Carroll, *Saint George and the Dragon*, 1875, albumen silver print. The Metropolitan Museum of Art, New York, Gilman Collection, Purchase, Ann Tenenbaum and Thomas H. Lee Gift, 2005 (2005.100.21)

amateur theatricals. The result was a large, deluxe volume, with a printed title-page, an introduction, and captions facing the photographs, which were tipped in on the right-hand pages and were mostly the size of cartes-de-visite. Prout published multiple copies of the album and also sold individual pictures from it as cartes-de-visite.[21] He inscribed a copy of the album to Wingfield, and it may have been Wingfield who facilitated Prout's commission as photographer at the Braemar Gathering, which would later allow Prout to advertise himself as "photographer to their Royal Highnesses the Prince & Princess of Wales."[22]

Although Prout was a professional photographer, the types of photographs in the Mar Lodge album – portraits, staged tableaux, architectural views, and landscapes – are common to many amateur albums. The subjects of the tableaux, which are historical, literary, and allegorical, are representative of Victorian staged photography in general. The album is typical in that it unites in a single volume photographs of imaginary subject matter with more factual depictions of people and places, and features pictures of the same individuals in and out of role. Although the heterogeneity of the album's contents is consistent with many albums of this period, its internal organization, which groups all the fanciful depictions together, is somewhat exceptional. Another feature the Mar Lodge album does share with many other albums that include staged photographs is the use of literary quotations as captions, a practice that reinforces the subjects depicted and helps realize more fully the fantasy they suggest.

The Mar Lodge album commemorates an event in which the photographer and the camera were active participants. Photography was not only a way of documenting the event, but was also part of the event: posing in front of a camera was one of many activities that members of this elite social circle enjoyed as part of a weekend's entertainment. Although the performances depicted in the Mar Lodge album were staged by and for members of the upper class, the resulting photographs are consistent with British staged photographs that were made and displayed in less exclusive circles.

The album's four-page introduction describes the games and the entertainment that followed over several days, which included a ball, deer-hunting, and performances of tableaux vivants and theatricals. The album has a very clear structure, beginning with single and group portraits, continuing with photographs of the tableaux vivants and amateur theatricals, then featuring interior and exterior views of the house, and concluding with a series of views of local scenery. The album's arrangement functions like a cinematic panning-out, beginning with the specific and pulling back to encompass the more general. It moves from the individual to the social, from the house to its broader geographical location.

The nineteen photographs of the theatrical performances that form the core of the album, together with the introduction, which reproduces the entire programs of the tableaux vivants and plays, emphasize the most overt performances in an album that includes multiple expressions of theatricality.[23] Both the introduction and the photographs contain frequent references to Scottish culture, which is enacted in various ways throughout the album, particularly in the games, the dress of the guests, and the themes of several of the tableaux vivants.

The Braemar Gathering itself, along with the Highland-themed costumes and decorations at Mar Lodge, displayed a version of Scottish national identity that had been adopted relatively recently.[24] The modern version of the kilt was invented in the mid-eighteenth century by an English industrialist and was accepted as Scottish national dress only after Sir Walter Scott made Highland customs the theme of the pageantry he organized for King George IV's visit to Scotland in 1822.[25] Queen Victoria's enthusiasm for all things Scottish helped further popularize Scottish culture. She dressed her children in kilts, owned a home in the Highlands, and in 1868 published *Leaves from a Journal of Our Life in the Highlands,* a book that became an immediate best-seller.[26]

In December 1848, the year Queen Victoria first attended the Braemar Gathering, the royal children performed a charade of the word "Highlander" as a birthday surprise for their father, Prince Albert. The queen recorded in her diary that after acting out each syllable separately, they concluded with "a tableau with Bertie, Vicky, Alice, and Lenchen all in kilts, which looked extremely pretty with flags and guns."[27] The performance was one of many forms of theatrical entertainment in which the royal children would

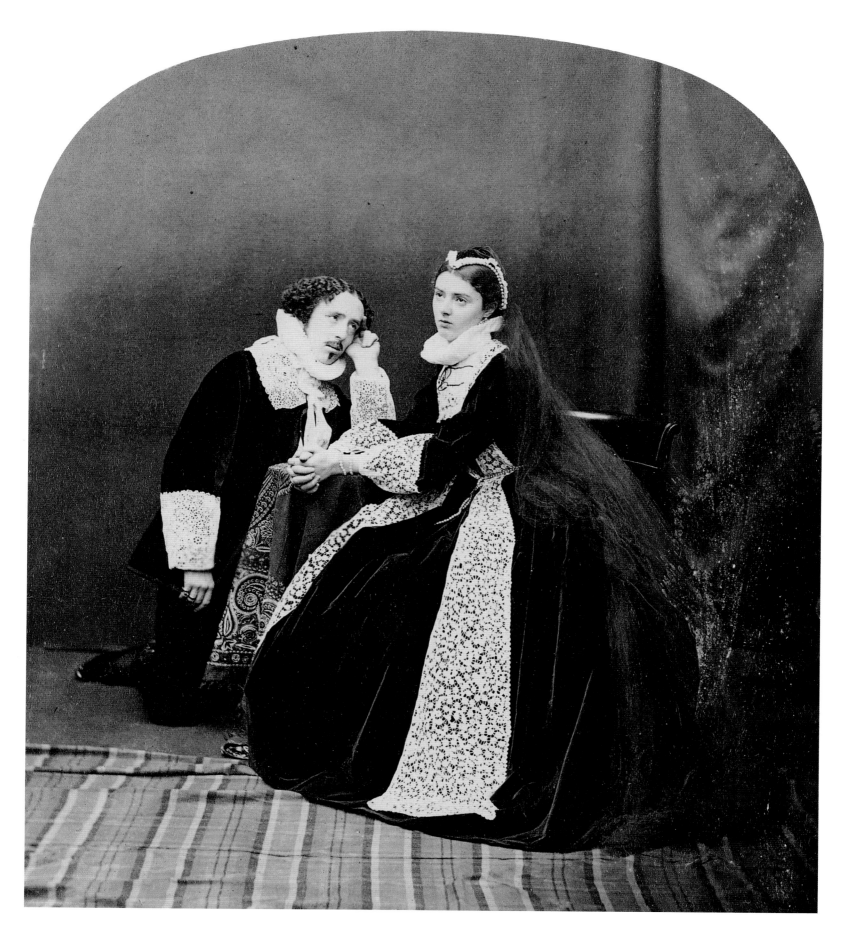

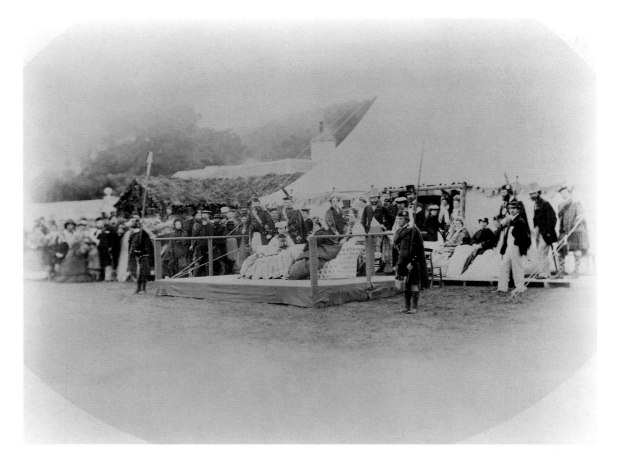

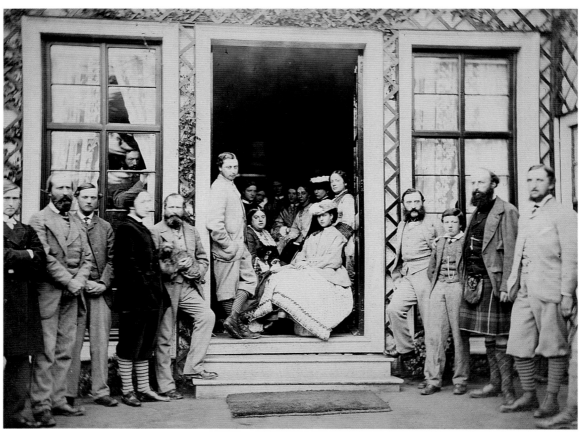

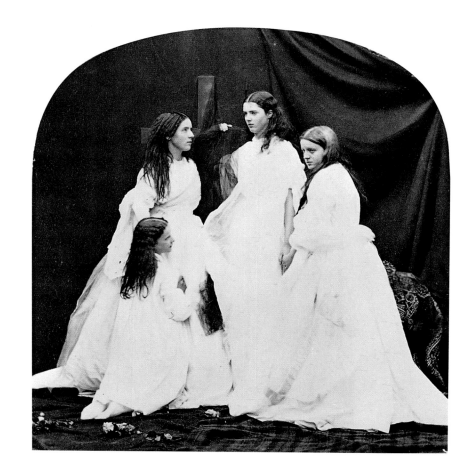

Fig. 87
Victor Albert Prout, *Audience at the Braemar Gathering, including the Prince and Princess of Wales,* 1863, albumen silver print. Scottish National Portrait Gallery, Edinburgh (PGP 162.4)

Fig. 88
Victor Albert Prout, *Mar Lodge, Group in the Doorway of the Smoking Room, Including the Prince and Princess of Wales,* 1863, albumen silver print. Scottish National Portrait Gallery, Edinburgh (PGP 162.5)

Fig. 89
Victor Albert Prout, *Faith, Hope, and Charity: Tableau Featuring Miss G. Moncrieffe, Lady Anne Duff, the Hon. Miss White, and Lady Agnes Duff,* 1863, albumen silver print. Scottish National Portrait Gallery, Edinburgh (PGP 162.39)

participate as they grew up. Although on this occasion no photographs recorded the performance, six years later, when the children acted out tableaux vivants of the Four Seasons, they played their parts both for their parents and in front of the camera of Roger Fenton (fig. 84). The 1848 charade united the royal family's passion for amateur theatricals – shared by many middle- and upper-class Victorians – with their fascination with the Highlands. Fifteen years after acting in the "Highlander" charade, "Bertie" (Albert Edward, the Prince of Wales), once again "clad in Highland costume,"[28] attended the celebration of the Braemar Gathering, which also combined Scottish motifs with theatrical entertainment.

Part of the pleasure of watching a private performance of tableaux vivants or amateur theatricals would have come from witnessing the transformation of a familiar person into an imaginary character. The organization of the Mar Lodge album offers that pleasure to any viewer, by first introducing the performers and later showing them in theatrical guises. Lewis Wingfield, the co-designer of the tableaux vivants, appears six times, first as himself (in a group portrait and on his own); then as Rizzio, secretary to Mary Queen of Scots (fig. 86); next as Mr. Primrose in the play *Popping the Question;* and finally as John Grumley in another play, *Domestic Economy.* As an amateur photographer, Wingfield was familiar with both sides of the lens. Over the course of his life, he dabbled in various theatrical pursuits ranging from professional acting, costume design, and adapting Schiller's *Mary Stuart* for the London stage to reviewing plays and lecturing on costume history. He engaged in offstage impersonation as well, "going to the Derby dressed as a 'negro minstrel,' spending nights in a workhouse and pauper lodgings, and becoming an attendant in a madhouse."[29] Georgina Moncrieffe, who played Mary Queen of Scots alongside Wingfield's Rizzio, also appears in the album in four other guises: as Faith in a tableau of the three Christian virtues; as

Miss Winter-blossom in *Popping the Question;* as Mrs. Kingsley in *Domestic Economy;* and out of costume, as herself. She would later become the Countess of Dudley, a celebrated society beauty whose portrait made its way into many carte-de-visite albums.[30]

Social hierarchy dictates some aspects of the album's organization, and the Prince and Princess of Wales, both individually and together, are the subjects of the first three portraits in the volume. In these formal portraits, the prince sports a kilt and other Highland regalia, and the princess wears a tartan skirt (fig. 83). As *The Times* noted in its coverage of the Braemar Gathering:

> The Prince was dressed in full Highland costume, with broadsword, sporran, and dirks complete. The "garb," it was universally admitted, became him remarkably well. The Princess wore a Victoria dress of the tartan pattern, and thereby won additional favour in the eyes of the Highlanders.[31]

The royal couple next appear in two group portraits. The first shows them watching the games from a dais, along with their hosts and some of the other guests. As the introduction informs us:

> The Prince and Princess arrived upon the ground between three and four o'clock in the afternoon.... In an instant, news ran through the crowd, and all were eager to catch a glimpse of the Royal pair. The enthusiasm when the Prince came into view, clad in Highland costume, with his fair young bride by his side, was thoroughly Scottish in its intensity.... A dais had been erected in the most favourable position for viewing the sports, and the Princess at once took her place upon it.... The Prince stood a few paces in the rear with the Earl of Fife, and remained standing until the end.[32]

In this image, the prince and princess watch the spectacle of the games from their own stage-like structure, with a crowd of onlookers in the background (fig. 87). Even as spectators, the royal pair are self-consciously on display, but this is actually one of the few photographs in the album in which the sitters are not clearly posed for the camera. The camera is at its most neutral here, in contrast to the portraits or tableau photographs, in which all posing is done for its benefit. However, if it is one of the least staged photographs, surprisingly, it is also the least informative. The camera is far from the action, and the main subjects of the picture, the prince and princess, are small figures lost among other spectators. The text alone describes the pageantry and athletic events that took place in front of the royal audience, including a "highly-exciting foot-race," a "spirited sword-dance," and "putting the stone, throwing the hammer, and tossing the caber."[33]

Although the introduction lists the winners of the competitions, the athletes are not pictured in the album. Instead, the next photograph is a second, more deliberately posed group portrait of some of the guests at Mar Lodge (fig. 88). The prince and princess are at the centre of the composition, framed by the doorway. Once again they are elevated, in this instance by a few steps. They are flanked by two rows of men, lined up shoulder to shoulder as if facing an audience for a curtain call. At the left, one guest parts an actual curtain to peek out at the camera from the dark interior of the house. Aside from the figure at the window, all the men are positioned outside while the women remain indoors. The woman seated between the prince and princess is the hostess of the party, the Countess of Fife; her husband, the Earl of Fife, stands holding a small dog to the left of the prince. To his left is Lewis Wingfield, slightly blurry in a velvet suit and boldly striped stockings.

Numerous individual portraits follow, offering the pictorial equivalent of a society column listing the guests at Mar Lodge. Although these sitters do not wear theatrical costumes, the portraits are as contrived as the tableau photographs that follow, with their limited repertoire of formal poses, consistent camera distance, and carefully selected backgrounds. The final portrait shows "McClennan, the Piper," posed with the mouthpiece of his bagpipes to his lips in front of a craggy patch of rocks and grass. He marks the end of the series of portraits and heralds the beginning of the theatrical performances. Indeed, the introductory text describes a performance of Scottish music at the dinner preceding the tableaux vivants.

Given the explicitly Scottish theme of the event, the choice of Mary Queen of Scots for the first three tableau photographs is an obvious one. Mary, played by

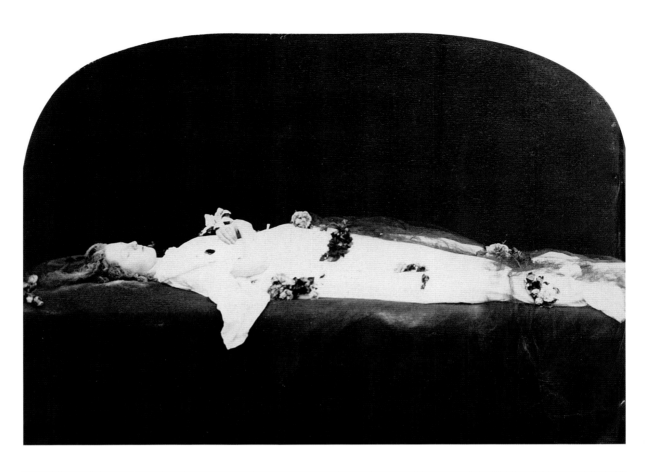

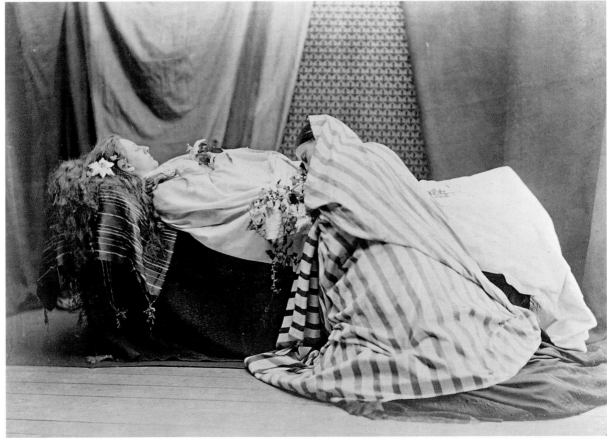

Georgina Moncrieffe, sits at a small table, which is
draped with a paisley shawl, as Rizzio, played by Lewis
Wingfield, kneels (fig. 86). Both lean on the table, angled
slightly toward each other, and as Rizzio looks up at
Mary, she gazes into the distance with an expression that
is either anguished or bored. The photograph shares the
page with one variation on the same subject and another
entitled *Mary Queen of Scots at Wemyss Castle,* in which
the queen is surrounded by her four attendants, each also
named Mary. One more picture of Mary Queen of Scots
alone occupies its own page at the end of the series of
tableaux vivants. Mary Stuart's beauty and tragic history
appealed to the Victorian imagination, and she was a
popular subject for paintings, fancy-dress ball costumes,
and staged photographs.[34] Even the Princess of Wales
dressed as Mary Queen of Scots for a ball in 1871.[35]
Mary Stuart's story had been popularized by Sir Walter
Scott's 1820 novels *The Monastery* and *The Abbott,* and
by several biographies published soon after. From 1820
to 1897 fifty-six depictions of Mary Queen of Scots were
exhibited at the Royal Academy, and thousands of prints
of her were in circulation.[36]

Unlike the portraits, which employed a simple
studio backdrop, a doorway of the house, or a fragment
of the natural landscape as background, the tableau
photographs are set against a background that is both
more dramatic and more improvised, featuring a large,
dark, curtain-like swath of drapery at the right and
a tartan blanket spread – not quite smoothly – on the
ground. Along with the subject matter of several of the
tableaux, the tartan reinforces the Scottish motif that runs
through the album and contributes to its rustic quality. It
is also a reminder of the makeshift nature of the tableaux
and other theatrical performances, and the fleetingness
of the transformations they entail.

The posing for the tableau photographs in the
Mar Lodge album was a distinct event, separate from
the performance of the tableaux vivants themselves.
According to the introduction, "when their Royal
Highnesses rose from the table, they proceeded to the
drawing-room, where several artistic tableaux were
represented by the guests." While the tableaux
were performed indoors, after dinner, the photographs
would have been executed in the daytime, outdoors.
A variant of the *Faith, Hope, and Charity* tableau from
a different album, which is not as closely trimmed as the

version in the Mar Lodge album and therefore includes
part of a window frame and a fragment of the trestle on
the exterior of the house, confirms that the photographs
were staged outside.[37] The photographs thus do not
simply document the tableaux vivants as they were
performed, but are actually re-creations of the tableaux
for the sake of the camera.[38]

Another tableau performed at Mar Lodge that,
like the Mary Queen of Scots tableaux, depicted a tragic,
female historical figure was entitled *Charlotte Corday
Contemplating Her Picture before Her Execution.* It shows
Marat's assassin seated behind an easel, gazing at the
painting on it while an executioner cuts her hair. The
theme of the three Christian virtues, Faith, Hope, and
Charity, is staged in another tableau (fig. 89). This type
of allegorical tableau – like the one performed by the
royal children in 1854, in which the personifications of
the Four Seasons surround a "Spirit Empress" (fig. 84) –
was by 1860 a common enough photographic motif
for Lewis Carroll to satirize in his short story "A
Photographer's Day Out," in which the unfortunate
Mr. Tubbs spends a day in the country photographing
a family. The final picture he is called upon to make
is "a family group, designed by the two parents, and
combining the domestic with the allegorical," which
the story's narrator describes in comic detail:

> It was intended to represent the baby being crowned
> with flowers, by the united efforts of the children,
> regulated by the advice of the father, under the
> personal superintendence of the mother; and to
> combine with this a secondary meaning of "Victory
> transferring her laurel crown to Innocence, with
> Resolution, Independence, Faith, Hope and Charity,
> assisting in the task, while Wisdom looks benignly
> on, and smiles approval!" Such, I say, was the intention;
> the result, to any unprejudiced observer, was capable
> of but one interpretation – that the baby was in a fit –
> that the mother (doubtless under some erroneous
> notions of the principles of Human Anatomy) was
> endeavouring to recover it by bringing the crown
> of its head in contact with its chest – that the two boys,
> seeing no prospect for the infant but immediate
> destruction, were tearing out some locks of its hair as
> mementos of the fatal event – that two of the girls were
> waiting for a chance at the baby's hair, and employing

the time in strangling the third – and that the father,
in despair at the extraordinary conduct of his family,
had stabbed himself, and was feeling for his pencil-case,
to make a memorandum of having done so.[39]

Although they at first appear to be a single
pyramidal mass of flowing white drapery and loose
hair, the allegorical figures of Faith, Hope, and Charity
photographed by Prout are more legible than in the
confused tableau poor Tubbs tries to record. The tall
woman at the centre of the group with an arm around
the large wooden cross is Faith; Charity is the figure at
the left accompanied by the barefoot kneeling girl; and
Hope (whose expression is actually more apprehensive
than hopeful) holds Faith's hand to complete the familiar
trio of Christian virtues. The individual pictures of
each of the virtues on the album's next page were the
photographs from the Mar Lodge series that were most
frequently reproduced and circulated as cartes-de-visite.
Tableaux vivants such as this one continued to be a
favourite pastime of the royal family for the rest of the
century. Having performed as children, adult members
of the royal family posed for a tableau of the same subject
in the early 1890s; powdered white from head to toe,
they posed as a sculpture of Faith, Hope, and Charity.[40]

The Scottish theme of the tableaux is
taken up again in *The Soldier's Return,* a genre-style
picture of a reunited family, accompanied by lines
from a song by the Scottish poet Robert Burns. The
arrangement of the figures in the tableau is reminiscent
of Millais's 1852 painting *The Order of Release, 1746,*
which suggests that Prout and Wingfield may have
worked from a visual as well as a literary source for
The Soldier's Return.

By far the most frequently mined source of
literary inspiration for Victorian staged photographs was
the work of the poet laureate, Alfred Tennyson. Within
Tennyson's oeuvre, the story of Elaine was a particularly
popular choice. In *Idylls of the King,* Elaine, the "lily maid
of Astolat," dies of unrequited love for Lancelot. Her
corpse, lavishly adorned and clutching a letter to
Lancelot, is sent by boat to Camelot. In a picture in the
Mar Lodge album that shares a page with *The Soldier's
Return,* the deceased Elaine is laid out on a flower-strewn
bier (fig. 90). Eyes closed, she lies in profile, with her
long, loose hair spread out around her head, and holds a
single lily in her hand. Except for her bare forearms, she
is draped in a white robe from neck to toe, and because
both the background and the platform are covered
in dark fabric, her body appears to float, just as Elaine's
corpse floated by boat to Camelot. Printed opposite the
photograph is an excerpt from Tennyson's *Idylls of the King*:

> "Lay the letter in my hand
> A little ere I die, and close the hand upon it;
> I shall guard it even in death.
> And when the heat is gone from out my heart,
> Then take the little bed on which I died
> For Lancelot's love, and deck it like the queen's
> For richness, and me also like the queen
> In all I have of rich, lay me on it.
>
> So that day there was dole in Astolat."[41]

Paradoxically, this depiction of a beautiful young
corpse originated as a tableau vivant, literally a "living
picture." The death of Elaine, whether staged in front of
an audience at a country house party or for the sake of
the camera, yielded a romantic picture with relatively
little effort on the part of the model. Like *Fading Away,*
it depicts a beautiful young woman dead of a broken
heart. The recurring depictions of illness and dying in
Victorian staged photographs, which often refer to a
literary source, feature almost exclusively female subjects.
These photographic depictions of sickness and dying
aestheticize the subject matter and tend to present their
models as passive objects of feminine beauty.[42]

Around 1870 the amateur photographer Ronald
Leslie Melville also photographed several versions of
Elaine (see fig. 91).[43] In comparison with Prout's austere
interpretation, Melville's staging of the scene is even
more makeshift, a riot of fabrics in contrasting patterns
and textures. Like Prout's Elaine, the model lies in profile,
her hair spread luxuriantly around her, clasping a lily in
her hands. A second lily, a symbol of purity and a direct
reference to Elaine's status as the "lily maid of Astolat,"
is tucked behind her ear. A mourner kneels next to
Melville's Elaine and rests her head next to a vine of ivy,
which represents fidelity. Despite Tennyson's immense
popularity, when Melville exhibited this picture at the
1871 International Exhibition in London under the
title *Broken Lilies,* the reviewer for *The British Journal*

of Photography claimed to be unable to identify the picture's subject:

> We are left in some doubt as to the story intended to be told by the production. Of course it is a tale of woe, although we have not discovered the point. A female form lies recumbent on a couch, but whether the lady is dead, slumbering, or merely studying botany in connection with some flowers placed on her bosom, we are a little uncertain.[44]

The ambiguity of the model's pose was (perhaps unintentionally) appropriate to the original source, since Tennyson writes that Elaine's "clear-featured face / Was lovely, for she did not seem as dead, / But fast asleep, and lay as though she smiled."[45] A Scottish aristocrat, Melville may have seen Prout's version of Elaine in the Mar Lodge album. Like Prout, Melville also took up the subject of Mary Queen of Scots.

Not all photographic representations of fictional scenes of the sick, dying, or dead had as lofty aspirations as Prout's or Melville's *Elaine* or even Robinson's *Fading Away*.[46] An untitled album page created by Constance Sackville West has more in common with *Fading Away* than with either of the *Elaine* photographs, insofar as it represents a contemporary, domestic scene of an ailing girl attended by an older woman (fig. 92). The girl is tucked into a canopy bed, and in the centre of the room there is a table with medicine bottles and a jar marked "PILLS." Just as Robinson composed his picture out of multiple negatives manipulated in the darkroom into a single print, this sickbed scene is also a montage, made up of two figures cut from photographs and pasted onto a watercolour background. But while Robinson relied on multiple negatives to form a composition that would have been impossible to achieve if he had photographed all the elements at once, Sackville West used scissors, paste, and watercolour to create a picture that photography alone could not have accomplished. However, the morbid sentimentality expressed in Robinson's picture is entirely absent from the Sackville West collage. Her composition is a playful re-imagining of two ordinary studio portraits, transposed into a watercolour bedroom setting. The painting is fairly crude, but the goal here is a humorous restaging of formal portraits, not the construction of a convincing, seamless

whole. The other pages in the Sackville West album, which feature photographs incorporated into watercolour renderings of jewelled lockets, picture frames, and elaborate seaside scenes, confirm the lack of seriousness of the sickbed collage. A widespread pursuit among upper-class Victorian women, making imaginative collages from photographs was a form of staging: instead of sitters dressing up and posing in front of the camera, the collage-makers invented scenes using cut-out photographs and watercolours.[47] Alexandra, the Princess of Wales, made such albums, and they would have been familiar to the aristocratic women who acted in the tableaux vivants at Mar Lodge.[48]

Victorian albums, whether made by photographers such as Victor Prout or by collectors such as Constance Sackville West, offer valuable insights into the context in which staged photographs were created, and reveal that making, displaying, and posing for staged photographs were interrelated social activities. Albums not only house staged photographs that might have otherwise been lost but also preserve the intimate experience of viewing them as Victorians did, page by page, accompanied by captions, and juxtaposed with other types of pictures.

Albums were often displayed in drawing-rooms, such as the one pictured in a photograph near the end of the Mar Lodge album (fig. 93). The tableaux vivants were also performed in the drawing-room, but in this view, the furniture has been returned to its usual arrangement. Exhausted guests are collapsed into the chairs, perhaps worn out after the ball – the introduction informs us that "at three o'clock in the morning all was yet gaiety and animation; and at half-past three the company merrily engaged in a country dance, the Prince leading off."[49] On the table in the foreground is a large clasped volume that appears to be a photograph album. A guide to etiquette published in the same year as the Mar Lodge album offered the following advice to socially aspiring ladies: "If you are at the house of a new acquaintance and find yourself among strangers … to shrink away to a side-table and affect to be absorbed in some album or illustrated work" would be a *gaucherie* that "no shyness can excuse."[50]

If, however, you seek a deeper understanding of Victorian staged photographs, there could be no better recommendation than to absorb yourself in just such an album.

NOTES

I would like to thank Peter Bunnell for his comments on this essay and Roger Taylor for many helpful conversations on Victorian staged photography.

1 Sel d'Or, "Notes on the Exhibition of the Photographic Society of Scotland," *The Photographic Journal*, 1 January 1859, p. 8.

2 Many viewers, however, did not realize that Robinson had used five separate negatives to create the picture. When Robinson explained his technique, he sparked a debate within the photographic community as to whether forming a single picture from negatives of various subjects, taken on different occasions, constituted a betrayal of photography's truthfulness. See H.P. Robinson, "On Printing Photographic Pictures from Several Negatives," *The British Journal of Photography* 7, no. 115 (1860), pp. 94–95, and the responses that followed in subsequent issues.

3 See Malcolm Daniel, "Darkroom vs. Greenroom: Victorian Art Photography and Popular Theatrical Entertainment," *Image* 33, no. 1–2 (1990), pp. 13–20.

4 The lines are from *Queen Mab* (1.12–17): "Must then that peerless form, / Which love and admiration cannot view / Without a beating heart, those azure veins / Which steal like streams along a field of snow, / That lovely outline which is fair / As breathing marble, perish!" Just as the poem likens death to the transformation of a live body into a marble statue, the photograph seems to immobilize the dying girl into a picture.

5 "Critical Notices: The Photographic Exhibition at the Crystal Palace," *The Photographic News*, 1 October 1858, p. 40.

6 See A.D. Coleman, "The Directorial Mode: Notes toward a Definition," in *Light Readings: A Photography Critic's Writings, 1968–1978* (Oxford and New York: Oxford University Press, 1979), p. 254.

7 Ibid., pp. 251–252.

8 Ibid., p. 250.

9 Douglas R. Nickel, *Dreaming in Pictures: The Photography of Lewis Carroll* (San Francisco: San Francisco Museum of Modern Art; New Haven, Conn., and London: Yale University Press, 2002), p. 35.

10 During this period, an amateur photographer was not the casual hobbyist of today, but was a non-professional who dedicated a significant amount of time (and usually money) to learning and practising what was still a difficult and unwieldy process.

11 Cuthbert Bede, *The Further Adventures of Mr. Verdant Green, an Oxford Under-graduate* (London: Nathaniel Cooke, 1854), pp. 73–74.

12 Martin Meisel, *Realizations: Narrative, Pictorial, and Theatrical Arts in Nineteenth-Century England* (Princeton, N.J.: Princeton University Press, 1983), pp. 48–49.

13 Johann Wolfgang von Goethe, *Italian Journey*, quoted in Sara Stevenson and Helen Bennett, *Van Dyck in Check Trousers: Fancy Dress in Art and Life 1700–1900* (Edinburgh: Scottish National Portrait Gallery, 1978), p. 54.

14 These included "Despair in the Dungeon; Hope at the Sea Shore; Revenge and Pity – the Sacked and Burned City; Jealousy – the Garden; Melancholy – the Convent Garden" and finally a "Grand Allegorical Groupe. St. Cecilia Surrounded by the Passions." Quoted in Meisel, *Realizations*, p. 48.

15 Michael R. Booth, *Victorian Spectacular Theatre, 1850–1910* (Boston and London: Routledge & Kegan Paul, 1981), p. 10.

16 Stevenson and Bennett, *Van Dyck in Check Trousers*, p. 48.

17 Meisel, *Realizations*, p. 47.

18 Morton N. Cohen, ed., *The Letters of Lewis Carroll* (London: Macmillan; New York: Oxford University Press, 1979), vol. 1, p. 45, letter dated 18 December 1860.

19 See Patrizia Di Bello, "The 'Eyes of Affection' and Fashionable Femininity: Representations of Photography in Nineteenth-Century Magazines and Victorian 'Society' Albums," in *Phototextualities: Intersections of Photography and Narrative*, ed. Alex Hughes and Andrea Noble (Albuquerque: University of New Mexico Press, 2003), pp. 254–270, and Diane Waggoner, "Seeing Photographs in Comfort: The Social Uses of Lewis Carroll's Photograph Albums," *Princeton University Library Chronicle* 62, no. 3 (2001), pp. 403–433.

20 Queen Victoria had attended the Braemar Gathering every year since 1848, but in 1862 the games were cancelled in honour of Prince Albert's death, and in 1863 the prince and princess represented the royal family at the games. See Grant Jarvie, "Highland Games," in *Sport, Scotland and the Scots*, ed. Grant Jarvie and John Burnett (East Linton: Tuckwell, 2000), pp. 128–142.

21 The album's title page reads: *A Series of Photographs, Illustrating the Visit of Their Royal Highnesses the Prince and Princess of Wales to Mar Lodge, the Seat of the Earl and Countess of Fife, during the Braemar Gathering of 1863. By Victor A. Prout. Published at 15, Baker Street, Portman Square, London, 1864*. The printer was Clayton & Co., 17 Bouveries Street, London. Although it is not known how many were made, at least four complete copies of the album survive. One is in the collection of the Scottish National Portrait Gallery, Edinburgh; another is in the Glasgow University Library; and two more have been auctioned at Sotheby's London. There are various individual cartes-de-visite from the series in private and public collections, some loose and others preserved in albums.

22 The copy inscribed to Wingfield was sold at Sotheby's Belgravia, 22 March 1978, lot 196, and again at Sotheby's London, 25 March 1983, lot 113. For Prout's advertisement, see Alan Davies and Peter Stanbury, *The Mechanical Eye in Australia: Photography 1841–1900* (Melbourne: Oxford University Press, 1985), p. 197.

23 *The Times* of London also printed the full program of the tableaux vivants in its coverage of the Braemar Gathering. "The Prince and Princess of Wales in the Highlands," *The Times*, 31 August 1863, p. 7.

24 The language of the album's introduction reinforces the stereotypes of Scottish and especially Highland culture, referring to the crowd's excitement as "thoroughly Scottish in its intensity" and the dancing as exhibiting "true Highland spirit and vigour."

25 Hugh Trevor-Roper, "The Invention of Tradition: The Highland Tradition of Scotland," in *The Invention of Tradition*, eds. Eric Hobsbawm and Terence Ranger (Cambridge: Cambridge University Press, 1983), pp. 15–41.

26 Michael J. Stead, *Queen Victoria's Scotland* (London: Cassell, 1992), pp. 15–29. As Andrew Bolton explains, "if King George's visit to Scotland elevated Highland costume to the status of national dress, Queen Victoria's cult of the Highlands effectively brought about its commodification" (*Bravehearts: Men in Skirts* [London: V&A Publications, 2003], p. 102).

27 Royal Archives, Windsor Castle, Queen Victoria's Journals, 4 December 1848. Quoted in Sarah Mountbatten-Windsor, Duchess of York, with Benita Stoney, *Victoria and Albert: Life at Osborne House* (London: Weidenfeld & Nicolson, 1991), p. 100.

28 *A Series of Photographs, Illustrating the Visit of Their Royal Highnesses the Prince and Princess of Wales to Mar Lodge*, p. 3.

29 Joseph Knight, "Wingfield, Lewis Strange (1842–1891)," rev. J. Gilliland, *Oxford Dictionary of National Biography* (Oxford and New York: Oxford University Press, 2004), vol. 59, p. 731.

30 "Photographs of the Princess of Wales, Mrs. Langtry, Mrs. Cornwallis West, Mrs. Wheeler and Lady Dudley collected crowds in front of shop windows … wherever Georgina Lady Dudley drove there were crowds round her carriage when it pulled up, to see this vision of beauty" (Margot Asquith, *The Autobiography of Margot Asquith*, ed. Mark Bonham Carter [London: Eyre & Spottiswoode; Boston: Houghton Mifflin, 1962], p. 46).

31 *The Times*, 31 August 1863, p. 7.

32 *A Series of Photographs, Illustrating the Visit of Their Royal Highnesses the Prince and Princess of Wales to Mar Lodge*, p. 3.

33 Ibid.

34 Mary Queen of Scots was also a favourite guise in which sitters wanted to be represented in their portraits. In *Pictorial Effect in Photography, Being Hints on Composition and Chiaroscuro for Photographers* (London: Piper & Carter, 1869; reprint, Pawlet, Vt.: Helios, 1971), pp. 84–85, Henry Peach Robinson cites an anecdote of a woman having her portrait drawn as Mary Queen of Scots:

> Sitters often want to be made to look like other people … Peter Cunningham gives an anecdote that may, possibly, be out of place here, but is too good to omit. "When Bernard Lens was drawing a lady's picture in the dress of Mary Queen of Scots, the fastidious sitter observed: 'But, Mr. Lens, you have not made me like Mary Queen of Scots!' 'No madam,' was the reply, 'if God Almighty had made your ladyship like her – I would.'" The same might be said of half the *lenses* of the present day!

While a painter could have idealized his subject, a photographer had less choice. Trying or hoping to be photographed a certain way was no guarantee that the photograph would come out as the sitter (or photographer) imagined it. The photographer's dependence on the skills of the model is mentioned repeatedly in the photographic literature of the period.

35 Frances Dimond, *Developing the Picture: Queen Alexandra and the Art of Photography* (London: Royal Collection Publications, 2004), p. 97.

36 Roy Strong, *Painting the Past: The Victorian Painter and British History*, rev. ed. (London: Pimlico, 2004), pp. 134–135.

37 "Mammoth carte-de-visite album with decorative boards," Christie's South Kensington, 21 April 1988, lot 214.

38 The introduction lists six tableaux vivants and two amateur theatricals, but the album contains eleven photographs of tableaux and eight relating to the plays.

39 Lewis Carroll, "A Photographer's Day Out" (1860), in Helmut Gernsheim, *Lewis Carroll, Photographer* (London: Max Parrish, 1949), pp. 117–118.

40 A photograph of this tableau is in the album "Tableaux Vivants, Devonport, 1892–93" (Wilson Centre for Photography, London). Other examples of photographs of models posing as sculpture include Julia Margaret Cameron's studies after the Elgin Marbles (figs. 30 and 31) and, more recently, Anne Ferran's *Scenes on the Death of Nature, I and II* (fig. 44).

41 Alfred Tennyson, *Idylls of the King*, "Lancelot and Elaine," 1107–1113, 1129, as printed in the Mar Lodge album.

42 Exceptions include Oscar Gustave Rejlander's *Head of Saint John the Baptist in a Charger* (fig. 67), James Robinson's *Death of Chatterton*, and a few of Julia Margaret Cameron's illustrations of *Idylls of the King*.

43 Henry Peach Robinson first exhibited *Elaine Watching the Shield of Lancelot* (1859–1860) at the British Association Exhibition in 1861 (Margaret Harker, *Henry Peach Robinson: Master of Photographic Art, 1830–1901* [Oxford: Basil Blackwell, 1988], p. 103). In 1875 Julia Margaret Cameron would make a series of photographs illustrating several episodes from Elaine's story, including her body's transportation by boat to Camelot and its display in King Arthur's castle (Julian Cox and Colin Ford, *Julia Margaret Cameron: The Complete Photographs* [Los Angeles: Getty Publications; London: Thames & Hudson, 2003], entries 1190–1192, pp. 480–481).

44 Review of the International Exhibition, *The British Journal of Photography*, 12 May 1871, p. 216, quoted in Helen Smaills [Smailes], "A Gentleman's Exercise: Ronald Leslie Melville, 11th Earl of Leven, and the Amateur Photographic Association," *The Photographic Collector* 3, no. 3 (1982), p. 272.

45 Tennyson, *Idylls of the King*, "Lancelot and Elaine," 1152–1154.

46 Actual post-mortem photography was extremely rare in Victorian Britain, although it was a common practice in nineteenth-century America. See Jay Ruby, *Secure the Shadow: Death and Photography in America* (Cambridge, Mass.: MIT Press, 1995).

47 See Marta Weiss, "Dressed Up and Pasted Down: Staged Photographs in Victorian Albums," *Archive* (National Museum of Photography, Film and Television, Bradford, England), no. 3 (September 2004), pp. 32–37. The Kate Gough album in the Victoria and Albert Museum, London, includes a similar collage of a cut-out photograph of a female figure tucked into a watercolour canopy bed.

48 Dimond, *Developing the Picture*, pp. 29–39.

49 *A Series of Photographs, Illustrating the Visit of Their Royal Highnesses the Prince and Princess of Wales to Mar Lodge*, pp. 4–5.

50 *Routledge's Etiquette for Ladies* (London: George Routledge & Sons, 1864), pp. 48–49.

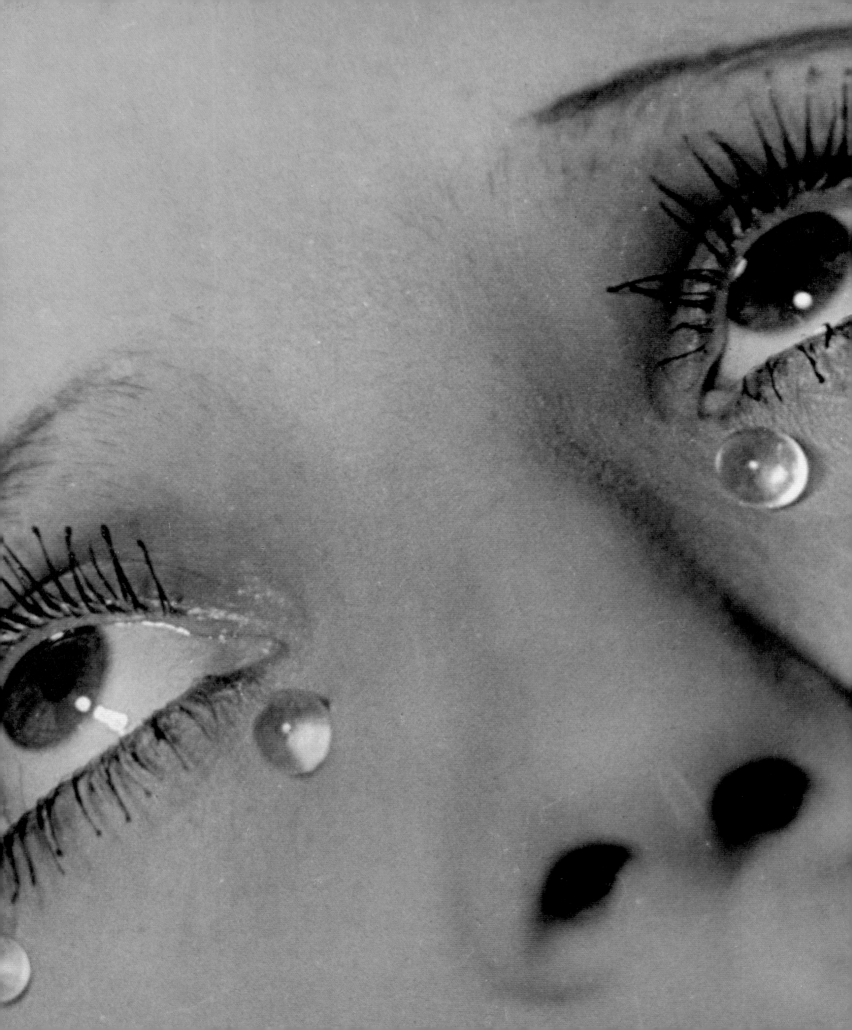

Intent on revising the language of art both
conceptually and formally, the Modernist program
that dominated the early part of the twentieth
century saw photography primarily as a means
to capture new perspectives, to abstract form,
to record chance encounters, and to visualize
the previously unseen. This ethos manifested itself
in the renderings of landscape, architecture, and
portraiture made by photographers working in
the style of the New Vision, who questioned the
primacy of content over form, as well as through
the collages and montages of the Dada and
Surrealist artists, who employed photography as
a way to include references to the outside world
in their exploration of the unconscious. Given
the Modernists' interest in promoting abstraction
and their favouring of a non-representational
aesthetic, there was little to suggest that
staged photography with its narrative character
would become part of the Modernist vocabulary.

 Nor do the writings of the principal
practitioners of Modernism and Modernist

photography offer any evidence that the staged photograph featured prominently in their thinking. In fact, what they frequently lauded is in opposition to the premises underlying photographic tableaux. Louis Aragon's 1936 essay "The Quarrel over Realism," for example, praises the camera's new role: "It has mixed into life.... It no longer shows us human beings posing, but men in movement. It arrests moments of their movement that no one would have ventured to imagine or presumed to see."[1]

In contrast, although the photographers Raoul Hausmann and Werner Gräff, writing in 1933, did not specifically advocate the posing of models, they did introduce the concept of directing precisely how the photograph should be formally constructed: "Exact guidance of the viewer's gaze, careful selection of the pairs of opposites (form and form detail, light and dark, large and small); this is the only way to turn photography from an imitative, at best documentary technique into a medium of creative expression."[2] Yet this call to creativity in composition is still far removed from the advocacy of *mise en scènes* with narrative content, the appearance of which is somewhat puzzling within the Modernist aesthetic of non-representationalism. There is an irony, then, to the adoption of the staged photograph as an aesthetic method in Modernism, given that Modernist photography was conceived as a rebellion against the imitation of painterly techniques and strategies, a mode favoured by the Pictorialists and camera club enthusiasts working in the early decades of the twentieth century. In light of this apparent contradiction, the most compelling reason why the staged photograph was incorporated into Modernist expression can be found in Modernism's openness to exploiting every potential avenue photography offered. In the broad scheme of the Modernist credo, this stance both underscored the belief in free experimentation and made available a format in which the intangible subjects of the subconscious and the self could be explored. All three practices of Modernist photography – expressive medium, advertising, and photojournalism – used the technique of staging events, people, and objects in order to construct a narrative.

The staged photograph took several forms. The first involved arranging models in front of the camera to compose narrative tableaux of varying complexity. Emerging in the mid-nineteenth century in the context of Victorian narrative art, its first major practitioners were Oscar Gustave Rejlander and Henry Peach Robinson. Later in the century and throughout the first four decades of the twentieth century, Pictorialist photographers such as F. Holland Day and Gertrude Käsebier, as well as William Mortensen, Harold Kells, and Madame Yevonde, elaborated on this approach. These last three worked with some of the Pictorialist themes but employed a slicker, less soft-focused, more intensely illusionistic manner of rendering form. Using highly theatrical lighting and elaborate costumes and stage settings reminiscent of the epic creations of such filmmakers as Cecil B. DeMille, Fritz Lang, and D.W. Griffith, their picture-making tended toward a mannered style of expression. Common to all these photographers was an interest in exotic, Greco-Roman, and biblical themes.

The second form of the staged photograph, a slightly less elaborate variation on the first, featured the artist as primary actor or model, emphasizing individual role-playing and frequently concentrating on issues of identity. While this genre was embraced early on by Pictorialists such as Day, an eccentric and talented figure in the history of photography with a penchant for theatre (see fig. 26), it evolved into a more radical form of picture-making under the Surrealists Man Ray, Marcel Duchamp (in collaboration with Man Ray), and Claude Cahun.

Similar to the body of staged work by Cahun, whose approach involved her assuming various masculine and feminine personae, the third type was more emphatically performance-based, the photographers themselves acting out sequences of choreographed actions for the camera, sometimes using props, sometimes focusing on the expression of a range of gestures and emotions. Beginning early in the twentieth century with the work of the Italian Futurist Fortunato Depero, this genre would re-emerge in the 1970s with the fetishistic auto-erotic imagery of Pierre Molinier. Other photographers working in this mode included the Polish artist Stanisław Ignacy Witkiewicz and the Czech Surrealist Václav Zykmund.

PICTORIALISM

Although Modernism set out to challenge the romantic sentiments that lay at the heart of Pictorialism, the

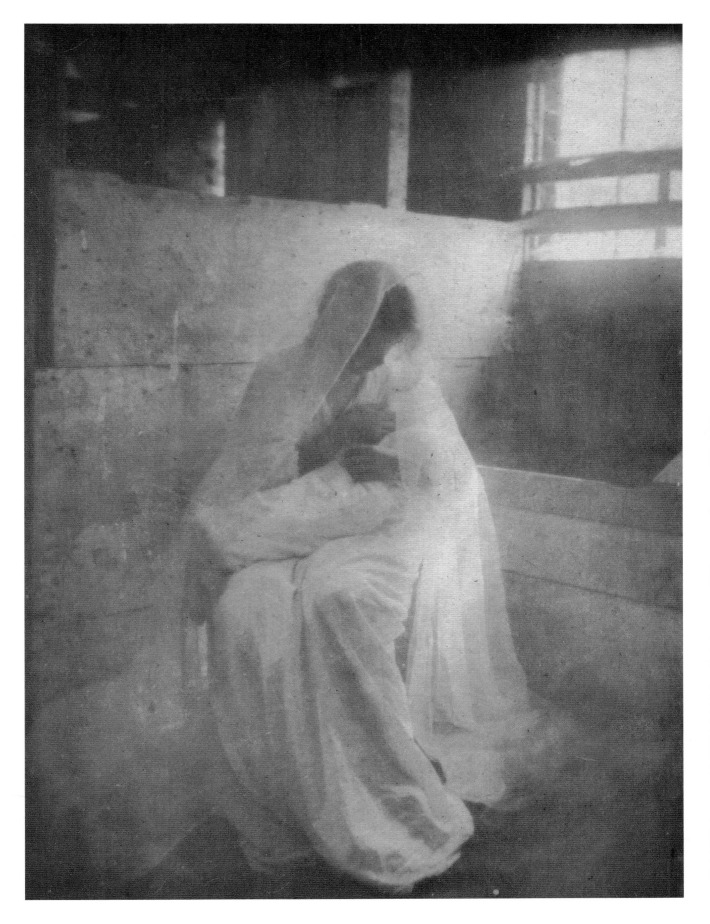

Fig. 95
William Mortensen, *Flemish Maid (costume details)*, from William Mortensen, *The Model: A Book on the Problems of Posing* (San Francisco: Camera Craft, 1948), p. 137

Fig. 96
William Mortensen, *Flemish Maid*, c. 1935, gelatin silver print. National Gallery of Canada, Ottawa (32109.5)

particular qualities of the Modernist tableau are best understood when seen against the backdrop of Pictorialist examples. Posing their models in allegorical arrangements that addressed such themes as childhood, the virtues of motherhood, and the beauty of nature, the Pictorialists advocated romantic ideals, narrative messages, and gestural pictorial conventions. They also favoured sentimental subject matter over the crisp, clean-edged abstractions of the New Objectivity movement and the fantastic and often disturbing imagery of the Surrealists. Gertrude Käsebier's typically Pictorialist staged works such as *The Manger* (fig. 94), also known as *Ideal Motherhood*,[3] were perhaps made under the influence of F. Holland Day.[4] *The Manger*, which first appeared as a platinum print in the 1899 Philadelphia Salon, shows the illustrator Frances Delehanty enacting the role of a solicitous mother in a Nativity scene. While the setting of a whitewashed stable was an appropriate choice, the infant was represented by just a bundle of swaddling cloths, a detail that appears to have had no adverse effect on the work's popularity.[5] The white "angel" robes worn by Delehanty for the occasion were reportedly lent by Day, who was known to dress up in exotic Middle Eastern and Oriental attire not only for the purposes of photography but for the sheer pleasure of it.[6] For his own photographs, Day sometimes used actors as models, but he would also seek out non-professional models of Middle Eastern, Mediterranean, or North African origin. He recommended the study of great painters rather than photographers, and drew his inspiration from themes in art and literature.[7] Opposed to the idea of limiting photography to mere factual recording, he ventured fully into the territory previously explored by Rejlander and Robinson. As Estelle Jussim has noted: "He was a leader among image makers who longed for a return to the metaphysical manifestations of human life and

objected to the very accuracy of photography as catering to the demands of the masses for representationalism; he agreed with Baudelaire's rejection of verisimilitude for its own sake."[8]

The turn-of-the-century art critic Sadakichi Hartmann criticized Day's photographs for their lack of naturalness and objected to the overreliance on painters as sources of inspiration: "He has set himself to get painter's results, and that is from my point of view not legitimate."[9] Hartmann considered Day's talents more suited to the work of a stage manager than to that of a photographer.

The influence of Käsebier and Day on a later generation of tableau vivant photographers should not be overlooked. Perhaps more than any other practitioners of the art in the late nineteenth and early twentieth centuries, they raised this pictorial form to new heights of expression.

Two other accomplished photographers who similarly advocated studying great painters, William Mortensen, the American master of the staged photograph, and Harold Kells, the unchallenged master of its Canadian realization, pushed the genre to an extreme point of theatricality, thereby defining the limits of this style during the 1920s and 1930s. Mortensen took Rejlander's conception of the photograph as an instrument for depicting moral narrative and turned it into a version of a Hollywood poster. As the critic A.D. Coleman noted, "Mortensen worked exclusively in the directorial mode, staging the events he photographed (mostly in the studio), creating tableaux vivants that involved scenarios, actors, props, costumes, makeup, careful posing, and controlled lighting."[10]

Mortensen had studied at the Art Students League in New York,[11] but despite his progressive training he expressed very conservative views about

Fig. 97
Harold F. Kells, *Death of Cleopatra*, 1934, gelatin silver print. National Gallery of Canada, Ottawa (31286)

the photography of his time, attacking its "shallowness and topical quality." He complained that "we are stopped short by the simple objective fact of the picture, by its mere is-ness."[12] Condemning the contemporary photograph for its apparent lack of even the barest narrative, he argued that "there must be *meaning* beyond the mere physical fact of the model.... A model as part of a picture not only *is* but *means* something."[13] Compare this striving for significance with László Moholy-Nagy's characterization of his own photograph of Julia Feininger as "an attempt at an objective portrait: the individual to be photographed as impartially as an object so that the photographic result shall not be encumbered with subjective intention."[14]

A conscientious technician, Mortensen placed high value on the way he was able to take the concept of tableau imagery, his chosen genre of photographic expression, and turn it into a fully developed picture-making system, replete with "how-to" publications and classes at the Mortensen School of Photography, which he founded at Laguna Beach, California, in 1932. Although far more flamboyant than Day both in his choice of subject matter and in his composition, he also looked to the work of painters to give form and meaning to his photographs, often citing specific artists as embodiments of his ideas about composition and lighting. In his mannered representation *Aspasia,* which he contends was not made with a Classical theme in mind, he credits the late nineteenth-century painter Lawrence Alma-Tadema as the source of inspiration: "About half-way through the sitting, something about the model's reclining pose suggested the classical manner of Alma-Tadema."[15] The appeal of Mortensen's tableau method would extend beyond the confines of camera club practitioners to the world of advertising, where its influence is most directly observed in the work of Lejaren A. Hiller, whose contribution will be discussed later in this essay.

Whereas Day turned to the theatre for his sense of atmosphere and dramatic climax, Mortensen incorporated his years of working in the early 1920s as a stills photographer on Hollywood sets. As much as this experience influenced his work, Mortensen was nevertheless conscious of the literal nature of movie stills, drawing a distinction between a "picture of drama" and a "dramatic picture."[16] For the photographer to achieve

the latter, he believed that the picture itself had to be animated, transcending the mere fact of being a posed tableau. Sensitive to the specific characters of painting and photography, Mortensen made a point of explaining the challenges that faced the photographer, particularly in depicting human models: "The painter may adjust perspectives and warp arms and legs into attitudes that are becoming or compatible to his design. But the photographer must take things as they are. The arms and legs that he deals with are flesh and bone, and are uncompromisingly unmalleable."[17] He took his role as director seriously, underlining the importance of remaining sensitive to both the physical and psychological aspects of posing models in a tableau. The process that the actor-models are engaged in he likened to pantomime rather than theatre, where the emphasis is less on what the actor thinks or feels and more on what the "beholder thinks that the actor thinks." It was Mortensen's contention that "the model is the means through which the artist realizes himself."[18] He also believed that pantomime should serve as inspiration when it came to translating physical facts into pictorial language: "The pictorial language of expression takes the form of *pantomimic symbols* … the ancient universal art of pantomime which translated thought into physical movement and attitude by means of standardized and stylized gesture."[19]

Mortensen's highly meticulous approach to conceiving and staging his tableaux led him to itemize and publish the nine basic costume elements required to create a staged photograph (see fig. 95). These necessary accoutrements ranged from frayed and torn cloth sacks to brocades, furs, velvets, scarves, underdresses (petticoats and bodices), grey drapes, ivory-coloured lace, and handmade jewellery. The construction of the Flemish Maid's outfit (fig. 96) is described in detail:

The procedure of building up this costume was as follows: the blouse was put on, with the sleeves tucked up and the gathered neck drawn fairly close. A wide scarf was tied about the hips. The headdress was built of two pieces of lace and a scarf laid over the head. With this much of the costume in place, the model seated herself and the piece of brocade was adjusted over her lap. Several exposures were made. The arm of the chair was then partially covered with another

Fig. 98
Madame Yevonde, *Lady Malcolm
Campbell as Niobe,* from the
Goddesses series, 1935, printed
c. 1999, pigment transfer print.
Yevonde Portrait Archive,
Winchester, England

scarf and the jewelry was added. More exposures were made with various arrangements of the bracelets and various positions of the arms and head. Finally, to give point to her gesture, the knitting needle or bodkin was placed in her hand. This is in reality nothing but a twig plucked from a bush outside the door. Small hand properties such as this are so integral a part of the pictorial conception that they are properly regarded as a department of costume.[20]

In creating such tableaux, Mortensen believed that photographers should not consult "costume plates but the work of great painters of the past."[21] Mortensen issued fastidiously detailed instructions on posing, costume, and makeup, and insisted on significant gesture and narrative.[22]

Harold Kells, an amateur photographer and painter, operated a photography studio in Ottawa from 1933 to 1938. Kells regularly submitted his photographs, which tended to favour Greco-Roman mythological themes, to international salons.[23] His elaborate stage settings – arrangements of models in melodramatic tableaux of Classical figures – suggest the pronounced influence of Mortensen's work and of movie stills in general. *Death of Cleopatra* (fig. 97), made in 1934, the same year as Cecil B. DeMille's film *Cleopatra,* is one of Kells's most accomplished works, drawing on his skill as a composer of tableaux. It was praised as a "veritable triumph" by C.J. Symes: "The interest, naturally enough, centres in the brightly illumined and reclining figure on the pedestal, the others being subordinate in varying degree but each playing its part in contributing to the significance of the whole.... The idea, if a little inclined toward theatricality, is big. It is great not only in conception but in treatment and in execution."[24]

A discussion of the Pictorialist staged photograph and its treatment of Classical motifs would be incomplete without a mention of the work of Madame Yevonde, the owner of a series of successful commercial portrait studios in London from 1914 to 1975. Madame Yevonde united the studio portrait tradition and the photographic representation of Classical mythology in a unique hybrid form that came to be known popularly as "The Goddesses." *Niobe, Europa,* and *Medusa* (figs. 98–100) are three examples from her studio in the mid-1930s. Her use of VIVEX, a three-colour carbro process that allowed

Yevonde to manipulate the chromatic vibrancy of her prints, made these images especially appealing at a time when the standard process for commercial portrait studios was black-and-white.

In 1932 Yevonde held her first exhibition of portraits in the carbro colour process at the Albany Gallery in London. This debut was followed in July 1935 by *An Intimate Exhibition – Goddesses and Others,* which featured new portraits from the Berkeley Square studio she had recently opened. Inspired in part by eighteenth-century portraits and also by a recent London charity ball with a Greco-Roman motif, the theme of this exhibition was the society woman transformed into goddess. Using props and the lavish costumes designed for the ball, Yevonde "envisaged nothing less than an entire pantheon of Goddesses and other figures from Classical mythology, each one embodying a specific attribute to which she felt women of her day could relate."[25] Lady Malcolm Campbell was cast as Niobe, the goddess of female suffering, her face marked with rivulets of fake tears created by an application of soap. The fad for Madame Yevonde's melodramatic, comical, and "camp" staged work did not last beyond the period of the Second World War (when the VIVEX processing plant was forced to close), but her colour portraits from the 1930s continue to amuse and delight select audiences today. Even though she operated a commercial studio after the war, she never regained her earlier prominence.

It is this kind of Pictorialist imagery, combined with the Classical ideals and allegories expressed in much of Day's contrived photographs of the early part of the twentieth century, that set the backdrop for the more radical developments of the Futurists and the Surrealists, and that also informed the work of photographers in advertising and photojournalism at that time and in later decades.

THE AVANT-GARDE

In sharp contrast to Mortensen's, Kells's, and Yevonde's insistence on a set of formal conventions (one might even say formulae) of elaborate staging and a fierce commitment to mythological narrative was the radical abandonment of these pictorial conventions and Classical themes by the Futurist Fortunato Depero, the outsider

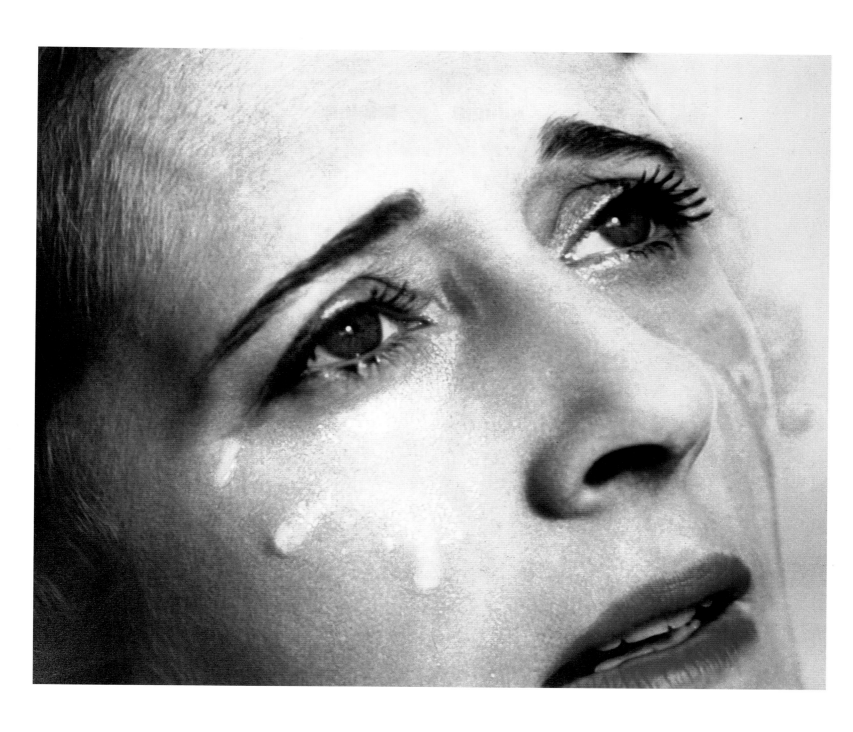

Fig. 101
Fortunato Depero, *Self-Portrait
with Clenched Fist*, 1915,
gelatin silver print. Museo d'Arte
Moderna e Contemporanea
di Trento e Rovereto

Fig. 102
Václav Zykmund, *Self-Portrait*,
1937, gelatin silver print.
Moravská Galerie, Brno

Fig. 103
Janina Turowska-Leszcyñska
and Stanisław Ignacy Witkiewicz
improvising *The Monster of
Düsseldorf*, 1932, gelatin silver
print. Collection of Ewa Franczak

Fig. 104
Man Ray, *Relâche*, 1924,
gelatin silver print. Juliet Man
Ray Collection

Fig. 105
Man Ray, *The White Ball of the
Count and Countess Pecci-Blunt,
Paris, 1930*, from Man Ray, *Self
Portrait* (Boston: Little, Brown,
1988), p. 138

Fig. 106
Marcel Duchamp, *Monte Carlo
Bond*, 1924–1938, offset
lithograph in red, black, green,
and yellow. National Gallery
of Canada, Ottawa (18395)

artist Stanisław Ignacy Witkiewicz, the Surrealists Man Ray and Václav Zykmund, the Bauhaus photographers, and other artists of their generation.

The avant-garde approach to staged photography stood in opposition to the Pictorialist attitude, favouring the creation of spontaneous actions that relied on available props and the use of friends and fellow artists, as well as the photographer, as models. Lighting and composition were often improvisational. More conceptually based than inspired by narrative structure, avant-garde staged photography privileged radical, tough subject matter over the sentimental and exotic themes of the Pictorialists. The performative portrait, a genre that involved a constructed staging of a sequence of events by the artist, which we see practised in some depth by Claude Cahun in the late 1920s, had its origins in the work of the painter, sculptor, and photographer Fortunato Depero. Depero was a pioneer in this practice, beginning with a body of photographs made in 1915–1916[26] in which the artist spontaneously staged performances that involved himself along with other players.[27] These "photo-performances" (as they were called by the historian of Futurist photography Giovanni Lista), which were captured in a series of grainy black-and-white prints (see fig. 101), are reminiscent of the

more scientifically oriented mid-nineteenth-century enquiries into human expression in which the performer sequentially enacts a set of extreme gestures and facial expressions. As Lista explains, "photo-performance embodied the collusion between art and life."[28]

Some fifteen years later, around 1930, Stanisław Ignacy Witkiewicz, the painter, writer, and photographer known as Witkacy, would adopt an approach similar to Depero's for the recording of his "Theatre in Life" performances (see fig. 103),[29] although there is no published evidence to suggest that he saw Depero's photo-performances. While Witkiewicz is sometimes cited as the author of these works, they can be considered collaborations: it was his friend Józef Glogowski, an amateur photographer, who recorded many of the absurdist photo-performances in which Witkiewicz assumed various personae and disguises.[30]

Stefan Okołowicz has observed that the period during which the "Theatre in Life" photographs were made marks a coalescing of the artist's complex interests: "Serving ... to realize his complex personality, or what Hesse described as the 'infinite diversity of the play of life,' Witkacy's private theatre embraced both commonplace occurrences as well as undertakings bordering, or directly bearing on art. By the 1930s,

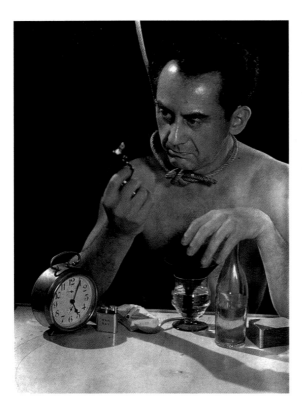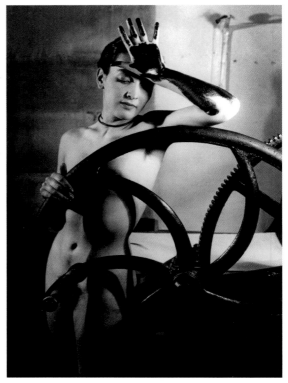

Fig. 107
Man Ray, *Self-Portrait – Suicide,*
1932, gelatin silver print. Lucien
Treillard Collection

Fig. 108
Man Ray, *Érotique voilée,* 1933,
gelatin silver print. Lucien
Treillard Collection

when 'theatrical' forms of expressing his personality greatly expanded and developed, photography became an important part of such activities."[31] Okołowicz goes on to note that the "Mime" performances, which Witkiewicz staged virtually all the time, took on an especially intensive character during special sessions in front of the camera. These performances resulted in numerous series of images registering the successive stages of his "Faces."[32]

Later in the same decade, Václav Zykmund, a member of the avant-garde group Ra, would also engage in extensive photo-performance work, setting up scenes that involved himself, his friends, and other artists. Although Zykmund was not involved in the theatre, his *mise en scènes* were constructed as dramatic vignettes, often of a menacing nature (see fig. 102). Antonín Dufek, a Czech historian of photography who ranks Zykmund's action photographs "among the most significant examples of Surrealist staged photography,"[33] speculates that the principles of staging provided Zykmund with the possibility of exploring issues relating to temporality and ontology: "The most important are Zykmund's staged compositions, including also some of his self-portraits.... The idea of the reflection and reversal of time is an expression of Zykmund's nascent interest in the temporal continuum.... A characteristic theme ... was a juxtaposition of the animate and inanimate and a blurring of the two."[34] Like Witkiewicz, Zykmund would occasionally call upon a fellow artist – in his case, Bohdan Lacina, a fellow member of Ra – for assistance in capturing the scene he had conceived.[35]

Unlike Depero and Witkiewicz, whose sources of inspiration seemed to be more conceptual than visual, Zykmund acknowledged the influence of Man Ray's photograph *Relâche*. This image (fig. 104) shows Marcel Duchamp as Adam and Brogna (or Bronja) Perlmutter as Eve acting out a tableau vivant of a Lucas Cranach painting for a performance during the interlude in the 1924 ballet *Relâche*.[36] As Zykmund later recounted, "I recall some of Man Ray's photos, but particularly Duchamp's photograph called Adam and Eve. It was not, however, just a non-committal game because persiflage, irony and parody came with it, and its results were in many respects identical with what was, much later, called an 'action' or 'happening.'"[37] In this autobiographical text Zykmund also draws attention to the random and absurdist nature of what he was doing: "Fantasy was set no limits and the collective play, the 'working' stages of which were recorded by Miloš Koreček, the play without a screenplay, without a prearranged plan, with props picked up randomly, developed, verging on the absurd."[38]

Man Ray's fascination with photographing *mise en scènes* is not confined to one period, but seems to have surfaced sporadically throughout his career. Like Depero, Witkiewicz, and Zykmund, he favoured spontaneously generated ideas for tableaux vivants, using a minimum of props and emphasizing the ludic and outrageous aspects of his actions. His practice of dressing up for the camera was also not restricted to his Surrealist years. Throughout the 1920s he photographed himself in

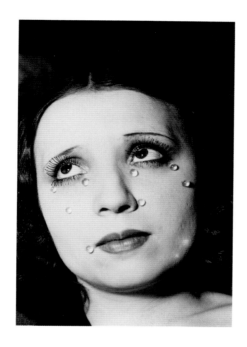

Fig. 109
Man Ray, *Les larmes* (*Tears*),
1932, work print, gelatin silver.
Centre Pompidou, Paris,
Musée national d'art moderne/
Centre de création industrielle
(AM 1994-394 [2263])

Fig. 110
Man Ray, *Larmes* (*Tears*),
1930–1933, gelatin silver
print. J. Paul Getty Museum,
Los Angeles (84.XM.230.2)

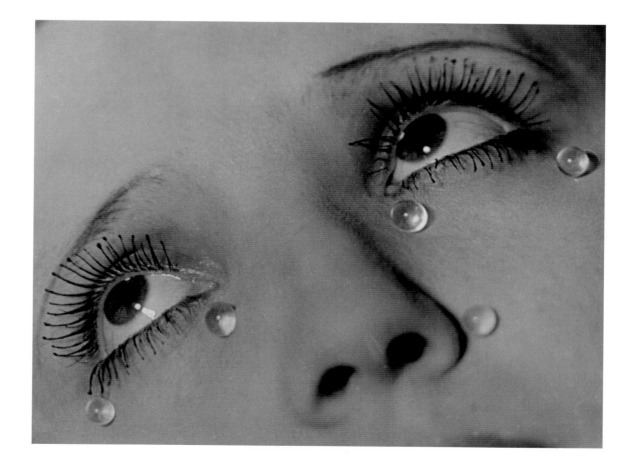

costume – often as an Oriental potentate – and his female friends Kiki and the photographer Lee Miller in exotic Middle Eastern outfits. In the 1940s he and his wife, Juliette, along with Max Ernst and Dorothy Tanning, posed for the camera wearing elaborate costumes. With the exception of his 1930 photograph of the "mock-Classical" tableau struck in the garden by some of the guests attending the White Ball of the Count and Countess Pecci-Blunt (fig. 105), Man Ray's photographs of the various costume parties thrown by the Noailles and other well-to-do Parisian families never transcended the level of mere documentation. *The White Ball of the Count and Countess Pecci-Blunt*, however, would have humbled both Mortensen and Kells.

The earliest evidence of Man Ray's fabricating an event for photography appears in his collaborations with Marcel Duchamp. Duchamp arrived in New York in 1915 and shortly afterward was introduced to Man Ray by Walter Arensberg, marking the beginning of a lifelong friendship. Man Ray began to work in photography at this time,[39] although it would become an important part of his practice only at the end of the decade and into the early 1920s. He not only photographed some of Duchamp's paintings[40] but also entered into a playful and sometimes iconoclastic partnership in which Duchamp transformed his own appearance (by shaving his head or donning women's attire, for example) while Man Ray documented these transformations with his camera. *Rrose Sélavy* (fig. 5), the celebrated portrait of Duchamp enacting his fictitious alter ego (the eponymous Rrose Sélavy), is a statement about art and modes of representation as much as it is about gender and identity.

In 1923 or 1924 Man Ray made a series of photographs of Duchamp lathering his face and hair with shaving cream and creating coifs, goatees, and horns out of the foam. The somewhat demonic image of Duchamp with his hair shaped into ram's horns was selected from the series to appear in one of his lithographed prints, *Monte Carlo Bond* (fig. 106), a whimsical but layered commentary on art, economics, and identity. Besides the photograph, other emblematic elements in this work reflect Duchamp's interest in elements of chance, including random numbers, and in word play.[41] The signature of Rrose Sélavy also appears on the bond.

Apart from his collaborative work with Duchamp, two photographs by Man Ray are of particular

importance to the theme under consideration: *Self-Portrait – Suicide* (fig. 107) and *Érotique voilée* (fig. 108).

The theme of suicide in Man Ray's work goes back to an aerograph (airbrush painting) he made in 1917, itself titled *Suicide*.[42] According to Arturo Schwarz, Man Ray was so depressed at the critical reception of his first two exhibitions (in 1915 and 1917) at the Daniel Gallery in New York that he was contemplating the idea of suicide. His planned modus operandi for this event resembled a blueprint for an art happening. Placing *Suicide* in front of him on an easel, and behind it a gun with a string attached to the trigger, it was the artist's intention to pull the string, thus releasing the trigger and hence the bullet, which would penetrate first the painting and then his body.[43] Man Ray abandoned these plans because he had no desire to give the critics of his airbrush painting technique the satisfaction of condemning his suicide in the very same terms that they attacked his art: "I thought that I'd be accused of committing suicide with a mechanical instrument. You know, when I began painting with the airbrush I had already been accused of debasing art by painting with a mechanical instrument."[44]

In 1924, three years after having settled in Paris, Man Ray was invited, along with several other Surrealists, to respond to an article by André Breton addressing the pros and cons of suicide. The article and the responses were to be published in the second issue of *La Révolution surréaliste*. Man Ray's contribution was a photographic reproduction of the painting *Suicide*, which was duly published as an illustration to the article. Over the next five to seven years, Man Ray continued to be preoccupied with the subject, making several humorously macabre staged photographs of himself surrounded by the paraphernalia of a contemplated suicide (noose, guns, razors, and poison) and various models in equally melodramatic poses. It has been suggested that some of the images of this type dating from 1932 "spoofed his desperation" at Lee Miller's leaving him.[45] Katherine Ware speculates that *Tears* (see figs. 109 and 110) might also have been created out of the same mood of ironic despair over Miller's departure.[46]

One image, *Érotique voilée*, was selected to illustrate André Breton's article "La Beauté sera convulsive," which appeared in the 1934 issue of *Minotaure*. It came from a group of several photographs

Fig. 114
Herbert Bayer, *Knight with Flowers*, 1930, printed later, gelatin silver print. National Gallery of Canada, Ottawa (29158)

Fig. 115
Edward Weston, *Civilian
Defense*, 1942, printed before
July 1969, gelatin silver print.
National Gallery of Canada,
Ottawa (33671)

MODERNITY AND THE STAGED PHOTOGRAPH ANN THOMAS 119

Fig. 116
Edward Steichen, *Lillian Gish as Ophelia*, 1936?, gelatin silver print. National Gallery of Canada, Ottawa, Edward Steichen Bequest by direction of Joanna T. Steichen, New York, and the George Eastman House, Rochester, 1985 (28931)

Fig. 117
Eikoh Hosoe, *Killed by Roses, no. 34*, 1962, gelatin silver print. National Gallery of Canada, Ottawa (22846.34)

showing the artists Meret Oppenheim and Louis Marcoussis posed individually and together next to Marcoussis's printing press in his studio. (A Cubist painter well known in Paris and Berlin, Marcoussis had donned a false beard for this series of *mise en scène* photographs.) *Érotique voilée* is an enigmatic image from a body of work that appears to have been created in a spirit of inspired mystification. As Philippe Sers observed: "The atmosphere in these photographs is evocative of some unknown event, the meaning of which we are unable to grasp. And the ambiguous title gives free rein to our imagination."[47] Interpreted variously as an encounter between the "machine célibataire and the female body"[48] and a contrapuntal celebration of the "play of the intellect in relation to the body,"[49] *Érotique voilée*, with its juxtaposition of the vulnerability of human flesh and the indomitable strength of the machine, met Breton's desire that art produce sensations of "physical disturbance" and "erotic pleasure."[50]

Elaborately staged images such as *Érotique voilée* and *Self-Portrait – Suicide* are more typical of the Surrealist movement than of the other art movements of the period. The Surrealists were attracted to the tableau vivant because it allowed them to explore dream and fantasy imagery as well as narrative sequencing, but most of the Modernist movements were resistant to it.

A somewhat different kind of staged photograph came to prominence in the context of the Bauhaus movement. The Bauhaus school epitomized the Modernist urge to transcend past conventions and find new means of expression. In spite of its interdisciplinary program of theatre, dance, and music, which might have been expected to generate integrated modes of expression such as the staged photograph, the genre is almost non-existent within the practice of the photographers and artists associated with this influential school. Photographs of Bauhaus theatrical performances, while of some importance to the present theme, are products of a documentary interest rather than of an event that was staged in order to be photographed. According to Gisela Barche, the Bauhaus sought more publicity after 1923, when Oskar Schlemmer assumed the directorship of the theatre program.[51] Photography became the medium of recording the performances, often with a photocall at the end of each act, for which "all lanterns were specially focused and turned up to a high level." There were also sessions during which "actors or dancers posed, often in large groups, falsifying the events of the play."[52] T. Lux Feininger was probably the most active documenter of Bauhaus events, photographing, among other productions, Oskar Schlemmer's *Das triadische Ballett* (1922) and the *Musikalischer Clown* (1927).

Perhaps even more pertinent to the theme of the staged photograph is Feininger's *Self-Portrait as Charlie Chaplin*, in which he appears in front of a mirror dressed as the famous comedian (fig. 111). The idea of presenting oneself as a clown, or indeed of masquerading in any form, fascinated many European painters and photographers working in the period between the wars. The clown as self-parodying figure, social commentator, and source of laughter seems to have particularly appealed to the Bauhauslers.[53] Charlie Chaplin captured the imagination of many artists of this generation, including Pablo Picasso, and was probably the most revered comic figure of the day.

The German Modernist photographer Werner Rohde, who shared the Bauhaus aesthetic ideology and worked in a style reminiscent of the New Vision, also play-acted before the camera. Rohde began his artistic career as a painter, making self-portraits during the early 1920s. In 1925 he registered at the Kunstgewerbeschule in Burg, and his first photographic work dates from about a year later. At the beginning of 1928 Rohde took the initial photograph in the series *Porträtfoto*. Among the three portraits in the group that represented his work at *Film und Foto*, the 1929 landmark Modernist photography exhibition in Stuttgart, was *Self-Portrait with Mask* (fig. 112), in which Rohde represents himself as a carnivalesque or Pierrot figure. Equally significant is Rohde's posing for the photographer Marianne Breslauer in his hotel room dressed as Vincent van Gogh's *Père Tanguy* (fig. 113), in homage to a painting he greatly admired. The close friendship he developed with Breslauer, who was part of Man Ray's circle, seems to have spurred him on to explore the boundaries of the portrait and attendant questions of identity. He is also thought to have started his series of self-portraits as a clown during the period he spent in Paris between 1929 and 1932.

The Bauhaus student and teacher Herbert Bayer took a mocking look at the knight in shining armour when he staged a photograph of Friedrich Vordemberge-Gildewart wearing a medieval soldier's visor in *Knight with Flowers* (fig. 114). The occasion for the making of this playful image was a visit by Feininger, in the company of other artists, to a castle in Switzerland owned by the art lover and patron Madame de Mandrot. There is no evidence that Bayer became seriously interested in the staged photograph as a means of expression, and one can see *Knight with Flowers* only as an inspired one-off, made spontaneously with objects that were readily to hand.[54]

Similarly, Edward Weston's *Civilian Defense* (fig. 115), which shows his lover Charis wearing a gas mask, is an exception in the photographer's work from this period. In spite of the Pictorialist style of his early photographs, Weston was appreciated above all for his adherence to the principles of straight photography, a prevailing photographic aesthetic in the United States in the 1920s through the 1940s that favoured a direct and "pure" capture of the world. Seen in this context, the staging of *Civilian Defense* represents an intriguing and anomalous act of dissent. The image of Charis lying stretched out on a couch, naked but for the gas mask covering her face, owes much to Weston's awareness of Surrealism. Underscoring the absurdist, grotesque, and dehumanizing aspects of life under wartime conditions, and perhaps prompted by Weston's somewhat bitter and macabre mood, this series of staged photographs created a stir among the members of the photographic community.

Before leaving the realm of art photography and moving to the role of the staged photograph in advertising and photojournalism, it is important to look at the body of work by Eikoh Hosoe, a Japanese photographer responsible for creating several staged and sequenced series of tableau photographs that were then compiled in portfolio and book form. *Killed by Roses*, published in Japan in 1963, is one of Hosoe's most noteworthy productions. Characterized by an intense theatricality and commitment to narrative, it is the most elaborately staged of all his works, furnished with a wealth of props, backdrops, and models. The central model is the controversial Japanese writer Yukio Mishima, who ended his life in a well-publicized act of ritual suicide, or *seppuku*, in 1970. In Hosoe's view of his own craft, "the studio is the stage and the photographer is the director."[55] The theatrical performance undertaken for this body of work combined the "erotic pleasure" and "physically disturbing" tenets of Surrealist art decreed by Breton. An intense collaboration between photographer and subject, the sequences in *Killed by Roses* centre on the national and sexual identity of the principal model. Mishima selected props that reflected his fascination with Italian Renaissance paintings of Saint Sebastian and with the symbol of the Japanese nation, the sun. This was not the only time that Mishima participated in the making of tableaux vivants for a photographer. They were clearly a vehicle for the expression of his vivid fantasies and self-destructive plans. He initiated a similar collaboration with the Japanese photographer Kishin Shinoyama, in which he posed in a series of mock death scenes two months before his suicide; the sequence was titled *Death of a Man*. In the preface to *Ordeal by Roses*, the 1971 revised edition of *Killed by Roses*, Mishima discusses the new arrangement and sequence of the photographs, pointing out that in the chapter "Dreams and Death" the model "appears in Renaissance pictures and plays

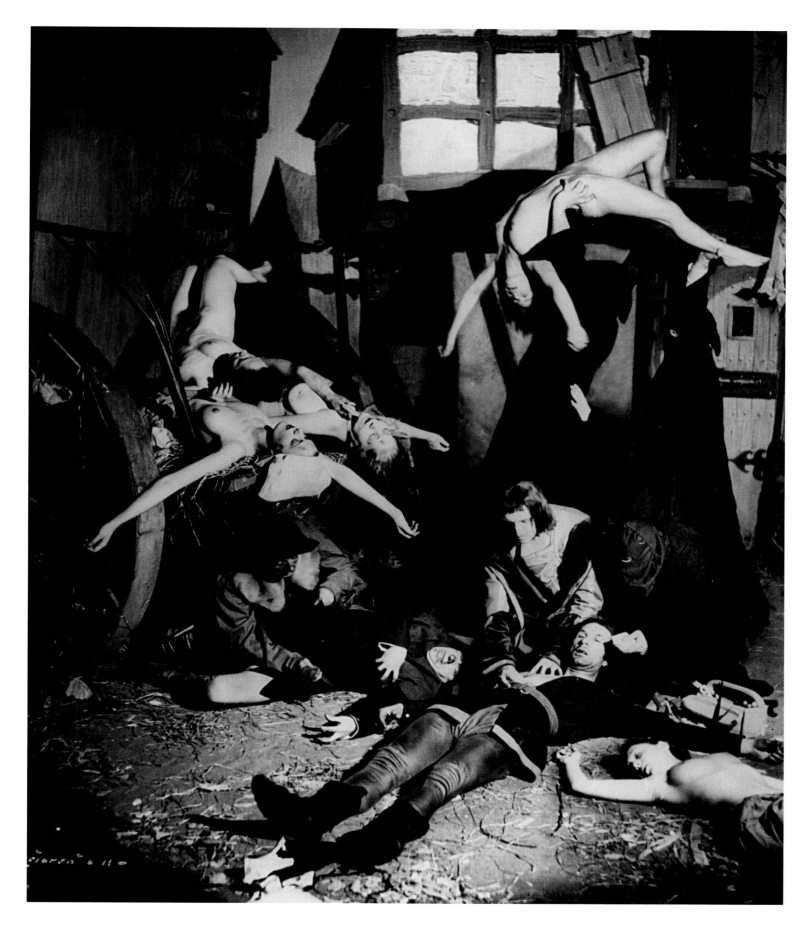

Fig. 119
Robert Capa, *Spain*,
5 September 1936, gelatin silver
print. National Gallery of Canada,
Ottawa (21305)

Fig. 120
Evgeny Khaldei, *Victory Flag
over the Reichstag, Berlin*,
1945, gelatin silver print. George
Eastman House, Rochester,
Museum Purchase, Ford Motor
Co. Fund (1996:0359:0004)

Fig. 121
Lee Miller, *Henry Moore
at Holborn Underground Station*,
re-creation for the filming of
Out of Chaos, London, 1943,
gelatin silver print. Lee Miller
Archives, England

with many historic and mythic images like a shadow
in a time-machine." The image shows Mishima leaning
against a tree trunk, his arms behind his back in a pose
traditionally associated with Saint Sebastian (fig. 117).

ADVERTISING PHOTOGRAPHY

The advertising industry borrowed a number of
picture-making strategies from the world of art in
the 1920s and 1930s, including photomontage and
photocollage, extreme perspectives, the narrative
tableau, and the transformation of objects into striking
near-abstract patterns. As the technology for taking
photographs and reproducing them continued to
advance, advertising became increasingly reliant on
photography for its images,[56] prompting the observation,
in 1929, that the importance of photographs "is steadily
growing, and it is impossible to say what may come
from the use of photographs in the future. However,
it is obvious that they have added much to advertising
on the side of truth and verisimilitude, and it is difficult

to foresee any limit to the good that may result from
their increased use."[57]

This idea that the photograph represented "truth
and verisimilitude" made it an alluring choice of medium
for advertising.[58] Its seductive crispness and illusionistic
quality in conjunction with the narrative tableau
permitted the creation of a complete visual scenario in
which consumer objects and life-style references could
be inserted. Readers of advertisements would be able to
project their own dreams and hopes into these apparently
ideal set-ups. In addition, the photograph wielded
authority simply by virtue of its supposed neutrality.

Although Edward Steichen is primarily
recognized for his contributions to art photography
in the early decades of the twentieth century, he, along
with the American photographers Paul Outerbridge,
Jr., Lejaren A. Hiller, and Ralph Bartholomew, Jr.,
occasionally also resorted to set-ups and the use of
models both in the studio and in *plein air*, with theatrical
lighting and often with the kinds of gestures reminiscent
of silent films.[59] Both Steichen and Hiller had experience
in film and the theatre, which gave them a certain
familiarity with choreographing dramatic groupings
and directing expressive gestures. Having also worked

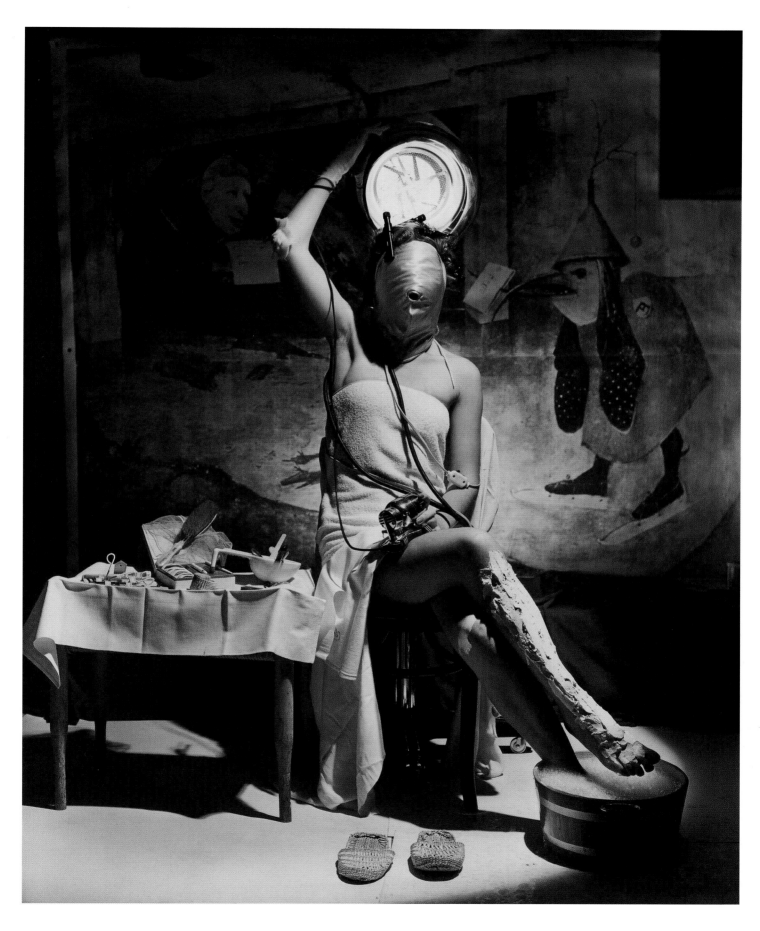

for *Vanity Fair*, *Vogue*, and the J. Walter Thompson Agency, Steichen developed a strong interest in the directorial approach to photography; according to his widow, Joanna Steichen, he once considered a career as a film director.[60] His photograph of Lillian Gish as Ophelia (fig. 116) was not, as might be thought, part of a commission, but was done in the context of Steichen's personal creative work and staged on the edge of a pond at his country home. As Steichen would later recall: "We had talked about the moment, described in *Hamlet*, when Ophelia 'fell in the weeping brook' and drowned.... The success of the picture lay in Miss Gish's performance. From the moment she stepped to the edge of the pond and grasped the trailing branch of the willow tree, she was no longer Lillian Gish. She had become Ophelia, 'a document in madness.'"[61]

The obviousness of the staging of Outerbridge's *The Coffee Drinkers* (fig. 3) and Hiller's *Étienne Gourmelen* (fig. 118) seems to have exempted these works from charges of trickery. Seduced by photography's effectiveness, one advertising executive went so far as to describe a tableau photograph made by Steichen in 1928 promoting Fleischmann's yeast as "thoroughly honest."[62]

It was not only the pictorial styles of modern art and photography that inspired photographers working in the advertising industry; often they were attracted to specific artworks that they incorporated in their set-ups. In 1939, the year that the Second World War began in Europe, the German fashion photographer Horst P. Horst made *Electric Beauty* (fig. 122). This striking image shows a seated woman undergoing a beauty treatment, her face covered by a heat mask with one small breathing hole. Electrical cords snake around her entire body, while she holds an electric nail buffer in one hand and steadies the overhead lamp with the other. One leg is lathered with hair-removing cream while her other foot rests in a tub of soapsuds. The analogy with the figures who animate the backdrop, a detail from Hieronymus Bosch's painting *The Temptation of Saint Anthony*, is not all that far-fetched.

If in art photography truthfulness was seen to be a matter of fidelity to the nature of the medium (that is, looking like a photograph rather than a painting), in advertising photography it had to do with adherence to the visual facts (whether faked or staged) of the scenes, figures, and objects in front of the lens. Photojournalism was an entirely different matter, with truthfulness predicated on the representation of events as they occurred in reality. As far as the news industry was concerned, the issues of truth to medium, pictorial integrity, and technical fidelity paled in their ethical dimension when considered in relation to the journalistic requirement to represent the world as it was. Even the smallest degree of editorial or directorial intervention in reporting on an event could cast doubt on the credibility of the newspaper or magazine. Yet this desire to make the photograph communicate an effectively dramatic story at the cost of accuracy and truth is, paradoxically, almost as old as the medium itself, beginning with the rearranging of corpses in the American Civil War. Arthur Rothstein's *Steer Skull, Badlands* (1936), Robert Capa's *Spain* (fig. 119), Joe Rosenthal's *Raising the Flag on Iwo Jima* (1945), and Evgeny Khaldei's[63] *Victory Flag over the Reichstag, Berlin* (fig. 120) are well-known examples from the twentieth century that are considered in every discussion of photojournalistic ethics. Lee Miller's haunting image of Henry Moore sketching a grim scene of people huddled in the London Underground at Holborn station during the Second World War (fig. 121), while less often discussed in this context, is a fascinating example of a photograph made of a re-created scene. Often taken to be a depiction of an actual event during an air raid, it is in reality a "location shot" made during a restaging of the event for Jill Craigie's film *Out of Chaos*.[64]

As antithetical as the posed photograph may have been to the principles of photojournalism, there have been moments when actual events inspired photographers to intervene and create images that are more about picture-making than they are actual photo reportage. Three examples of works that enjoy an ambivalent relationship to photojournalism because of their use of models as primary subjects and their emphasis on pictorial arrangement are Weegee's *The Critic*, Robert Doisneau's *The Kiss at the Hôtel de Ville*, and Ruth Orkin's *American Girl in Italy*.

In November 1943 Weegee photographed Mrs. George Washington Kavanaugh and her friend Lady Decies (Elizabeth Drexel) on their way in to a festive opening night at the Metropolitan Opera (fig. 123). The two ladies, wearing fur capes and diamond tiaras, are seen gazing confidently toward the camera, oblivious to the presence of the dishevelled and shabbily dressed woman just beside them. Originally published in *Life* magazine

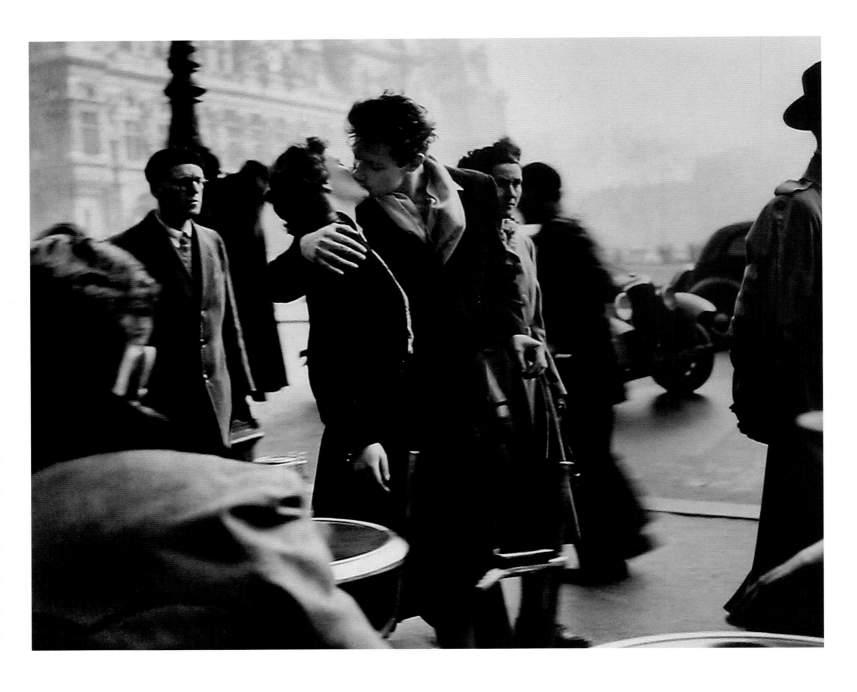

Fig. 124
Robert Doisneau, *The Kiss at the Hôtel de Ville* (*The Kiss on the Sidewalk*), 1950, gelatin silver print. Ackland Art Museum, University of North Carolina at Chapel Hill, Gift of William A. Hall, III (81.63.1.2)

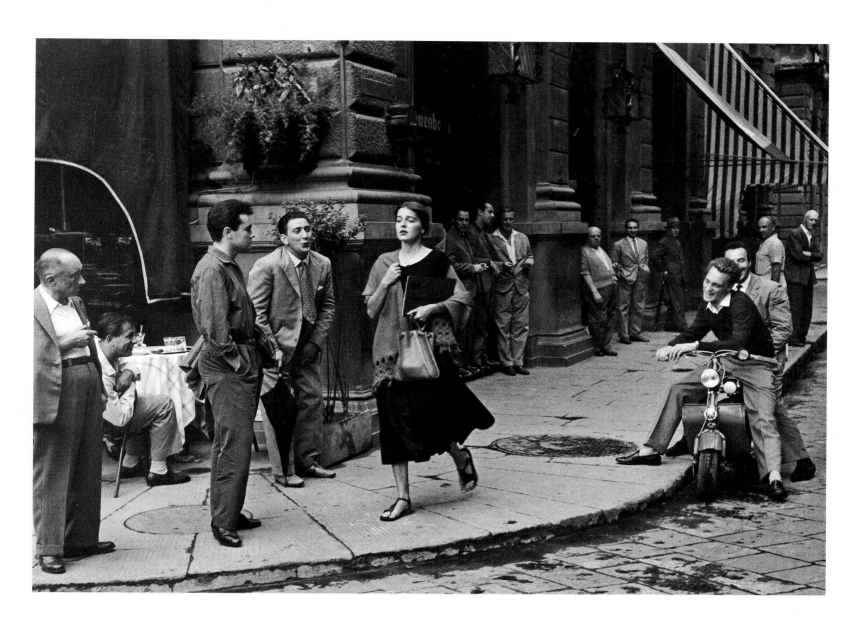

Fig. 125
Ruth Orkin, *American Girl in Italy*, 1951, gelatin silver print. Collection of Alan and Susan Solomont, Newton, Mass.

on 6 December 1943 (with the caption "The Fashionable People"), the photograph seems to record a completely fortuitous crossing of paths, a near-encounter of fabulously rich socialites and one of "the plain people," as Weegee called them. It was only later that Weegee's assistant, Louie Liotta, revealed that the scene captured in the photograph was not exactly the product of chance. Liotta was sent by Weegee to pick up one of the regulars at Sammy's Bar in the Bowery, offer her all the cheap wine she could drink, and then propel her in front of the entrance to the Opera at just the right moment. Weegee, for his part, liked to keep up the illusion, always claiming that he had not even noticed the woman at the side of the frame until after he had developed the film.[65]

Robert Doisneau's *The Kiss at the Hôtel de Ville* (fig. 124) is a celebrated example of a photograph that was thought to have spontaneously captured a passing moment of Parisian street life, with all of its stereotypical connotations. The scene is now known to have been directed by the photographer and posed for by two professional models. As Peter Hamilton notes: "For Robert this image was only one of several successful *mise en scènes* made for the *Life* assignment of early 1950.... As many as fourteen or fifteen [couples] presented themselves as *les amoureux* between 1985 and 1992, and Robert found himself unable to disabuse those for whom the illusion of their presence in this now omnipresent image was overwhelming."[66] These two photographs, with their strong graphic appeal and universal story-telling powers, have found appreciative audiences in the spheres of both art photography and photojournalism, underscoring the precariousness of the boundaries that ostensibly separate the two practices. In this respect, Mortensen's observation of the difference between a "picture of drama" and a "dramatic picture" takes on a particular relevance.

American Girl in Italy (fig. 125) is a partial *mise en scène* that Ruth Orkin created in 1951 while travelling in Italy. She had asked a young art student who was staying at her hotel in Florence to play the role of a woman travelling alone, for a photograph she hoped to sell to a magazine.[67] The vivid tableau inadvertently struck by a group of males standing near a corner of the Piazza della Repubblica became the iconic image *American Girl in Italy*. It was published the following year as part of a picture story in *Cosmopolitan* titled "When You Travel Alone."[68]

Both advertising photography and photojournalism of the 1920s and 1930s were quick to recognize the allegorical and narrative potential of the staged photograph, exploiting its seductive powers in order to sell their wares or their stories. As a practice that entered into the Modernist aesthetic through a side door, staged photography had its origins in an earlier period, when greater emphasis was placed on narrative structures in picture-making. How then can we account for its penetration into the vocabulary of such prominent avant-garde photographers as Depero, Witkiewicz, Zykmund, Man Ray, and Claude Cahun, as well as into the syntax of Modernist advertising photographers?

As has already been suggested, the first half of the twentieth century witnessed a desire on the part of photographers as well as painters to expand the language of picture-making, a phenomenon that would explain in part the receptivity to transforming an accepted genre. Film-making, too, with its production of stills and location shots, in addition to its emphasis on narrative structure, undoubtedly played a significant role in assuring the revitalization of the genre. Even if the mannered imagery of William Mortensen, Harold Kells, Madame Yevonde, and other photographers who turned to scenes from Classical mythology to choreograph their elaborate tableaux contradicts the spirit of Modernism, it took the genre and its narrative potential to a level of theatricality that had not been seen before. More significant, however, is the influence that the staged photograph has exerted on contemporary practice, in which the tableau photograph has commanded a great deal of critical attention, with particular scholarly notice directed at the intriguing intersections between such artists as Claude Cahun and Cindy Sherman. While Modernism is most often associated with more radical departures into the fields of abstraction and Surrealist imagery, Man Ray's staged portraits of Duchamp as Rrose Sélavy and Cahun's series of self-portraits spawned an interest in the photograph not simply as a record of the external world but also as a purveyor of personal insights and private realities. The Postmodernist revival of the tableau vivant, seen in the works of Cindy Sherman, Jeff Wall, Gregory Crewdson, and many other contemporary practitioners, is a complex response to the history of art from the mid-nineteenth century, including the Modernist forays into the staged photograph.

NOTES

1 Louis Aragon, "The Quarrel over Realism," in *Photography in the Modern Era: European Documents and Critical Writings, 1913–1940*, ed. Christopher Phillips (New York: Metropolitan Museum of Art/ Aperture, 1989), p. 73.

2 Raoul Hausmann and Werner Gräff, "How Does the Photographer See?" in Phillips, *Photography in the Modern Era*, p. 202.

3 Barbara L. Michaels, *Gertrude Käsebier: The Photographer and Her Photographs* (New York: Harry N. Abrams, 1992), p. 82.

4 Ibid., p. 55.

5 Ibid., p. 56.

6 Estelle Jussim, *Slave to Beauty: The Eccentric Life and Controversial Career of F. Holland Day, Photographer, Publisher, Aesthete* (Boston: David R. Godine, 1981), p. 88.

7 Jussim (ibid., p. 6) cites Guido Reni, Mantegna, Rembrandt, Hans Holbein, Velázquez, and Whistler as the important influences on Day in the construction of his tableau photographs.

8 Ibid., p. 7.

9 Quoted ibid., p. 100.

10 A.D. Coleman, "Disappearing Act: Photographs by William Mortensen," *CameraArts* 2, no. 1 (January–February 1982), p. 38.

11 Mortensen's life and career are discussed in detail in Michael Dawson et al., *William Mortensen: A Revival* (Tucson: Center for Creative Photography, University of Arizona, 1998).

12 William Mortensen, *The Model: A Book on the Problems of Posing* (San Francisco: Camera Craft, 1948), p. 171.

13 Ibid.

14 László Moholy-Nagy, *Painting, Photography, Film*, trans. Janet Seligman (Cambridge, Mass.: MIT Press; London: Lund Humphries, 1969), p. 96.

15 William Mortensen, *The Female Figure: Flesh and Symbol* (Newport Beach, Calif.: J. Curtis Publications, 1954), p. 10.

16 Mortensen, *The Model*, p. 178.

17 Ibid., p. 16.

18 Ibid., p. 17.

19 Ibid., p. 173.

20 Ibid., pp. 137–138.

21 Ibid., p. 141.

22 Coleman ("Disappearing Act," p. 38) notes that among the films that Mortensen worked on as a stills photographer was Cecil B. DeMille's *The King of Kings* (1927).

23 Joan M. Schwartz, "Kells, Harold Frederick," in *Private Realms of Light: Amateur Photography in Canada 1839–1940*, ed. Lilly Koltun (Markham: Fitzhenry & Whiteside, 1984), p. 316.

24 C.J. Symes, "Photograms of the Year," in *Photograms of the Year 1934–5*, ed. F.J. Mortimer (London: Iliffe & Sons, 1935), pp. 9–10.

25 Lawrence N. Hole, *The Goddesses: Portraits by Madame Yevonde* (Seattle: Darling, 2000), unpaginated.

26 Giovanni Lista, *Futurism and Photography* (London: Merrell, in association with Estorick Collection of Modern Italian Art, 2001), p. 34.

27 This genre of photographic practice continued throughout the twentieth century. Urs Lüthi, Hermann Nitsch, and Dieter Appelt figure among the artists who elected to document their performances with photography.

28 Lista, *Futurism and Photography*, p. 11.

29 Stefan Okołowicz, "Metaphysical Portraits," in *Witkacy: Metaphysische/Metaphysical Portraits*, ed. T.O. Immisch, Klaus E. Göltz, and Ulrich Pohlmann (Leipzig: Connewitzer Verlag, 1997), p. 26.

30 Ibid., p. 48.

31 Ibid., p. 46.

32 Okołowicz, in *Witkacy*, p. 48. "Thanks to the discovery of the collection of 35-millimeter film negatives of these photos we can now reconstruct the order in which successive 'Faces' were achieved. The documentary material also suggests that they were not exactly planned beforehand, but rather invented spontaneously, on the spur of the moment.... The atmosphere of these sessions helped to provoke new ideas, prompting all participants to invent the most absurd situations. While nonsensical and funny for their own sake, the moment they were registered by the camera, the humorous scenes were turned into artistic facts. At one such session as many as 37 photos were taken, the series ending with two pictures of Witkacy, entitled *Tovarich Pyeresmyerdloff observing an execution of Mensheviks*, and *Lord Fitzpur's best smile at the races at Southampton*, with the following annotation: 'Asia and Europe, Barbarity and Civilisation.'"

33 Antonin Dufek, "Václav Zykmund," in *Václav Zykmund: Fotografie 1933–1945 Photographs*, ed. Suzanne Pastor (Prague: Prague House of Photography, 1993), p. 9.

34 Ibid., p. 11

35 Jaroslav Anděl et al., *Czech Modernism, 1900–1945* (Houston: Museum of Fine Arts; Boston: Bulfinch Press, 1989), p. 137.

36 *Relâche* is a tableau vivant in the truest sense, in that it was an enactment by Duchamp of Cranach's painting *Adam and Eve*. Both the Man Ray photograph of Duchamp and Perlmutter and the interlude *Relâche* are sometimes titled *Ciné-Sketch*.

37 Václav Zykmund, "Actions," in Pastor, *Václav Zykmund*, p. 21.

38 Ibid.

39 Carl Belz, "Man Ray and New York Dada," *Art Journal* 23, no. 3 (Spring 1964), p. 208.

40 Edward Leffingwell notes that Man Ray photographed Duchamp's *The King and Queen Surrounded by Swift Nudes* (1912) and *Nude Descending the Staircase* (c. 1919–1920) in 1920 ("Marcel Duchamp/Man Ray at Sean Kelly," *Art in America* 88, no. 4 [April 2000], pp. 153–154).

41 *Monte Carlo Bond* was originally made as a collage to be printed as a bond in an issue of thirty copies. See Robert Lebel, *Marcel Duchamp*, trans. George Heard Hamilton (New York: Paragraphic Books, 1967), p. 50.

42 Merry Foresta et al., *Perpetual Motif: The Art of Man Ray* (Washington, D.C.: National Museum of American Art, Smithsonian Institution; New York: Abbeville Press, 1988), pp. 74, 85–86. The original title of the aerograph was *The Theatre of the Soul*. See Francis M. Naumann, *Conversion to Modernism: The Early Work of Man Ray* (New Brunswick, N.J.: Rutgers University Press, 2003), p. 184.

43 Arturo Schwarz, *The Rigour of Imagination: Man Ray* (London: Thames & Hudson; New York: Rizzoli, 1977), p. 40. Naumann (*Conversion to Modernism*, p. 186) contends that the idea of using this work to play a part in his suicide did not occur to Man Ray until the mid-1920s and was not contemporary with its making. Precisely when the aerograph was re-titled is not known.

44 Cited by Schwarz in *The Rigour of Imagination*, p. 40. Naumann (*Conversion to Modernism*, p. 186) speculates that the aerograph might well have been renamed by Man Ray following the devastating reviews his work received in 1917.

45 Janine Mileaf, "Between You and Me: Man Ray's *Object to Be Destroyed*," *Art Journal* 63, no. 1 (Spring 2004), p. 12. Mileaf notes that Antony Penrose, Miller's son, confirmed Man Ray's interest in suicide during this period and his apparent possession of a pistol at the time that Miller left him (p. 12, note 33).

46 Katherine Ware, *Man Ray: Photographs from the J. Paul Getty Museum* (Los Angeles: J. Paul Getty Museum, 1998), p. 56.

47 Philippe Sers, "Man Ray and the Avant-garde," in *Man Ray: Photographs* (London and New York: Thames & Hudson, 1982), p. 12.

48 Renée Riese Hubert, "From *Déjeuner en fourrure* to Caroline: Meret Oppenheim's Chronicle of Surrealism," in *Surrealism and Women*, ed. Mary Ann Caws, Rudolf E. Kuenzli, and Gwen Raaberg (Cambridge, Mass.: MIT Press, 1991), p. 41.

49 Mary Ann Caws, "Ladies Shot and Painted: Female Embodiment in Surrealist Art," in *The Female Body in Western Culture: Contemporary Perspectives*, ed. Susan Rubin Suleiman (Cambridge, Mass.: Harvard University Press, 1986), p. 275.

50 "Mad Love," in André Breton, *What Is Surrealism? Selected Writings*, ed. Franklin Rosemont (New York: Monad; London: Pluto Press, 1978), p. 160.

51 Gisela Barche, "The Photographic Staging of the Image – On Stage Photography at the Bauhaus," in *Photography at the Bauhaus*, ed. Jeannine Fiedler (Cambridge, Mass.: MIT Press; London: Dirk Nishen, 1990), p. 239.

52 Ibid.

53 Oskar Schlemmer is known to have enjoyed seeing Chaplin's film *The Circus* in Berlin in 1928.

54 Swann Galleries, *Important Nineteenth and Twentieth Century Photographs, Sale 1947*, 21 October 2002, unpaginated.

55 Darwin Marable, "Eikoh Hosoe: An Interview," *History of Photography* 24, no. 1 (Spring 2000), p. 86.

56 For an expanded discussion of this topic, see Robert A. Sobieszek, *The Art of Persuasion: A History of Advertising Photography* (New York: Harry N. Abrams, 1988), p. 33.

57 Leonard A. Williams, *Illustrative Photography in Advertising* (San Francisco: Camera Craft, 1929), p. 9.

58 "To attract the purchasing power of the growing and increasingly affluent postwar consumer market, advertising turned more and more toward depicting what have been called 'life-style' ads.... The fundamental aspect of such ads is the fact that they are overwhelmingly pictorial" (Sobieszek, *The Art of Persuasion*, p. 100).

59 Patricia Johnston, *Real Fantasies: Edward Steichen's Advertising Photography* (Berkeley: University of California Press, 1997), p. 86.

60 Joanna Steichen, ed., *Steichen's Legacy: Photographs, 1895–1973* (New York: Alfred A. Knopf; London: W.H. Allen, 2000), p. 285.

61 Edward Steichen, *A Life in Photography* (Garden City, N.Y.: Doubleday, in collaboration with the Museum of Modern Art, 1963), unpaginated.

62 "Even obviously staged photographs qualified as realistic. Although Steichen's photograph of happy picnickers eating cakes made with Fleischmann's yeast seems theatrical today, Gordon Aymar labeled it a 'thoroughly honest use of photography' in his textbook of graphic design. 'Here are all the inherent virtues of the camera – a scene recorded instantaneously, completely, without effort and without retouching. A remarkable piece of stage direction in which four separate individuals have been simultaneously infected with the occasion.' 'Stage direction' did not undercut the 'honest use of photography,' and obvious artifice never negated the photograph's 'realism'" (Johnston, *Real Fantasies*, p. 88).

63 Khaldei was a Soviet photojournalist who documented some of the most important moments of the Second World War from a Soviet perspective.

64 Antony Penrose, *The Lives of Lee Miller* (London: Thames & Hudson, 1988), p. 110.

65 See Miles Barth, ed., *Weegee's World* (Boston: Little, Brown, in association with the International Center of Photography, New York, 1997), pp. 26–28.

66 Peter Hamilton, *Robert Doisneau: A Photographer's Life* (New York and London: Abbeville Press, 1995), p. 354.

67 See Shaun Considine, "Candid or Contrived? The Making of a Classic," *New York Times*, 30 April 1995; *Ruth Orkin: American Girl in Italy; The Making of a Classic* (New York: Howard Greenberg Gallery, 2005).

68 Emil Jay, "When You Travel Alone," *Cosmopolitan*, September 1952, pp. 30–34.

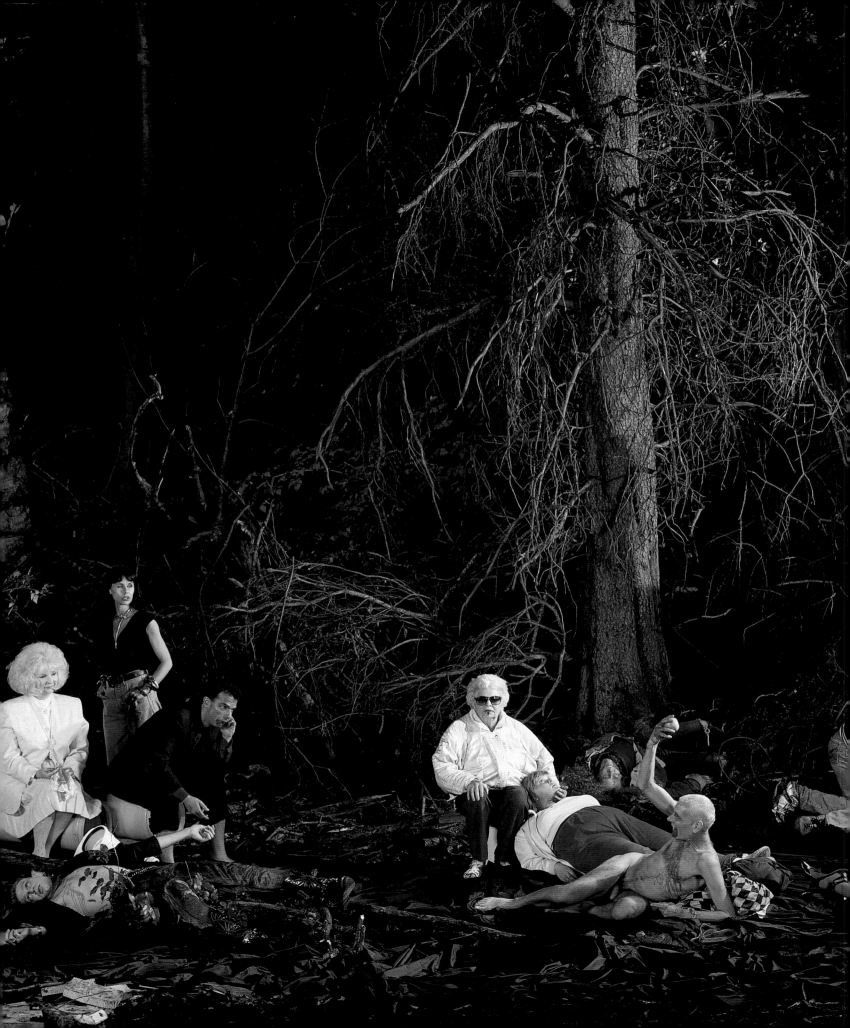

The Artful Disposition: Theatricality, Cinema, and Social Context in Contemporary Photography / KAREN HENRY

"ESSENCE MUST APPEAR," SAYS HEGEL, AND, IN THE REPRESENTED BODY, IT APPEARS AS A GESTURE WHICH KNOWS ITSELF TO BE APPEARANCE.[2]

Self-consciousness and the feeling of acting, of drawing experience from a bank of ready-made emotions and politics or creating new personas for particular occasions, and the attendant uncertainty about all appearances, infuse everyday life. On this shifting ground, theatricality is a natural recourse that artists, whose métier is representation, have readily adopted. Photography, with its lingering association with reflecting reality, is aptly positioned in this milieu.

While theatrical tableaux have been a part of photographic practice from its inception, since the 1980s there has been a proliferation of artwork in which theatricality, and its particular relation to the cinematic, has become both a strategy and, inherently, a subject of the work. The "gesture which knows itself to be appearance" is a self-reflexive mirror that reveals the nature of contemporary

representation. Within this context, the best work is able to reach beyond its own artifice and remain relevant to social circumstances.

Theatricality has historically had a bad name. In Plato's *Republic*, any artistic representation was termed theatrical and considered a parasitic activity, associated with degeneracy.[3] After these inauspicious beginnings in Western culture, theatricality evolved to be an attribute of art, debated in relation to the purity of representation in capturing the essence of experience. In contemporary times, however, penetrating to the essence is complicated by the fact that theatricality has become a representation of itself. To be theatrical is to appear affected or artificial. Since the 1970s, photographic images have become self-consciously theatrical, using devices that make the viewer aware of the staging and of the subjects as actors before the camera. These devices range from subtle associations of elements or a too-perfect veneer that hints at the contrivance of the image to more obviously staged tableaux. The proliferation of cinematic and theatrical effects has become a new genre in which these self-conscious strategies free artists from the burden of photographic truth that defined the previous era. These staged photographs use theatricality as a device that has the potential to reflect on social experience. In an era when all photographic representation has become suspect, these fictions encourage an interrogation of the "truth" of representation.

The space of the theatrical includes technology — the lights, the cameras, the effects, and the projection of cinema, as well as the ubiquitous video surveillance that defines our times. One could argue that all social activity in contemporary society takes place in the realm of representation, in the eye of the camera. The "rationalized, manageable and productive subject"[4] that French philosopher Michel Foucault identified as constructed by industrial modernity is undermined by the degree of information and image saturation that permeates our lives. The socially constructed subject is more and more illusive. The early twenty-first century is marked by a flattening of the world into digital matrices, a picture plane without perspective, context, or depth. Images merge seamlessly, and forms of representation used for entertainment are the same as those used for the news: reality and fiction are in constant flux. The screen is the space in which we interact and

"perform" our everyday tasks, a framed feedback loop cycled through the infinite representations of "real" life: surveillance cameras, reality TV, home videos, nanny-cams, docudramas, chat rooms, Internet dating sites, and so on.

THE THEATRICAL DEBATE IN MODERNISM

In an influential debate about theatricality in art, Diderot, writing about genre painting in eighteenth-century France, defined tableau as the self-contained formal unity of a picture that captures the imminent potential of an instant in time. To convey the essence of the event depicted in Diderot's terms, an artwork needed to overcome the inherent theatricality of representation — defined by the separation of image and audience — in order to facilitate the absorption of the viewer within a shared understanding of a coherent social order. The socially relevant and therefore "authentic" image should be "witnessed by but not addressed to the spectator."[5] This was the sphere that Modernism entered a century later with the emblematic paintings of Manet. *Luncheon on the Grass* and *Olympia* (1863) and later *A Bar at the Folies-Bergère* (1882) not only took liberties with established practices of composition and subject matter, combining disparate elements and representing working women, but also addressed the viewer directly, as a unique individual. Manet's work is identified with the "rupture" of Modernism, the break from the traditional cultural authority of representation, and the point at which painting became self-conscious, acknowledging its own artifice. In so doing, it came to represent the fractured spaces and relations of industrialized culture.

In *Techniques of the Observer*, Jonathan Crary makes the case that painting had, in fact, considerably less cultural impact than has been ascribed to it. The change in perceptual modes occurred outside painting, encouraged by experiments in light and vision in the eighteenth century that became the basis of the new sciences of physics and psychology. These experiments also precipitated the development of photography and cinema. The nature of social subjectivity changed during

Fig. 127
Jeff Wall, *Young Workers*,
1978–1983, transparencies
in light boxes. Emanuel
Hoffman Foundation, Basel

this period from what had been a situated perspective in a stable social order during Diderot's time (represented by the *camera obscura*) to one that involved the integration of fragmented and mobile elements (represented by the kaleidoscope and the zoetrope, both of which entered popular culture through early experiments in vision). For Crary, the revelations in painting were manifestations of the underlying scientific-social-psychological developments.[6] The proliferation of photographic images played a part in this profound cultural shift, in how people saw themselves. Photography facilitated an awareness of individual identity. Its rise was concurrent with that of industry, mass production, and the public museum, and also with the challenge to the fixed regime of privilege associated with established class divisions.

While painting could at one time indulge the idea of absorption in a coherent cultural space, photography never could. Photography was always partial and always included an audience. It was inherently an art of appearances, one that both resembled and participated in the fragmented relations of culture and meaning. Early technology dictated that what masqueraded as scenes from real life were actually posed tableaux. Truth and fiction merged in photography. It was not until the twentieth century, when the speed of resolution fostered the illusion of a moment stolen from the flow of real life, that the idea of documentary truth could be fully realized. Two world wars contributed to the development of the technology and to the global circulation of imagery. A need for immediacy and lack of illusion (*dis*illusion) in photography was felt during this time. The search for authentic engagement in Western culture resulted in a repudiation of theatrical representations as bourgeois diversions. This anti-theatrical bias was revealed in the absurd subversions of Dada and the non-illusionistic theatre of Bertolt Brecht, among other forms. In this context and for a brief period, the photographic image became an unequivocal conveyor of information, news, and social commentary. The gritty black-and-white photographs and documentary films provided an illusion of objectivity and of direct, unmediated experience.

The anti-theatrical bias in art continued after the war years. In the late 1960s two distinct views on anti-theatricality were articulated, neither of which was specific to photography, but both of which helped to define the moment when photography began to enter the official canon of contemporary art through conceptual and performance practices. Michael Fried expressed one of the views in a well-known polemic against the theatricality of minimalism. He argued that minimalism was theatrical in the self-consciousness of its objects – their indeterminate meanings and their repetitive serial forms that required an audience to complete the work.[7] Fried, like Diderot, pined for absorption in the authority of a work of art and thus its ability to communicate as a resonant and unified whole completely and instantaneously. Fried characterized the offending objects of minimalism as "projecting" their presence onto the viewer, anticipating the role of cinema in contemporary practice. Fried felt that cinema escaped the condition of theatricality because it took place in a dark space that absorbed the viewer, but that it could not be considered a Modernist art form because this was its nature, its "automatic" effect, and therefore it did not represent a true artistic triumph over theatricality.[8]

In the second view on anti-theatricality, Guy Debord and the Situationists identified the absorption in a unified whole sought by Fried as a negative factor in relation to the spectacle of capitalism. Debord believed that modern capitalist society had produced a consumer culture that was dominated by images and that the consumer had been reduced to the passive state of a viewer. He felt that art could not change the situation, but it could raise awareness of it and present alternatives. He encouraged a revolutionary program in which artists would assess the entrenched architecture of an urban centre through psycho-geographical exploration (the *dérive*) – a method of surveying the scenes, influences, and chance occurrences that define a city and its margins – and would then disrupt its unity through the playful recombination of elements in a constantly changing parody of the original (*détournement*).[9]

THE CINEMATIC FRAME

Influenced by these debates, the search for a non-exploited form of expression infused the art of the 1960s. By the early 1970s, conceptual art and performance had done away with the marketable object entirely. Performance

work sought authenticity in the actual interactions
of the artist and the audience in the same physical space
(although even performance artists sometimes circulated
staged photographs as documentation of their work[10]).
Video became an accessible recording tool for art
activities during this time, and spontaneity and
performance were bywords for authentic creative
experience. Artists adopted photography's lingering
association with documentary truth as a means of
recording actions as fragments of an expanding set of
propositions on art and life. Jeff Wall's *Landscape Manual*
(1969–1970), photographed in Vancouver and reproduced
on newsprint, is a prime example. The artist set out to
catalogue the generic detail of sprawling urban landscapes
by shooting "reams of tiny photographs"[11] randomly
from a car in a potentially endless stream of images. In
the text, the images become photo-cards that are shuffled
and reorganized, in a changing relationship to situations,
meaning, and time, as the artist moves through the
city. The written narrative unfolds in relation to the
cinematic, based on a chance incident – a conversation
between a man and two women overheard by the artist
in a theatre lobby – that Wall calls "a work of theatre,
undefined."[12] The artist begins to elaborate this incident
into a potential script for a film – an erotic encounter
between two women in a theatre washroom cubicle.
This voyeuristic tableau, defined by the male gaze of the
artist, is positioned within the context of the spectacle of
cinema, with the sound of the film in the background.[13]
Landscape Manual is one of the early works in which
cinema begins to be articulated in photographic practice,
through the back door, contrary to spectacle but
colluding with it.

There was a resurgence of interest in film in the
1960s and 1970s: the New Wave in French cinema, artists'
films such as those of Michael Snow and Joyce Wieland
in Canada, and Hollywood films of Hitchcock and
others. This was the backdrop for Roland Barthes's
discussion of the still image in the context of cinema. In
his influential essay "The Third Meaning," Barthes draws
on ideas of Russian Constructivist montage that define
the film as a combination of distinct elements. The movie
still, unlike a regular photograph, is a narrative fragment,
a quotation. It provides an opportunity for associations
that open out beyond the trajectory of the primary
narrative.[14] As the revolutionary spirit of the 1960s began

to fade, and with it the opportunity to pursue
a purer form of art untainted by the marketplace,
artists began to explore the narrative potential of
the single photographic image and to take a more
directorial role in relation to image-making.

Influenced by Barthes's ideas, Ian Wallace
produced several seminal works in the early 1970s
using actors and staged sets. *Summer Script* began as a
collaborative film project with Jeff Wall, but was finally
produced by Wallace as a series of stills in two groupings.
The first group of black-and-white images is defined by
the static distortion of the video image – an early record
of the use of video by artists and one that makes the
camera an obvious part of the construction of the
picture. The second group of images (see fig. 126) focuses
on a table on which are visible the script text and some
photographic images. The hand of an unseen (female)
protagonist holding a glass of wine emerges from
outside the frame. The narrative implies the process
of filmmaking and intimates a sensual mystique. These
large hand-coloured images bring together painting,
filmmaking, and photography, and evoke a kind of
romantic nostalgia for older forms of image-making
in relation to the video and for the idealism of the
turn-of-the-century avant-garde. Wallace pursued this
course in photographic practice with a series of narrative
stills related to his interests in literature and film.[15]

Jeff Wall set himself a more aggressive course
at this time, adapting the cinematic spectacle to art
practice in response to the broader field of vulgar
commercial images. He began to make large colour
transparencies in light boxes and to identify his work
with cinematography. *Faking Death* (1977), an early
three-panel work no longer in circulation, illustrates
the production of the photograph as theatre and clearly
positions the viewer as spectator. The first panel presents
the machinery of cinematic spectacle: lights, camera,
makeup, *mise en scène*, and crew are all part of the picture.
The other two images, both of the artist lying "dead" on
a bed, partially covered by a striped sheet, bare-chested
and with his head propped on a pillow, are essentially
identical. The construction and reproducibility of the
photograph are part of the work. Wall provides several
referents for this work, drawn from painting, film, and
performance: Jacques-Louis David's *Death of Marat*
(1793), Hitchcock's *Psycho* (1960), and Chris Burden's

Bed Piece (1972). Another potential source is Hippolyte Bayard's 1840 photograph *Self-Portrait as a Drowned Man* (see figs. 1 and 7), which would position Wall's work in relation both to the beginning of photographic practice and to the earliest theatrical representations.

Two other works by Wall from the late 1970s are particularly emblematic of the conscious move from the anti-theatrical agenda of the previous decade to one that both embraced and investigated theatricality using cinema as a strategy. The portrait series *Young Workers* (fig. 127) features young people posed against a white background, with their eyes upturned (perhaps the "nostalgic residue"[16] of revolutionary socialism). *Movie Audience* (fig. 128), another series in a similar format but using a black background, shows couples or small groupings of people with eyes staring ahead, their faces illuminated by the reflected light of the screen.

RE-ENACTMENTS

Starting in 1977, Cindy Sherman began to produce photographs of herself that depicted the types of women portrayed in film, revealing the impact of cinema on women's identity (see fig. 129). The images are haunted by nostalgia and by the constant presence of the artist herself as a cipher, donning theatrical roles as referents for shifting identities. Probably more than any other, this work identifies theatricality not only as a condition of

images, but also, expanding beyond the frame, as a model for behaviour. Sherman's work pushes the implications of fashion and makeup into the realm of the surreal, a "metamorphosis through consumption."[17] Unlike the women in Manet's paintings who address the audience directly, Sherman looks away, across and through the viewer; absorbed in filmic time, she remains the object of contemplation. By infusing the work with her presence, she makes the impact of these images cumulative.[18] They confront gender and desire, the later works appropriating pornography, fashion advertisements, historical portraits of women, fairy tales, and disasters in which the body is besieged and deformed, part plastic and part real. In these later images all the seductive devices of theatre and cinema are compounded into a grotesque masquerade that confronts the excess and violence of the times. While the anger in the images is palpable, the depictions are not entirely cynical. The artist's role-playing embodies a challenge: the object of the gaze has become active, changing her visage at will. She is a shape-shifter for whom theatre is a condition of communication and survival. The very corporeality of these representations implicates the viewer in a visceral way; the discomfort that accompanied the rupture of Modernism is extrapolated to the disorientation resulting from this play of fluid identity. The drama of our own time is played out on unstable ground.

Since the 1980s, all pretense of association with the real world has largely been dropped in the

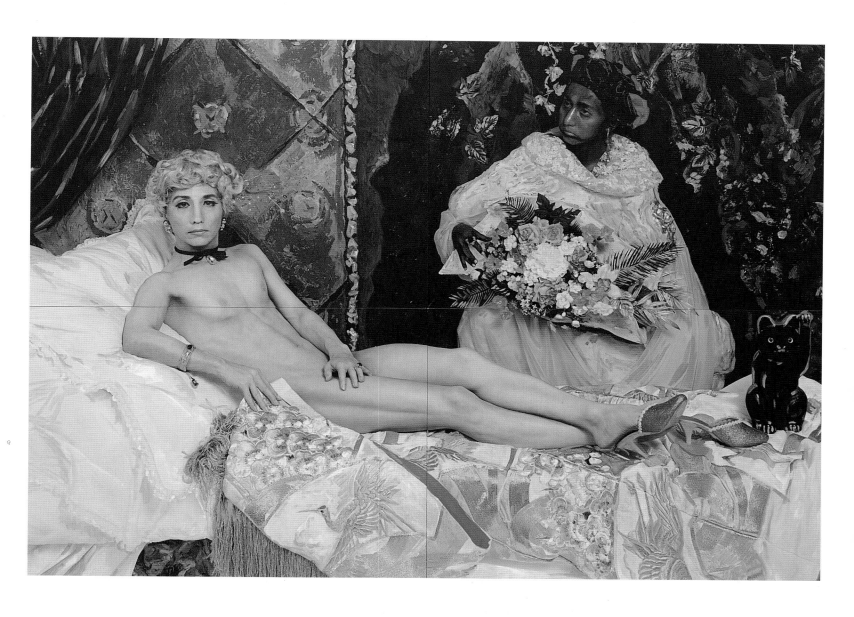

Fig. 132
Yinka Shonibare, *Diary of a Victorian Dandy*, 1998, dye coupler prints,
artist's frames. Collection of John and Amy Phelan, New York

Fig. 132a
Diary of a Victorian Dandy
11:00 hours

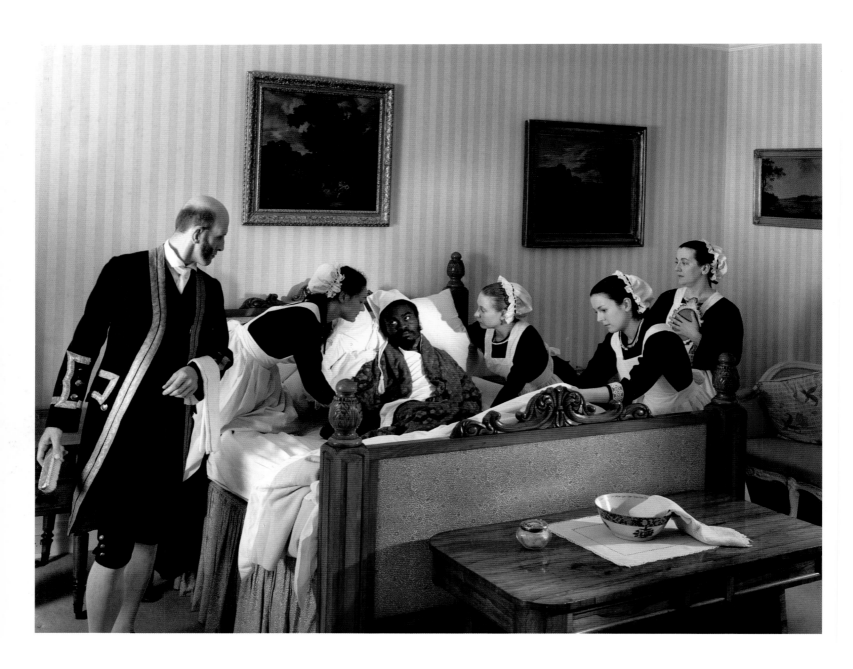

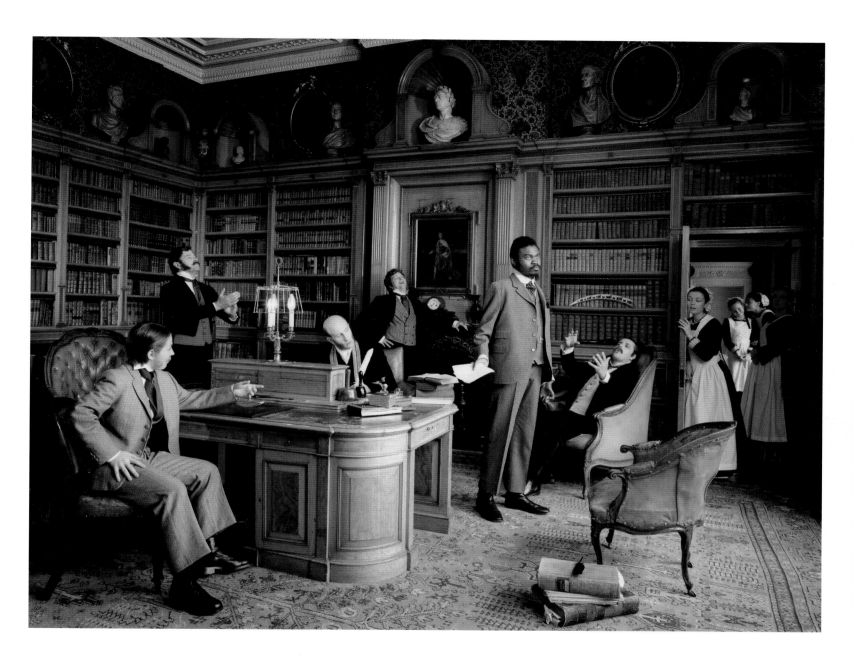

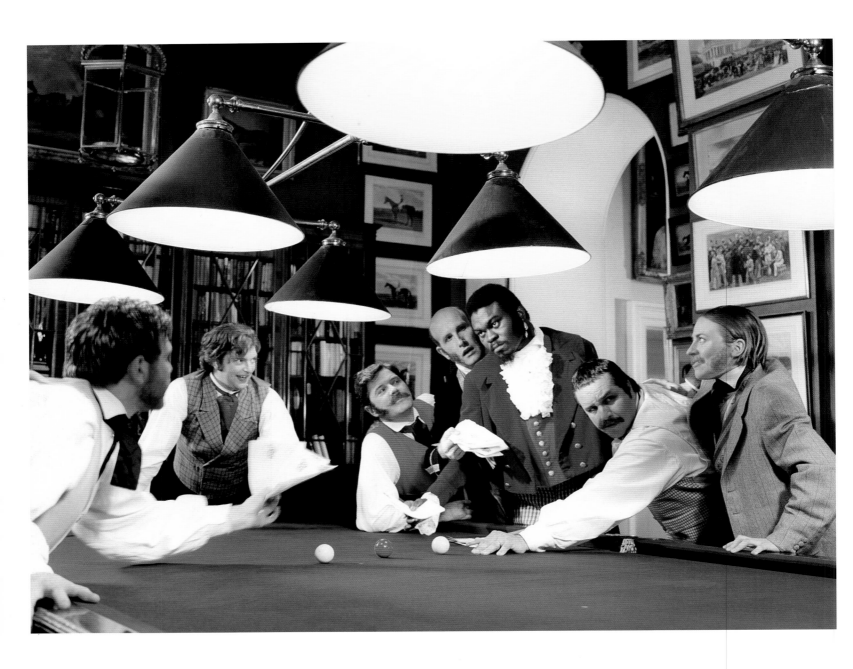

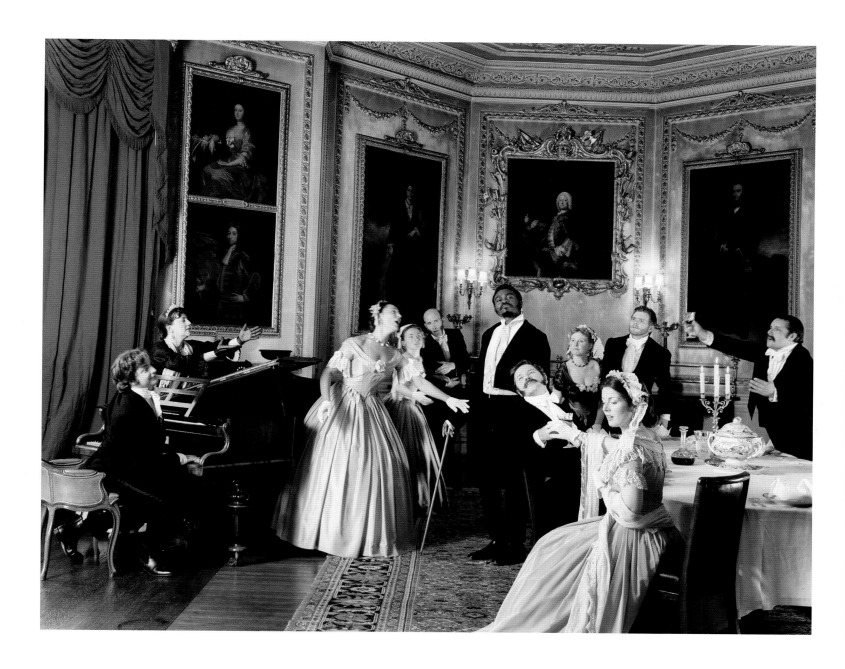

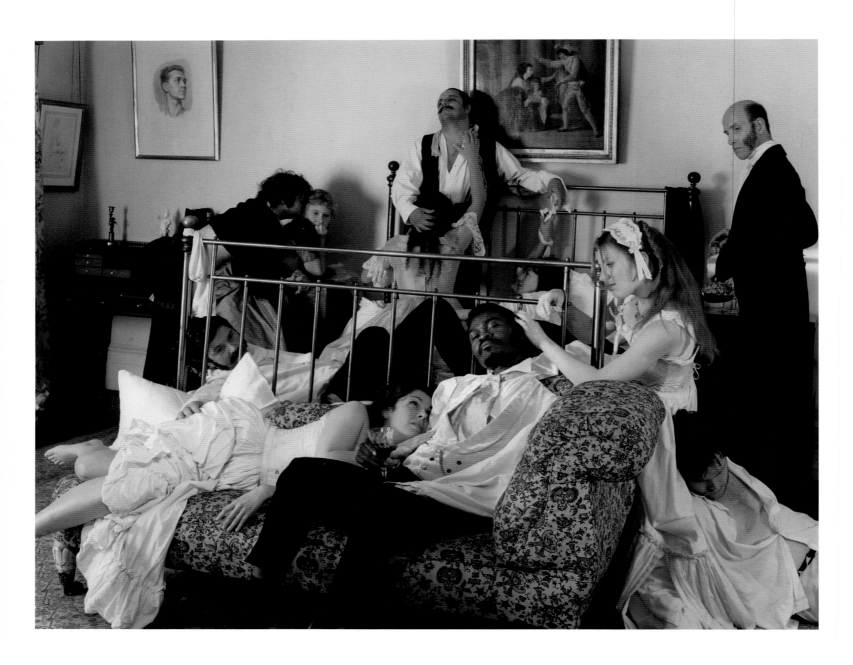

photographic image in art, and its self-referential nature in the context of image saturation has been accepted. The picture is positioned as a construct, an imitation, a proposition. Since the advent of digital technology, any claims to referents in real life have been called further into question. Theatricality is embraced, and with it the relationship between audiences and artists and even the position of the art object in consumer culture. The artist is free to develop a sophisticated language of symbolic imagery that resonates with social circumstances. Creating tableaux is a central strategy, evoking the multiple and complex, sometimes conflicting, associations of elements in the images. In the process, the images themselves have become larger and more colour-saturated, more cinematic.

Self-reflexivity in photography initially ushered in a period in the early 1980s of investigating old models, of restaging and re-photographing existing images. Re-enacting the social – performing the self as socially constructed, recuperating identity from the margins of media representations and Western art history – soon became a prominent type of work. One example, from the 1990s, is *Souvenirs of the Self* (fig. 130), originally produced as a series of postcards, in which the artist, Jin-me Yoon, a Korean-Canadian woman, stands against a background of iconic Canadian landscapes that are popular with Asian tourists. By posing in the ambiguous position of insider and outsider, she confronts the common perception that this land is home only to Caucasians. Her work continues to address ethnicity in landscape, but in ever more playful ways.

The Japanese artist Yasumasa Morimura began to restage Western art images with the same theatrical acumen as Cindy Sherman, though with the added charge of crossing gender and racial lines. *Portrait (Futago)* (fig. 131), with the artist posed on the bed of Manet's *Olympia*, is a witty and pointed indictment of the Western domination of the art market, exotic otherness, and homophobia, and uses a mix of Eastern/Western traditional and popular culture in a true pastiche. Morimura looks out from his disguise directly at the viewer, confronting his difference, demanding to be identified even within the complexity of signifiers. He continues to assume the roles of art history and popular culture, including such icons as Marilyn Monroe and Cindy Sherman.

Yinka Shonibare's images of a black Victorian dandy (fig. 132) were produced in the 1990s, as African artists began to enter the global art arena. These images of elaborately decorative artifice place the black artist at the centre of a fantasy of Victorian luxury and decadence, a situation that remains poignant in the context of the colonial history of slavery and the contemporary economic struggle of African nations. All these artists use tableaux to assert the invisibility of racism in Western cultural history.

Wang Qingsong's *Beggar* (fig. 133) is a more literal depiction of signifiers. The artist adopts the guise of a downtrodden (possibly disabled) Asian man with his hand outstretched toward a female Caucasian tourist, who is decked out in exotic clothes associated with Asia and readily available in tourist stores. A pert Pekingese dog trails behind her. In this image, obviously shot in a studio, the beggar and the tourist are separated diagonally by a forlorn piece of wood and the money that has been dropped for the beggar – an allegory of race and power, class and culture, enacted across a dividing line of resources and capital. The image's background is without physical perspective, devoid of detail: nowhere in particular, or anywhere that white tourists roam in Asia. It is clearly a concept rather than a place, and the people represented are not unique but all too familiar.

While such images enact social allegories, others explore more uncertain territory, drawing on intimate models such as family photographs and combining them with the drama of soap operas. The works of Tina Barney reside in this grey area between truth and fiction. The artist focuses ostensibly on scenes of domestic life, showing family members in a melodramatic narrative atmosphere (see fig. 134). The voyeurism of reality TV is evoked by these images. They are tableaux in the classic sense, harbouring the concentrated energy of impending action but without the grand themes of an earlier time. Theatricality is particularly veiled in Barney's works, which can masquerade as snapshots of real life. Whether they involve actors or family members, posed or not, does not really matter; they are theatrical by implication. What makes them so is their deliberate ambiguity, the slippage between real and representation resulting in an emphasis on the artifice of the display.

Gregory Crewdson also explores the territory of the imminent event, often using a detached

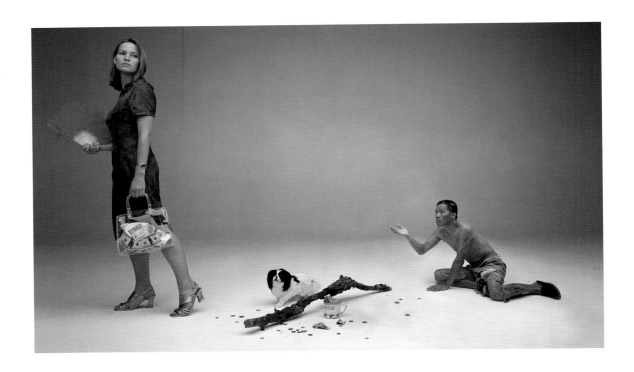

Fig. 133
Wang Qingsong, *Beggar*,
2001, dye coupler print.
Collection of the artist

perspective to present urban and suburban scenes that appear about to burst into action (see figs. 135 and 136). The ghosts of B movies and bad dreams inhabit the images. These atmospheric pictures expose an unsettling dissociation from material, lived experience and the underlying anxieties and fears that characterize contemporary culture. Their absorption in theatrical artifice is complete. They raise the question: where, if anywhere, is the grounding in significant action that inspired earlier generations of artists?

Hal Foster has written about the condition of loss, of coming after the revolutionary narratives (including those on anti-theatricality) that defined a purposeful art practice for modernity. He suggests that artists have developed strategies of "living on," ways of working without ideological frameworks but within which the social project still has relevance. One of these strategies is a "nonsynchronous" approach that recoups old forms to recombine them in new ways or translates one medium to another in a kind of broken allegory, making use of their associated histories and differences in order to shed light on the chasm between them. Another approach is to evoke a "spectral" trace of the past, an afterlife with an uneasy relationship to the present.[19]

In *Please* (fig. 137), Judy Radul employs both strategies in a series of video stills of an actor masquerading as a beggar. The work was created by the artist as a billboard specifically for the inside of Vancouver's old Canadian Pacific Railway station, and the images are set in front of the station's large white pillars. The actor's costume and manner echo Oscar Gustave Rejlander's *Poor Jo* (fig. 138) and the classic

1938 film version of *A Christmas Carol*, both theatrical representations of the nineteenth-century poor. Radul's work is unsettling. In five consecutive grainy images, the actor, who wears a dark suit and Victorian-style cap and leans on a crutch that is much too small for him, seems to await an offering that appears in his hand in the third image. The final image is a close-up of the actor's face. The artifice is declared in several ways: by the recognizable quality of the video image, by the disjuncture in time when a contemporary bicyclist appears in the fourth frame, and by the stage makeup on the face and the fawning, slightly sinister grin that directly engages the viewer. The text printed below the images, "God bless you guv'nor," evokes the class relations of another time and also the justification for charity that religion supplies – to be grateful for small mercies. This is the religion that inspired the statue in front of the station, which depicts a First World War soldier being lifted to heaven by an angel, transcending the woes of this earth. The "pitiful disguise"[20] (which defines both the actor and the character of the work) calls attention to the reality that surrounds the staging: the station itself and its neighbourhood, a work space for artists and theatre companies, and a thoroughfare for all, but a home for the urban poor. Compared to typical Salvation Army images, for instance, Radul's work holds out no promise of the self-justification of charity. It poses a challenge. It calls into question the traditional romanticism that infuses representations of the urban poor, which imply that awareness and the occasional act of charity can solve the problem of illicit activities and the disenfranchised.

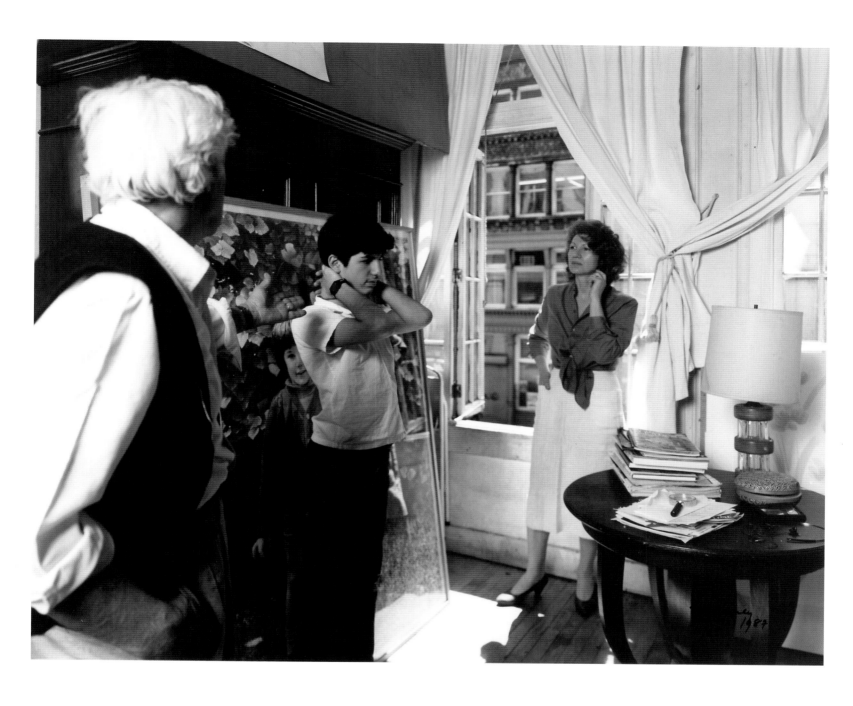

Fig. 134
Tina Barney, *The Son*, 1987,
printed 1991, dye coupler print.
National Gallery of Canada,
Ottawa, Gift of Photographers
+ Friends United Against AIDS,
New York, 1988 (39859.2)

The oppositions in the work complicate any easy reading and set up an oscillation between past and present, truth and illusion – the broken allegories that Foster identifies as a contemporary strategy. Theatre is part of the obvious content of the work – the costume, the props, and the excessive carnivalesque makeup. The bicyclist riding through the frame breaks the historical illusion and introduces into the image contemporary life on the street. This disjuncture disturbs the equilibrium and compels an interrogation.

Barthes's concept of the third meaning could be relevant here. In his essay, he suggests that images have three levels of meaning: an informational level (the setting, the characters, the costumes, and so on); a symbolic level (the recognizable cultural associations); and a third level, which is more "obtuse" or elusive. He depicts the latter as located "on the back" of the obvious signification of the image. Barthes describes an image from one of Eisenstein's films in a way that could be applied to Radul's work:

All these traits … have as their vague reference a somewhat low language, the language of a rather pitiful disguise. In connection with the noble grief of the obvious meaning, they form a dialogism so tenuous that there is no guarantee of its intentionality. The characteristic of this third meaning is indeed … to blur the limit separating expression from disguise, but also to allow that oscillation succinct demonstration – an elliptic emphasis … a complex and extremely artful disposition …

The obtuse meaning, then, has something to do with disguise … it declares its artifice but without in so doing abandoning the "good faith" of its referent …: an actor disguised twice over … without one disguise destroying the other; a multi-layering of meanings which always lets the previous meaning continue, as in a geological formation.[21]

The role of the third meaning is to resist a single reading of the image. At the very least, it acts as a discomfiting prod, a schism in the facade of illusion. It is this rupture, like the previous one in Modernism, that causes us to reflect on society and its representations.

This prod is playfully depicted in Rodney Graham's *City Self / Country Self* by a kick in the pants (see fig. 139). In this video projection work, based on a nineteenth-century cartoon, Graham plays twin characters – a split personality. The film is an elaborate staging of costume, including a mask of the artist's face, and cinematic techniques. The narrative unfolds as follows: one of the characters, a peasant, picks up a top hat (presumably belonging to someone else) that has fallen on the ground and puts it on his head; the camera shows the hands of a clock, which move toward the hour as he and the other character, an urban dandy, walk inexorably toward each other; at the climax, the dandy kicks the peasant, the hat falls off, sound stops, and the kick is replayed; then the whole sequence recycles in a loop. Graham's skill and wit turn this moving scene from the past into an allegory relevant to the present. As well as eliciting an awareness of the theatrical devices, the play of sound, time, and repetition, and the multiply acted roles, it re-enacts class relations that continue to be entrenched. Graham reveals the cinematic techniques for creating suspense and makes time as duration tangible in this sequence by focusing on the clock and orchestrating the sound to an obvious crescendo.

Bill Viola also masterfully conveys this sense of the extended cinematic moment in his exquisite slow-motion videos. These reference sixteenth-century paintings, using actors to re-create theatrical gestures and expressions. *The Greeting* (fig. 140), inspired by Jacopo da Pontormo's *The Visitation* (fig. 141), is a richly coloured composition of three women, two of whom are moving into an embrace. The image, which is distinguished by the strong diagonal lines of the architecture in the background, contains the classic drama of the eternal triangle within its condensed duration.

The works of Thomas Demand are re-enactments of a sort that operate as negative tableaux in which the social is implied by its absence. His large-scale photographs are of seemingly real constructions that in fact are made of paper. *Space Simulator* (fig. 142), for example, is an immense yellow machine composed of identically coloured cabinets, all clustered claustrophobically around a silver space capsule. The object's sterile artificiality – its lack of life or signs of use, the absence of product identity or text of any kind – makes it uncanny, out of time and place. The scale and complexity of the machine reflect

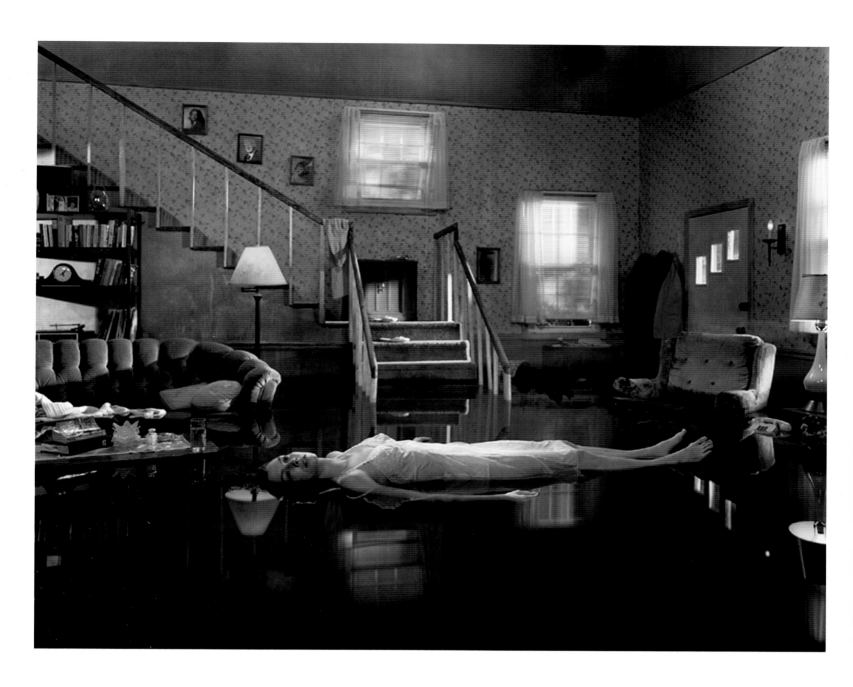

the massive infusion of capital that supports the effort to colonize new territory and maintain the perspective of power. The image presents the irrefutable materiality of the project, as well as its statement of theatrical presence, its artifice. Demand's works are often derived from highly charged scenes of politics and crime, the meanings of which are hidden. The works make much of the monumental facade. How is this hiding behind the authority of the gesture different from the crime? Its redemption is in the declaration of the masquerade, the tiny telltale marks of construction, and the stories alluded to – the historical contexts of the image. The painstaking fabrication of the objects and the perfection of the photographs constitute the artist's reconstructive and recuperative process *in relation to* actual circumstances. In their uncanny muteness, the pictures maintain the character of narrative stills. Through the oscillation of fragility and materiality, and through their layers of obdurate process and meaning, the images present the theatricality of their construction as *illusion*. These are not tableaux in which something is imminent, but ones in which something has already happened, something to be contemplated in more depth. That is what confronts the viewer: not the promising potential, but the need to look beyond, to reconstruct, reorient, heal, and live on.

This strategy of living on and remaining alert is not new. Ralph Ellison, for example, wrote the novel *Invisible Man* in 1952, at a time when African Americans were still very much second-class citizens. The novel's main character, who is unnamed and largely apolitical, takes on a series of roles and confronts the power dynamics of entrenched racism in the university, the corporation, the union. In the end, he finds freedom by literally going underground, feeding illicitly off the power grid, cocooning; he is a potentially revolutionary figure, awaiting the right circumstances. In the meantime, he lives on, and he finds hope: "Step outside the narrow borders of what men call reality and you step into chaos … or imagination."[22] He is invisible because he refuses all association with illusion, but he needs light: "Without light I am not only invisible, but formless as well; and to be unaware of one's form is to live a death…. That is why I fight my battle with Monopolated Light & Power. The deeper reason, I mean: It allows me to feel my vital aliveness."[23] In *After "Invisible Man" by Ralph Ellison, the Prologue* (fig. 143), Jeff Wall has created a brilliant homage

to this spectral figure, staging a scene from the novel in which the man sits alone in his basement room, continuing to work on the task of filling his entire dwelling with light. In Wall's large backlit image the man is projected into the cinematic, back into the social complex, through the very light that harbours and sustains him. As the character says later in the novel: "Even hibernations can be overdone, come to think of it. Perhaps that's my greatest social crime. I've overstayed my hibernation, since there's a possibility that even an invisible man has a socially responsible role to play."[24] Focusing on his work, with his back to the viewer, the man in Wall's image is not yet ready for active life, but he plays the role not only of a representation of the unactualized revolutionary potential of the past, but also of an emblematic figure who is living on, maintaining vital aliveness.

The spirit of this staged image is in marked contrast to that of *The Vampires' Picnic* (fig. 144), a work by Wall from a decade earlier, in which the theatrical poses of both the dead and the undead conspire in a lifeless engagement focused on an aging male nude who holds aloft a green apple in a bloody hand. The hardware of photographic production – a lighting cart at the side of the image – is clearly illuminating this bleak circumstance. This is one of the early images in which the artist used digital technology to construct the picture, and the separation from life as a necessary source for photography seems complete.

Theatricality in early twenty-first-century photography makes no effort to deny the audience or its own constructed fictions. Rather, it invites viewers to participate in an imaginative engagement with representation itself and with the state of affairs in society in general. If painting most obviously provided this reflection on the social in the era of Modernism, photography and its digital incarnation do so in this one. Within the barrage of flashing and changing screen images that define the spectacle of contemporary life, these monumental objects/images created by artists have become strangely reassuring in their cinematic scale, their colour saturation, and, most important, their conceptual complexity. They reveal the techniques of illusion while reaffirming the possibility of meaningful representation. Like classic tableaux, they imply the continuing project of imminent transformation.

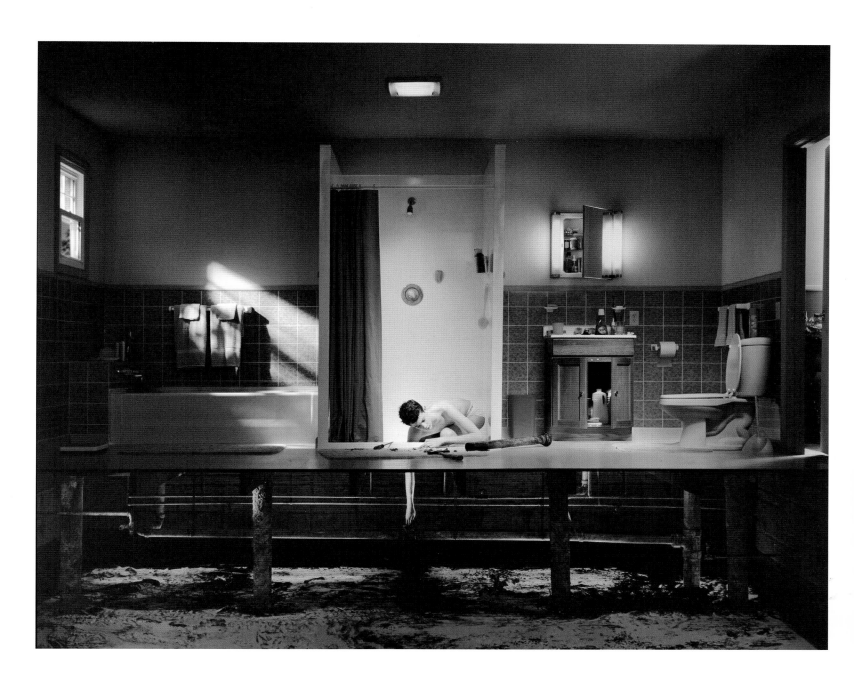

"God bless you guv'nor"

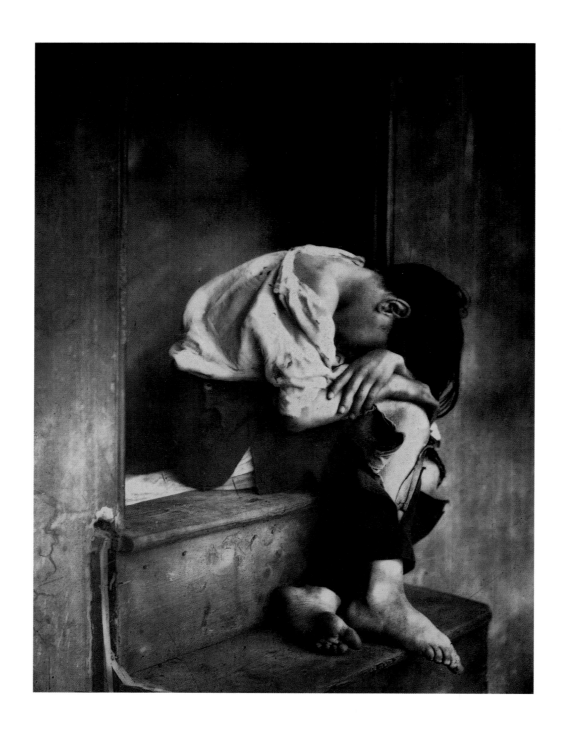

Fig. 137
Judy Radul, *Please*, 2001,
inkjet print (billboard). Courtesy
of the artist and Catriona Jeffries
Gallery, Vancouver

Fig. 138
Oscar Gustave Rejlander,
Poor Jo, before 1862, printed
after 1879, carbon print.
National Gallery of Canada,
Ottawa (37076)

Fig. 139
Production still from *City Self /
Country Self* (35mm film
transferred to DVD, 4 min. loop),
Rodney Graham, 2000. Courtesy
Donald Young Gallery, Chicago

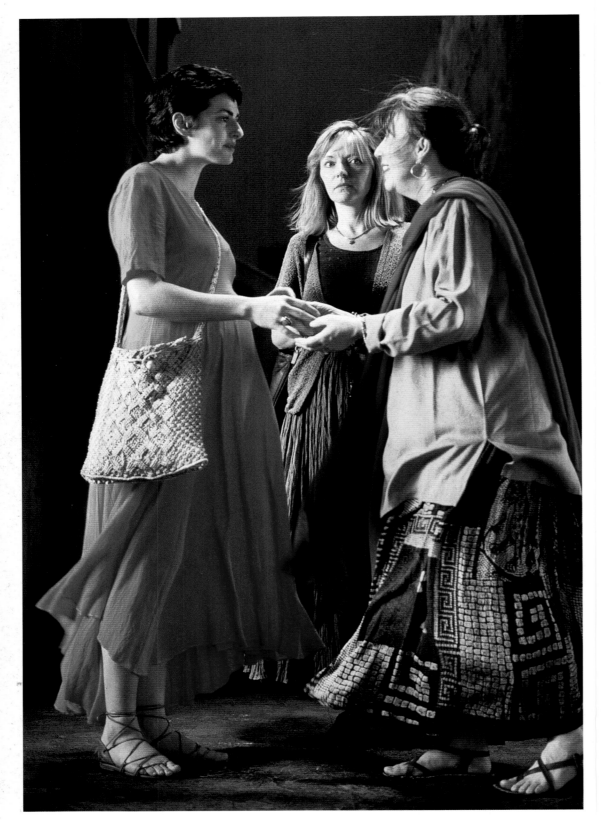

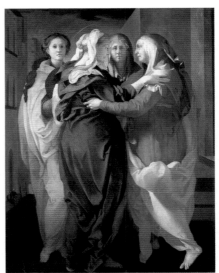

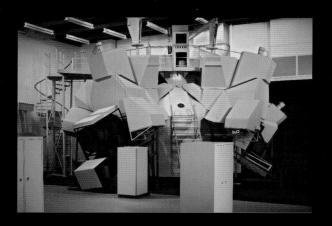

Fig. 142
Thomas Demand, *Space Simulator*, 2003, dye coupler print, laminated to Plexiglas (Diasec process). National Gallery of Canada, Ottawa (41424.1–3)

Fig. 143
Jeff Wall, *After "Invisible Man" by Ralph Ellison, the Prologue*, 1999–2001, transparency in light box. Courtesy of the artist

Fig. 144 (pp. 160–161)
Jeff Wall, *The Vampires' Picnic*, 1991, transparency in light box. National Gallery of Canada, Ottawa (36801)

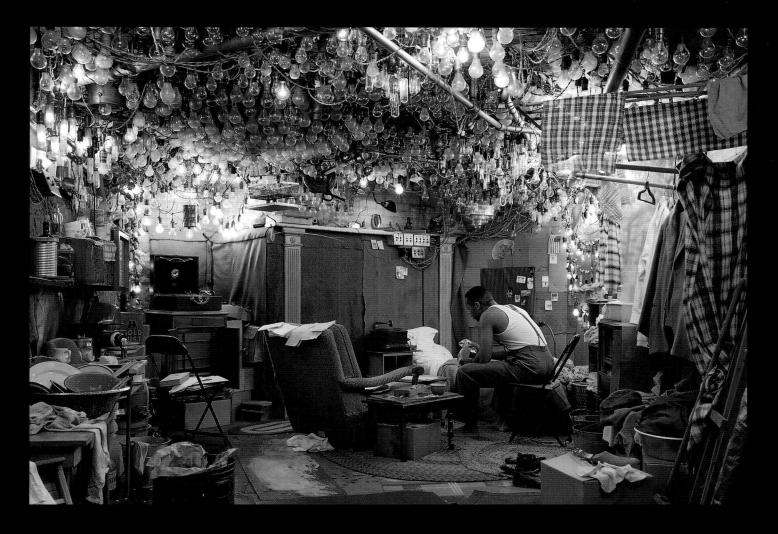

NOTES

I would like to thank Sharla Sava, Eric Metcalfe, Allyson Clay, and Lori Pauli for their thoughts on this essay in process.

1 Taken from Roland Barthes, "The Third Meaning," in *Image, Music, Text*, trans. Stephen Heath (New York: Hill & Wang; London: Fontana, 1977), p. 57.

2 Jeff Wall, "Gestus" (1984), in Thierry de Duve, Arielle Pelenc, and Boris Groys, *Jeff Wall* (London: Phaidon, 1996), p. 76.

3 Jonas Barish, *The Antitheatrical Prejudice* (Berkeley: University of California Press, 1981), pp. 5–31. The book as a whole provides a thorough discussion of attitudes toward theatricality.

4 Jonathan Crary, *Techniques of the Observer: On Vision and Modernity in the Nineteenth Century* (Cambridge, Mass.: MIT Press, 1990), p. 147.

5 Ben Brewster and Lea Jacobs, *Theatre to Cinema: Stage Pictorialism and the Early Feature Film* (Oxford and New York: Oxford University Press, 1997), p. 10.

6 See Crary, *Techniques of the Observer*, for the complete discussion.

7 Michael Fried, "Art and Objecthood" (1967), in *Minimal Art: A Critical Anthology*, ed. Gregory Battcock (New York: E.P. Dutton, 1968), p. 125.

8 Ibid., p. 141.

9 See the writings of Guy Debord from 1957 to 1961 in *Internationale situationniste*, as reproduced in *Art in Theory, 1900–1990: An Anthology of Changing Ideas*, ed. Charles Harrison and Paul Wood (Oxford and Cambridge, Mass.: Blackwell, 1993), pp. 694–700.

10 See Christine Poggi, "Following Acconci/Targeting Vision," in *Performing the Body, Performing the Text*, ed. Amelia Jones and Andrew Stephenson (London and New York: Routledge, 1999), p. 259.

11 Jeff Wall, *Landscape Manual* (Vancouver: UBC Fine Arts Gallery, 1969/1970), p. 1.

12 Ibid., p. 17.

13 For a discussion of the implications of Wall's description of this erotic encounter as it relates to the idea of mastery and to the whole project of trying to undermine the universal assumptions of Modernism, see Scott Watson, "Discovering the Defeatured Landscape: Conceptual Art in Vancouver in the Seventies," in *Vancouver Anthology: The Institutional Politics of Art*, ed. Stan Douglas (Vancouver: Talonbooks, 1991), p. 260.

14 Barthes, "The Third Meaning," pp. 66–67.

15 For a thorough discussion of this work, see Eric Cameron, "Semiology, Sensuousness and Ian Wallace," *ArtForum*, February 1979, pp. 30–33.

16 Jeff Wall, "An Outline of a Context for Stephan Balkenhol's Work" (1988), in Duve, Pelenc, and Groys, *Jeff Wall*, p. 101. Wall suggests that in Balkenhol's figurative sculpture, "the monadic figure may be freed from its old identity as universal abstract emblem, and so could not exist as a nostalgic residue of a part form of unity, an oppressive reminder of the 'good old days,'" which these images by Wall do seem to be.

17 Stuart Ewen and Elizabeth Ewen, *Channels of Desire: Mass Images and the Shaping of American Consciousness*, 2nd ed. (Minneapolis: University of Minnesota Press, 1992), p. 70, as quoted by Amada Cruz, "Movies, Monstrosities and Masks: Twenty Years of Cindy Sherman," in *Cindy Sherman: Retrospective* (London and New York: Thames & Hudson, 1997), p. 3.

18 "Cindy Sherman," in Arthur C. Danto, *Encounters and Reflections: Art in the Historical Present*, (Berkeley: University of California Press, 1990), pp. 121–122.

19 Hal Foster, *Design and Crime and Other Diatribes* (London and New York: Verso, 2002), pp. 129–142.

20 Barthes, "The Third Meaning," p. 57.

21 Ibid., pp. 57–61.

22 Ralph Ellison, *Invisible Man* (Toronto: Random House, 1995), p. 576.

23 Ibid., p. 7.

24 Ibid., p. 581.

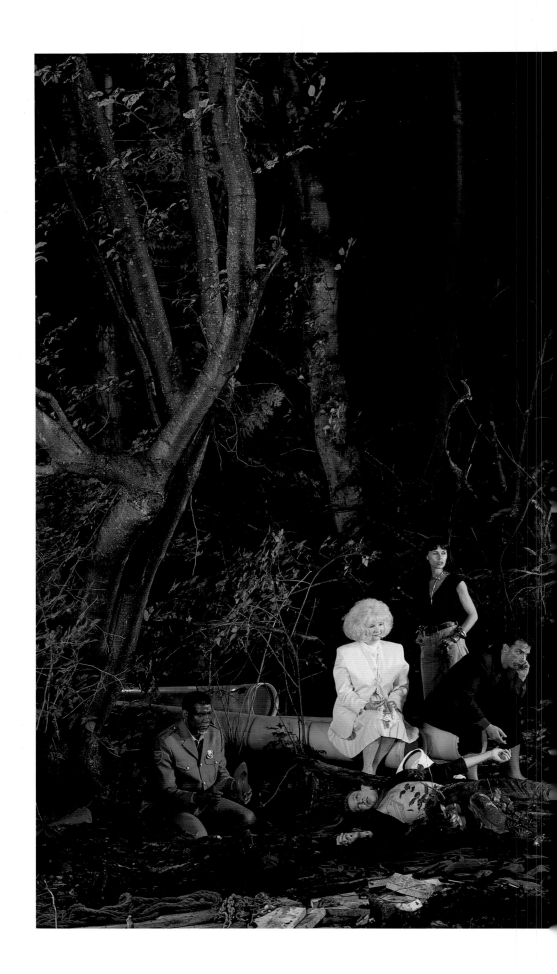

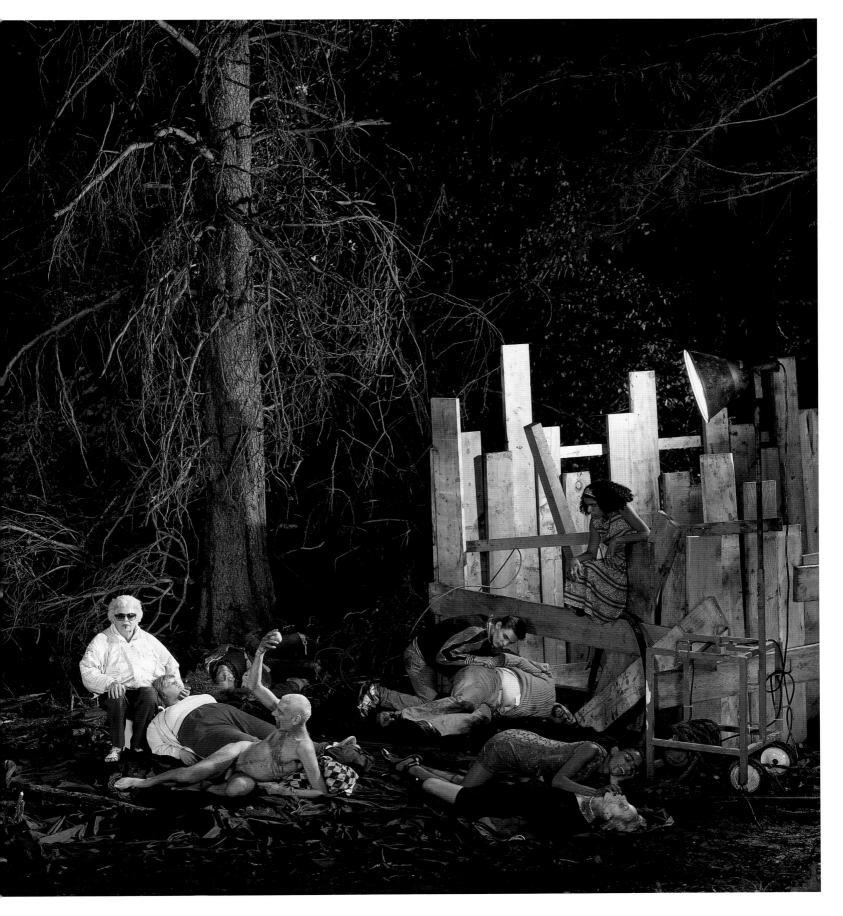

ARTISTS IN THE EXHIBITION / KATHERINE STAUBLE

ELEANOR ANTIN

Born in New York, 1935. An influential figure in the contemporary American art scene, Eleanor Antin is a painter, photographer, filmmaker, installation and performance artist, and writer. Antin studied creative writing and art at the City College of New York, taking acting lessons on the side. In the early 1960s she concentrated on painting, but soon moved to conceptual art. Inspired by the feminist movement in the late 1960s and early 1970s, she began exploring concepts of identity and representation, incorporating biography, autobiography, and history into her art. Antin's work has been shown in numerous exhibitions, performances, and screenings, and a considerable body of critical writing has been devoted to her. Since 1975 she has been an emeritus professor of visual arts at the University of California, San Diego. Antin has won numerous honours, including a 1997 Guggenheim Fellowship and the 1998 Cultural Achievement Award of the National Foundation for Jewish Culture.

TINA BARNEY

Born in New York, 1945. In her photographs Tina Barney explores family relationships, friendships, and the domestic rituals of her own upper-class milieu. Barney took an interest in photography in the early 1970s while working as a volunteer at the Museum of Modern Art. She soon began collecting photographs, and took photography classes from 1976 to 1979 in Sun Valley, Idaho. In her large, richly detailed prints, Barney captures subtle postures and expressions that imply narratives. Although clearly sympathetic to her subjects, she is able to convey undercurrents of vulnerability and tension. In recent years Barney has travelled to Europe to create portraits reminiscent of the Old Masters. Her photographs are widely collected and exhibited.

RALPH BARTHOLOMEW, JR.

New York, 1907 – Scarsdale, New York, 1985. Ralph Bartholomew, Jr., was a commercial photographer renowned for his storytelling approach and technical innovation. Bartholomew studied at the Art Students League in New York from 1927 to 1929. He worked for two years as an art director at an advertising agency, and then enrolled in the Clarence White School of Photography. In 1932 he began working as a freelance photographer. In 1936 he joined Underwood and Underwood Studios, where he was influenced by the dramatic illustrative style of Lejaren A. Hiller. Returning to freelance work in 1938, he operated a studio in Manhattan for the next thirty-five years, with an impressive client list that included General Electric, DuPont, Eastman Kodak, and Texaco. Through his photography, Bartholomew reached a large middle-class audience, effectively mirroring its values and desires. He combined the techniques of stroboscopic lighting with cinematic references and chiaroscuro to create highly theatrical images.

HIPPOLYTE BAYARD

Breteuil-sur-Noye, France, 1801 – Nemours, France, 1887. A civil servant and a friend to numerous painters and lithographers, Hippolyte Bayard began experimenting with photography in 1837. In February 1839, following the announcements of both Louis-Jacques-Mandé Daguerre's and William Henry Fox Talbot's inventions, Bayard successfully created a silver iodide paper negative. By March he had developed a direct positive paper process, and in July he mounted an exhibition of his work. In 1841 he moved to Talbot's calotype process, and in 1852 he invented a method of printing landscapes with separate cloud negatives. As a founding member of the Société héliographique, he took the first photographs of architectural monuments for the Commission des monuments historiques in 1849. Bayard won a first-class medal at the 1855 Exposition universelle in Paris. He was a founding member of the Société française de photographie and a Chevalier de la Légion d'honneur.

HERBERT BAYER

Haag, Austria, 1900 – Montecito, California, 1985. Herbert Bayer led a distinguished career as a painter, sculptor, typographer, graphic designer, exhibition designer, and photographer. Through his commercial work, he played an important role in bringing

modern art to the public. From 1921 to 1923 he was enrolled at the Bauhaus in Weimar, where he studied mural painting and design under Vassily Kandinsky and Paul Klee. He made his first photographs in 1924. In 1928 he became an independent photographer and director of the Dorland Design Studio in Berlin. His work was included in the 1929 *Film und Foto* exhibition in Stuttgart. Bayer's earliest photographs were strongly influenced by László Moholy-Nagy's "New Vision." After his 1928 move to Berlin, he began making photomontages, combining photographic realism with elements of Dada and Surrealism. His images of objects, or *Fotoplastiken* series, followed around 1936. In 1938 Bayer moved to New York, and by 1951 he was a leading figure in American graphic and architectural design.

ERWIN BLUMENFELD

Berlin, 1897 – Rome, 1969. A pioneer of Dadaist/Surrealist photography, Erwin Blumenfeld brought an avant-garde Pictorialist style to fashion photography. As a teenager, Blumenfeld frequented Berlin cafés, where he met several leading Expressionists and future Dadaists. After serving during the First World War, he moved to Amsterdam in 1918. There he made paintings, collages, photomontages, and photographs, while operating a leather boutique. In 1936 he moved to Paris and began photographing cabaret performers, avant-garde artists, and nudes, as well as architectural and landscape subjects. He mounted his first exhibition in his first year there, and contributed photographs to the magazines *Verve* and *Vogue* and the annual *Photographie*. By 1939 he was working as a Paris correspondent for *Harper's Bazaar*, but was soon after interned in a series of French concentration camps. He obtained an American visa and fled to New York in 1941. Within two years, he was among the best-paid freelance photographers in the country. Blumenfeld perfected numerous photographic techniques, including multiple printing, the use of sandwiched negatives, solarization, and bleaching-out.

CLAUDE CAHUN (LUCY RENÉE MATHILDE SCHWOB)

Nantes, France, 1894 – Jersey, Channel Islands, 1954. Claude Cahun explored questions of identity and gender in her photographic self-portraits and photomontages as well as in her writings. Cahun was a member of the Surrealist movement and a friend to such avant-garde artists as André Breton and Robert Desnos. In 1912 she began making photographic self-portraits. She enrolled in philosophy and literature studies at the Sorbonne, settling in Paris in 1920 with her stepsister and lifelong companion Suzanne Malherbe. In the 1920s and 1930s she published poems, essays, and photographs in leading journals. She exhibited her assemblages of objects at Galerie Charles Ratton in 1936. Her photographs were used to illustrate the 1937 volume of poetry *Le Coeur de pic*. Cahun was a founding member of the anti-fascist group Contre-Attaque. She and Malherbe moved to Jersey in 1938 and were active in the French Resistance there during the Second World War.

JULIA MARGARET CAMERON

Calcutta, 1815 – Kalutara, Ceylon (now Sri Lanka), 1879. Born in India, Julia Margaret Cameron (née Pattle) spent much of her childhood in France and England, tutored primarily by her French grandmother. On an 1835 trip to South Africa, she met John Herschel, a pioneer in the chemistry of photography and her future mentor. She subsequently returned to her native city, Calcutta, and in 1838 married Charles Hay Cameron. In 1848 the family moved to southeastern England, where Cameron met many of the literary figures she would later photograph, including Alfred Tennyson. She took up photography on the Isle of Wight in 1860, and set up her first studio there. Primarily a portraitist, Cameron greatly admired the work of Oscar Gustave Rejlander and sought his assistance on occasion. She was elected to the Photographic Society of London in 1864, and participated in many of its annual exhibitions. She mounted her first solo exhibition in 1865 and then began exhibiting regularly in Europe. She won the bronze medal at the International Exhibition in Berlin in 1865 and the gold in 1866. From 1874 to 1875 she produced photographic illustrations for Tennyson's *Idylls of the King*.

LEWIS CARROLL (CHARLES LUTWIDGE DODGSON)

Daresbury, Cheshire, England, 1832 – Guildford, Surrey, England, 1898. Lewis Carroll is known primarily as the author of the children's classic *Alice's Adventures in Wonderland*. Educated at Rugby School and at Christ Church, Oxford, he was introduced to the calotype by his uncle in 1855. William Lake Price's *The Scene in the Tower* made a strong impression on him at the 1856 exhibition of the Photographic Society of London. On his return to Oxford, Carroll bought photographic equipment and took his first photograph. For the next twenty-five years, while a mathematics lecturer at Oxford, he made portrait photography a central part of his life. In 1871 he had a studio built above his rooms in Christ Church. Although not a member, he exhibited his work at the Photographic Society. In the course of his career, he amassed more than three thousand negatives, photographing family, friends and their children, clergy, artists, and celebrities.

CAROLE CONDÉ AND KARL BEVERIDGE

Born in Hamilton, Ontario, 1940 / Ottawa, Ontario, 1945. Carole Condé and Karl Beveridge both studied at the Ontario College of Art, Toronto. Although Condé was originally a landscape painter, both artists were working in sculpture by 1969: Condé was exhibiting fabric wall pieces, and Beveridge was creating minimalist floor work. That year, the couple moved to New York, where they took an interest in literary activities and in social and political issues. They began their artistic collaboration in 1975, and in 1977 exhibited a series of collages in comic-strip style with a labour theme. After returning to Toronto later in 1977, Condé and Beveridge began producing their signature photo-text work. Based on extensive research and interviews, their projects explore themes related to union struggles, the nuclear industry, management practices, and women's issues. Their work has been exhibited widely in North America and abroad, at museums, art galleries, and labour organizations. Condé and Beveridge have also been active in various arts and labour projects, such as the Canadian Independent Artists' Union, the annual Mayworks Festival, and the Artists and the Workplace program.

GREGORY CREWDSON

Born in New York, 1962. Gregory Crewdson is considered a leading figure in contemporary narrative photography. Crewdson obtained his BFA in 1985 from the State University of New York at Purchase, and his MFA in 1988 from Yale University, where he has taught photography since 1993. Crewdson creates elaborately staged photographs depicting eerie suburban scenes. Strongly influenced by the art of the cinema, particularly the films of Orson Welles, Alfred Hitchcock, and Steven Spielberg, Crewdson has also drawn inspiration from the realist painter Edward Hopper and from psychoanalytic theory. His highly suggestive photographs expose the tension between order and disorder, reality and fantasy, beauty and shame. Crewdson's work is widely exhibited, nationally and internationally. He has been the recipient of the National Endowment for the Arts Visual Artists Fellowship and the Aaron Siskind Fellowship.

F. HOLLAND DAY

Norwood, Massachusetts, 1864 – 1933. Frederick Holland Day graduated in 1884 from Chauncey Hall School in Boston, earning a gold medal in English literature. With his friend Herbert Copeland he established the publishing company Copeland & Day, producing finely crafted books and avant-garde texts. Day began experimenting with photography in 1886. Between 1889 and 1901 he made frequent trips to England, where he met Oscar Wilde, Aubrey Beardsley, and the photographer Frederick H. Evans. In 1895 he was elected to the Linked Ring and began his *Nubian* series, featuring portraits of his black chauffeur. In 1898 he produced a series of 250 photographs on the subject of Christ's life and death, exhibiting them later that year in Boston and Philadelphia. By 1917 Day had ceased photographing and lived the rest of his life as a recluse.

ROBERT DOISNEAU

Gentilly, France, 1912 – Paris, 1994. Robert Doisneau's photographs stand out for their cinematic quality, playfulness, and sure composition. Doisneau made his first photographs between 1928 and 1929 while studying book arts at the École Estienne. In 1931 he became an assistant to the photographer André Vigneau. When he lost his job three years later, he was hired by Renault to do industrial and advertising photography. After the war, during which he photographed for the French Resistance, Doisneau joined the RAPHO Agency. He received international attention in 1950 for his *Life* magazine photo-story on Parisian romance, which included his iconic image *The Kiss at the Hôtel de Ville*. Doisneau participated in two exhibitions organized by Edward Steichen at the Museum of Modern Art: *Five French Photographers* in 1951, and *The Family of Man* in 1955. He later created photographic portraits of Picasso, Colette, Giacometti, and Matisse.

JAKUB DOLEJŠ

Born in Prague, 1975. The Toronto-based artist Jakub Dolejš grew up in Czechoslovakia, where he witnessed the transformation of a Communist regime into a Western-style consumerist society. Dolejš began exhibiting his work in 1994, the year following the establishment of the Czech Republic, and obtained his MFA in 1998 from the Academy of Arts, Architecture, and Design in Prague. He immediately moved to Canada, settling first in Vancouver and then in Toronto. His photographs address the tensions between historical and contemporary culture, the past and the present, reality and imagination. Most of his large-format images show staged photographic scenes with painted backdrops. In his early works he posed actors in the foreground, whereas in his more recent works the human figure is eliminated. Dolejš has recently had solo exhibitions in Toronto and has participated in group shows in Montreal, Los Angeles, Norwich, and Prague.

FREDERICK H. EVANS

London, 1853–1943. Frederick Evans is especially known for his photographs of cathedrals. Starting out as a bookseller, Evans befriended George Bernard Shaw and Aubrey Beardsley. He first experimented with microphotography in 1883, exhibiting his images at the Photographic Society of London in 1887. In 1890 he showed his first cathedral photographs, and in the following years he travelled to cathedral towns around England. Using platinum paper, he obtained an exceptionally subtle range of tones and precise definition. In 1901 Evans photographed F. Holland Day in Arab clothes recently brought back from Algiers. Evans's work was exhibited widely; the first of numerous American exhibitions was held in 1897 at the Boston Architectural Club. A prolific photography writer himself, he was the subject of *Camera Work*'s fourth issue. Evans retired from bookselling in 1898 and worked as a professional photographer for *Country Life*. He was a fellow of both the Linked Ring and the Photographic Society of London.

EVERGON (ALBERT LUNT)

Born in Niagara Falls, Ontario, 1946. Evergon pursued undergraduate studies in fine arts at Mount Allison University, Sackville, New Brunswick, and obtained his MFA in photography from the Rochester Institute of Technology, Rochester, New York, in 1974. With a background in painting and printmaking, Evergon was from the outset interested in alternative photographic processes, especially electrostatic photographic imagery. In the 1970s he made small works, often incorporating collage and Xerox colour prints, exploring themes of sexual identity. Around 1984 he moved to large, elaborately staged productions and Polaroid technology. The one-of-a-kind prints, often presented as diptychs or triptychs, are remarkable for their innovative composition, lush colours, and sensual, dramatic effects. References to religious icons, mythology, and art history are juxtaposed with homoerotic images and contemporary symbols. Widely exhibited, and the recipient of numerous awards, Evergon teaches photography at Concordia University, Montreal.

ROGER FENTON

Heap, Lancashire, England, 1819 – London, 1869. Roger Fenton studied law in London and painting in Paris. After attending the Great Exhibition of 1851 in London, he turned his interest to photography. In 1852 Fenton travelled to Russia and showed three of his photographs from this trip at the exhibition of *Recent Specimens of Photography* organized by the Society of Arts. From 1854 to 1859 he was the official photographer for the British Museum. A founder of the Photographic Society of London, he participated in its 1855 annual exhibition, showing architectural and landscape views from an expedition to Yorkshire. That same year Fenton was commissioned to photograph the Crimean War, and exhibited the resulting prints in private showings to Queen Victoria and Napoleon III, as well as at the gallery of the Society of Painters in Water Colours in London. The period from 1856 to 1859 was his most productive. Combining the Victorian passion for the Near East with the growing interest in staged tableaux, he made a series of fifty Orientalist pictures in 1858.

ANNE FERRAN

Born in Sydney, Australia, 1949. Anne Ferran studied at the Sydney College of the Arts and obtained her MFA from the College of Fine Arts at the University of New South Wales. She garnered attention with her 1984 exhibition *Carnal Knowledge*, featuring larger-than-life images of sleeping girls. Reminiscent of Classical sculpture, these soft, grey scenes hinted at adolescent sexuality and sisterhood. Ferran further explored the sculptural form and female relationships in her 1986 series *Scenes on the Death of Nature*. Her later work incorporated video and installation art, exploring themes related to Australian colonial history. Ferran teaches at the Sydney College of the Arts and is widely published. She was the recipient of the 2003 Gold Coast Ulrick Schubert Photographic Art Award.

ADAD HANNAH

Born in New York, 1971. Raised in a family of professional clowns and puppeteers, Adad Hannah grew up performing on streets and in theatres throughout Europe. He immigrated to Vancouver in the 1980s, and attended the Emily Carr School of Art and Design from 1994 to 1998. From 1995 to 2001 Hannah co-directed the Human Faux Pas performance arts collective, touring Canada and the United States. After moving to Montreal in 2001 to begin his MFA at Concordia University, he turned his attention to video art and photography. His performance-based video installations explore relationships between the human body and its photographic representations. Widely exhibited nationally and internationally, Hannah's work won awards in 2004 at the Images Festival in Toronto and the Videomedeja International Video Festival in Novi Sad, Serbia. Adad Hannah is a member of the Montreal-based multimedia research group Interstices.

DUANE HANSON

Alexandria, Minnesota, 1925 – Boca Raton, Florida, 1996. Duane Hanson is best known for his figurative sculptures portraying ordinary people engaged in ordinary activities. Hanson studied fine arts at Macalester College, Saint Paul, Minnesota, and obtained his MFA in 1951 from the Cranbrook Academy of Art in Bloomfield Hills, Michigan. In 1953 he moved to Germany to teach art, holding his first solo exhibition in Worpeswede in 1958. The following year, he met the German artist Georg Grygo, who taught him the polyester resin and fibreglass technique. Hanson returned to the United States in 1960, eventually settling in Florida. Inspired by the Pop Art movement, he began making realistic sculptures in 1967. In these works he presented a sympathetic vision of ordinary people, especially manual labourers, in static, contemplative poses. In 1977 he began photographing his models and sculptures as an aid to the sculptural process. He often photographed live people with his sculptures, perhaps to see how convincing his figures were. His small Polaroid and Kodak Instant prints were first exhibited in 2004.

GABRIEL HARRISON

Philadelphia, 1818 – New York, 1902. Gabriel Harrison is best known for his mammoth-plate daguerreotypes. Harrison was also a painter, actor, and author of many dramatic publications. He studied daguerreotypy in New York under John Plumbe, Jr. After working for William Butler from 1844 to 1848, he moved to Brooklyn, where he became prominent in dramatic, literary, and artistic circles. In 1848–1849 he operated a studio in New York with his partner L.F. Harrison, and from 1852 to 1859 he owned a daguerreotype studio. He received an honourable mention at the New York Crystal Palace of 1853–1854, where he exhibited allegorical daguerreotypes on large plates. His daguerreotype of Walt Whitman was used as a model for the engraving in the poet's *Leaves of Grass*.

ALEXANDER HESLER

Montreal, 1823 – Evanston, Illinois, 1895. Alexander Hesler spent his early years in Vermont and Wisconsin. In 1847 he studied daguerreotypy in Buffalo, New York, and then opened a gallery in Madison, Wisconsin. In 1851 he travelled by steamboat along the Mississippi River, taking photographs for *Harper's Illustrated Guidebook*. In 1853 Hesler was awarded a bronze medal for his exhibit at the New York Crystal Palace. From 1854 to 1856 he displayed various techniques, including stereoscopic views. His watercolour photographs and daguerreotypes won a silver medal at the American Institute. Hesler's 1852 daguerreotype of Minnehaha Falls inspired Longfellow's poem *Hiawatha*, and his 1860 portrait of Lincoln is considered one of the best American presidential photographs. Starting in 1879, he was among the first professional photographers to turn from wet-plate to dry-plate photography.

DAVID OCTAVIUS HILL AND ROBERT ADAMSON

Perth, Scotland, 1802 – Edinburgh, 1870 / Fife at Burnside (?), Scotland, 1821 – St. Andrew's, Scotland, 1848. The partnership of Hill and Adamson, though short-lived, was one of the most famous in photographic history. In just four years they produced 1,600 photographs, Hill contributing the artistic vision and Adamson the technical skill. In their series of 130 images of the inhabitants of Scottish fishing villages they created the first photographic social documentary.

David Octavius Hill attended Perth Academy and the Trustees Academy in Edinburgh, studying landscape painting under Andrew Wilson at the latter. He published a series of landscape lithographs at the age of eighteen, and in 1840 published 61 steel engravings illustrating The Land of Burns. Secretary to the Royal Scottish Academy, Hill exhibited nearly 300 paintings there over his lifetime. It was in 1843 that Hill turned his interest to photography as a way of dealing with the challenges of a monumental painting project that involved 474 portraits.

Robert Adamson apprenticed as an engineer and then took up photography because of ill health. In 1843 he opened a calotype studio in Edinburgh, where Hill visited him to obtain technical assistance on his portrait project. The two soon embarked on a partnership, exhibiting photographs and preliminary sketches for the project in 1843. By the end of that year, they had received public recognition, mounting an award-winning exhibition at the Board of Manufacturers. Hill moved to Adamson's studio in 1844, and for three years they participated in the annual exhibitions of the Royal Scottish Academy. After Adamson's premature death, Hill devoted himself almost exclusively to painting.

LEJAREN A. HILLER

Milwaukee, 1880 – New York, 1969. Widely credited with establishing the field of photographic illustration, Lejaren A. Hiller created images that are notable for their carefully constructed composition and theatrical poses and lighting. After apprenticing as a lithographer, Hiller studied at the Art Institute of Chicago from 1896 to 1902 and then later in Paris. To pay for his studies, he began producing drawings, paintings, and photographs as illustrations for magazines. By 1904 he was living in New York. Over the following ten years his illustrations appeared on more than a thousand magazine covers. In 1913 he persuaded *Cosmopolitan* to let him illustrate one of its stories with photographs, and the positive response launched his successful career

in photographic illustration and advertising. His series *Surgery through the Ages* was commissioned by a pharmaceutical company and appeared nationwide in advertisements and posters. In 1929 Hiller joined Underwood and Underwood, where he met and inspired Ralph Bartholomew, Jr. Hiller's son, Lejaren Hiller, was a highly regarded composer.

HORST P. HORST (HORST PAUL ALBERT BOHRMANN)

Weissenfels, Germany, 1906 – Palm Beach Gardens, Florida, 1999. Over his sixty-year career, Horst P. Horst became renowned for his extravagant and inventive fashion photographs. A master of lighting, line, and form, he also created still lifes, nude studies, and celebrity portraits. Out of an interest in the avant-garde, Horst began studying architecture in 1926 at the Kunstgewerbeschule in Hamburg. In 1930 he moved to Paris to train with Le Corbusier, but a meeting with the photographer Baron George Hoyningen-Huene influenced him to move to photography. By 1932 he was working for *Paris Vogue* and associating with prominent artists. His first Paris exhibition was held that year, and in 1938 he showed his photographs at the German Seligman Gallery in New York. Horst moved permanently to New York in 1940. He continued to travel extensively, portraying many prominent members of high society, including Rita Hayworth, Jacqueline Bouvier Kennedy, Maria Callas, and Coco Chanel.

EIKOH HOSOE (TOSHIHIRO HOSOE)

Born in Yonezawa, Yamagata Prefecture, Japan, 1933. Eikoh Hosoe is best known for his intensely dramatic, high-contrast photographs. The son of a Shinto priest, he began photographing at age fourteen. Hosoe studied at the Tokyo College of Photography from 1951 to 1954 and began his freelance career after graduating. In 1956 he mounted his first solo exhibition in Tokyo, and in 1963 he was named "Photographer of the Year" by the Japan Photo Critics Association. In the 1960s Hosoe created three celebrated series of photographs, *Man and Woman*, *Killed by Roses* (re-edited as *Ordeal by Roses*), and *Kamaitchi*. His recurring themes include love and death, tradition and modernity, and the search for ultimate insight. Hosoe began teaching photography in 1975 at the Tokyo Institute of Polytechnics, and is director of the Kiyosato Museum of Photographic Arts.

GERTRUDE KÄSEBIER

Fort Des Moines, Iowa, 1852 – New York, 1934. The Pictorialist photographer Gertrude Käsebier (née Stanton) is best known for the natural, direct quality of her portraits of mothers with children. She took her first family photographs before entering the Pratt Institute in Brooklyn in 1889. In 1894, after winning recognition in two photography contests, she left for a year's art study in Europe. In France she found her vocation as an indoor portrait photographer, and in Germany she mastered the technical side of her craft. She apprenticed as a commercial portrait photographer in Brooklyn, showing 150 of her photographs at the Boston Camera Club in 1896. By 1898 she had opened her first New York studio and participated in the inaugural Philadelphia Photographic Salon. Käsebier was a founding member of the Photo-Secession and the Pictorial Photographers of America, and a friend to Edward Steichen and F. Holland Day. Her work was frequently published in Alfred Stieglitz's influential *Camera Notes* and *Camera Work*.

HAROLD F. KELLS

Ottawa, Ontario, 1904–1986. Harold Kells gained prominence in the 1930s for his Pictorialist figure studies and landscapes. He was admired for his combination of strong technical and artistic abilities. Trained as an artist, he worked in commercial art and took an interest in photography in the late 1920s. In 1931 he entered a photograph in the Toronto Salon of Photography. From 1932 to 1935 he garnered numerous international awards, including the London Salon of Photography's "Print of the Year" for *Death of Cleopatra*. He served on the executive of the Camera Club of Ottawa and helped organize the first Canadian International Salon of Photographic Art in 1934. From 1933 to 1938 Kells operated a studio in Ottawa, producing

photographic portraits and illustrations. At the beginning of the Second World War he was commissioned to make a series of photographs documenting the war effort. Shortly after, he left his studio work and spent the remainder of his career in the Public Relations Branch of the Post Office Department of Canada.

LES KRIMS (LESLIE ROBERT KRIMS)

Born in New York, 1943. In his provocative work as a photographer, Les Krims addresses political, sexual, and racial issues. Krims studied painting and printmaking, obtaining his BFA in 1964 from the Cooper Union and his MFA in 1967 from the Pratt Institute. He taught himself photography as a graduate student and began working as a freelance photographer in 1967. Early in his career Krims began photographing staged scenes, which he published as small books or portfolios. His 1971 portfolio *The Little People of America* was a tragicomic series on dwarfs. *Idiosyncratic Pictures*, from 1979–1980, explored racism and anti-Semitism. Drawing on the conventions of advertising, pornography, and Pop and Op art, Krims creates highly imaginative if sometimes grotesque scenes, often featuring nudes juxtaposed against bizarre props. Krims has taught at various schools since 1966, including the State University of New York at Buffalo. His work has been widely exhibited nationally and internationally, and he has been the subject of numerous articles.

MAN RAY (EMMANUEL RUDNITSKY)

Philadelphia, 1890 – Paris, 1976. Man Ray studied art at the Ferrer Center in New York. On a visit to the 1913 Armory Show he saw Cubist works by Pablo Picasso, Francis Picabia, and Marcel Duchamp that made a strong impression on him. He began photographing his own paintings that year, and soon became interested in portrait photography. Between 1915 and 1921 he published written work and illustrations, exhibited paintings, drawings, and collages, and made his first cliché-verre. In 1920 he began a series of photographs of Duchamp dressed as his female alter ego, Rrose Sélavy. The following year Man Ray moved to Paris, where he met the French Dadaists and Surrealists. During the 1920s he created photographic portraits of many celebrated artists and worked as a fashion photographer, while at the same time contributing to Surrealist journals and making films. Collaborating with Lee Miller from 1929 to 1932, he developed a new process for solarization. Major exhibitions of his work were presented in London and New York in 1936. Man Ray was a founding member of New York Dada and the Société anonyme. He won the gold medal at the 1961 Venice Biennale, and in 1988, twelve years after his death, he was honoured with a major retrospective exhibition at the Smithsonian Institution in Washington, D.C.

RALPH EUGENE MEATYARD

Normal, Illinois, 1925 – Lexington, Kentucky, 1972. An optometrist by trade, Ralph Eugene Meatyard took up photography in 1954, studying with Van Deren Coke at the University of Kentucky and later with Minor White and Henry Holmes Smith. He joined the Lexington Camera Club and the Photographic Society of America, and his work was featured in numerous exhibitions, including *The Sense of Abstraction*, a 1959 group show at the Museum of Modern Art. Throughout his photographic career, Meatyard was concerned with concepts of family, time, and identity. His earliest work featured his trademark fabricated scenes, including figures with masks, family members in ruined buildings, and blurred images. He also produced photographs of cemetery sculptures, studies of abstract patterns in nature, and a *Zen Twig* series. A voracious reader, Meatyard frequently alluded to literary sources; *Romance (N.) from Ambrose Bierce #3* refers to an entry in Bierce's satirical *Devil's Dictionary*.

DUANE MICHALS

Born in McKeesport, Pennsylvania, 1932. The narrative photographs of Duane Michals have had a significant impact on contemporary photography. Michals studied art education at the University of Denver and graphic design at the Parsons School of Design in New York. In 1958, while working as a graphic designer for Time-Life, he travelled on holiday to the Soviet Union. The critical success of the photographs he took on that trip led him to pursue a career in commercial photography. By 1960 he was producing photographs for *Esquire*, *Vogue*, and the *New York Times*. In 1966 Michals began making narrative photo-sequences, exploring areas of unconscious thought through themes of love, religion, fear, and death. Influenced by Surrealism, he often used blurring and multiple exposures to suggest dreams or fantasy. In 1974 he began incorporating written texts into his work, and he later experimented with painting on photographs. Among his many honours, Michals is an Officier de l'Ordre des Arts et des Lettres, France.

YASUMASA MORIMURA

Born in Osaka, Japan, 1951. Yasumasa Morimura trained at the Kyoto City University of Art, obtaining his BA in 1975 and returning in 1978 to pursue further studies in visual design. Since 1985 he has been creating large, elaborate works that merge photography, painting, sculpture, theatre, and computer imaging. His photographs explore contemporary values and questions of gender, race, and cultural identity. Morimura first exhibited his work in Kyoto in 1983, and he achieved international fame in 1988 with his *Art History* series. Often posing as a female character, he would insert himself into his interpretations of European masterpieces. In later series, he continued to explore the canon of Western art, as well as themes of consumerism, social inequality, and popular culture. Morimura has had solo exhibitions in Japan, France, and the United States.

WILLIAM MORTENSEN

Park City, Utah, 1897 – Laguna Beach, California, 1965. Known for his sometimes eccentric Pictorialist style, William Mortensen borrowed themes for his photographic work from theatre, cinema, and painting. Having studied painting and drawing at the Art Students League in New York, Mortensen began experimenting with photography while teaching art in Salt Lake City. In 1921 he moved to Hollywood and found work designing sets, making masks, and photographing actors. In 1926 he began exhibiting his work in photographic salons, including international shows. That same year he was commissioned to produce still photographs for Cecil B. DeMille's *The King of Kings*. The world of silent film influenced Mortensen's directorial style and storytelling approach: poses were often melodramatic, and the photographs were technically altered or manipulated for greater effect. He authored numerous articles and books, and founded the Mortensen School of Photography, thus leaving his mark on readers and students from around the world. Mortensen was a member of the Camera Pictorialists of Los Angeles and the Photographic Society of America.

ADI NES

Born in Kiryat Gat, Israel, 1966. Based in Tel Aviv, Adi Nes is best known for his large-format photographs of Israeli soldiers. Nes obtained his BFA in photography in 1992 from the Bezalel Academy in Jerusalem. In 1996–1997 he pursued further studies in multimedia at the Sivan Computer School in Tel Aviv. Highly regarded in Israel, he gained international attention in 1998 through solo exhibitions in Amsterdam and at the Jewish Museum in New York. Nes's elaborately staged photographs often reinterpret famous European paintings or familiar scenes from recent Israeli history. His photographs explore the themes of masculinity, fraternity, and identity, while at the same time addressing specific social realities in Israel. Nes was awarded the 2000 Nathan Gottesdiener Foundation Israeli Art Prize and the 2003 Constantiner Prize for Photography.

RUTH ORKIN

Boston, 1921 – New York, 1985. A photographer and filmmaker, Ruth Orkin grew up in Hollywood, the daughter of silent-movie star Mary Ruby. She began developing her own photographs at age twelve, and was soon photographing celebrities. In 1943 Orkin moved to New York, where she worked first as a portrait and nightclub photographer and then as a photojournalist. From 1945 to 1952 she did extensive freelance work for major magazines, including a series of images of great musicians

in rehearsal. A trip to Israel in 1951 to photograph the Israel Philharmonic Orchestra led to an extended stay overseas. In Florence she created her signature image, *American Girl in Italy*. Orkin married the photographer Morris Engel in 1952 and collaborated with him on the film *Little Fugitive*, which won the Silver Lion at the Venice Film Festival in 1953 and was nominated for an Academy Award.

PAUL OUTERBRIDGE, JR.

New York, 1896 – Laguna Beach, California, 1958. Acclaimed for his work in carbro colour printing and for his elegant sense of design, Paul Outerbridge, Jr., studied in New York at the Art Students League and at the Clarence White School of Photography. In 1922 he began working as a freelance photographer for *Vogue*, *Harper's Bazaar*, and *Vanity Fair*, and shortly afterward trained under the sculptor Alexander Archipenko. He moved to Paris in 1925 and became acquainted with Man Ray, Duchamp, and Steichen, as well as Picasso, Stravinsky, and Picabia. Working for *Paris Vogue*, he also began to explore themes of eroticism, decadence, and fetishism. Outerbridge returned to New York in 1929 and worked at mastering his colour technique in commercial photography and in nude studies. He was very successful in magazine and advertising photography during the 1930s, and published his classic book, *Photography in Colour*, in 1940. In 1943 he moved to California and continued to photograph in semi-retirement.

WILLIAM LAKE PRICE

England, 1810–1895. William Lake Price was trained as an architectural and topographical artist, studying under the eminent architect Augustus Charles Pugin. From 1828 to 1832 he frequently exhibited his paintings at the Royal Academy and the Society of Painters in Water Colours. He took up photography in 1854, joining the Photographic Society of London and the Photographic Exchange Club of London. He submitted his first entry to the society's annual *Photographic Album* in 1855. That same year he exhibited a series of reconstructed historical scenes and began taking stereoscopic photographs. His image of *The Scene in the Tower* inspired Lewis Carroll to take up photography in 1856. In 1858 Price published a series of photographs entitled *Portraits of Eminent British Artists* as well as *A Manual of Photographic Manipulation*.

VICTOR ALBERT PROUT

Bristol, England, 1835 – England, 1877. Victor Prout, son of the painter John Skinner Prout, was active in both England and Australia. He exhibited his work at the Photographic Society of London as early as 1856, and opened a successful photographic business in London in 1860. For his 1862 album of photographs of the Thames from London to Oxford, Prout used a panoramic camera to create poetic images of riverside life. His 1864 album of photographs taken at Mar Lodge, in Scotland, included a series of portraits of the Prince and Princess of Wales. In 1866 Prout moved to Sydney, Australia, where he had spent four years of his childhood. Joining the respected studio of James and William Freeman, he produced landscapes, cityscapes, and portraits, establishing a reputation as a photographer of high society. By 1869 Prout had opened his own studio in Sydney and was advertising colourized photographs. In 1876 he returned to England, where he died the following year.

WILLIAM H. RAU

Philadelphia, 1855–1920. William Herman Rau was noted for his combined artistic, technical, and commercial abilities. Through his father-in-law, the photographer William Bell, Rau obtained a government position in 1874 to photograph the transit of Venus. In 1881 and 1882 he went on photographic expeditions to the American Southwest, Egypt, and the Holy Land, publishing his photographs of Colorado and New Mexico in *The Philadelphia Photographer*. In the 1880s and 1890s Rau participated in the annual joint exhibitions of the Photographic Society of Philadelphia, and in 1885 he opened a successful portrait studio. From 1890 to 1895 he was engaged as the official photographer for the Pennsylvania Railroad and the Lehigh Valley Railroad, creating his best-known works. His panoramic views, taken with

a mammoth-plate camera and printed on albumen contact paper, are remarkable for their tonal depth and detail. Rau also made a series of popular humorous stereographs, staging one-line jokes in his studio.

OSCAR GUSTAVE REJLANDER

Sweden, 1813 (?) – London, 1875. First known as a painter and lithographer, Oscar Gustave Rejlander pioneered the practice of combination printing, a photographic technique in which two or more negatives are used to create a single print. After studying art and antiquity in Rome, Rejlander settled in England, exhibiting his paintings at the Royal Academy in 1848. He learned photography from Nicholas Henneman in 1853. In 1857 and 1858 he exhibited his *Two Ways of Life*, a large allegorical study, at the Manchester Art Treasures Exhibition and at the Photographic Society of London. He met Henry Peach Robinson in 1858 and introduced him to his techniques. Rejlander established a studio in London in 1862 and subsequently concentrated on portrait work; his sitters included Lewis Carroll and Gustave Doré. In 1871–1872 he produced the illustrations for Charles Darwin's *The Expression of the Emotions in Man and Animals*.

GUIDO REY

Turin, 1861–1935. One of the leading Italian art photographers of his day, Guido Rey took his first photographs in the mid-1880s. Using the new portable camera, he documented his mountain climbing expeditions, winning a silver medal from the Italian Alpine Club in 1893. In 1895 Rey began creating images inspired by Greek and Roman compositions, and from 1898 to 1905 he produced works after the Dutch masters Johannes Vermeer and Pieter de Hooch. He was widely published in Italy, and was awarded an honorary diploma at the 1900 International Exhibition of Artistic Photography in Turin. By 1903 his photographs were appearing regularly in American magazines. He won first honourable mention at the 1906 New York Salon of the Metropolitan Camera Club. Two of his photographs appeared in *Camera Work* in 1908. Rey participated in the Photographic Salon of London from 1910 to 1915.

HENRY PEACH ROBINSON

Linney, Ludlow, Shropshire, England, 1830 – Tunbridge Wells, Kent, England, 1901. A master of the combination printing technique, Henry Peach Robinson was, along with Oscar Gustave Rejlander, a champion of genre and fine art photography. A trained artist, he exhibited a painting at the Royal Academy of Art in 1852. From 1844 to 1855 he was primarily engaged in bookselling and publishing. He learned photography from an itinerant daguerreotype portraitist, and was inspired by a meeting with the photographer Hugh Diamond at the Great Exhibition of 1851 in London. Robinson began photographing in 1852, and in 1857 joined the Photographic Society of London. He opened a studio first in Leamington Spa and later in Tunbridge Wells. Robinson was elected vice-president of the Photographic Society in 1887, later resigning and forming the rival Linked Ring association of photographers. Robinson wrote numerous influential works on photography, his landmark volume being the 1869 *Pictorial Effect in Photography*.

CINDY SHERMAN

Born in Glen Ridge, New Jersey, 1954. At the crossroads of photography and performance, Cindy Sherman's work explores questions of female identity and stereotypes. Sherman studied photography at the State University of New York at Buffalo, obtaining her BA in 1976, and moved to New York in 1977. In her student years she began making sequential series of staged photographs featuring herself in various guises. Her *Untitled Film Stills*, created between 1977 and 1980, quickly garnered attention; the series of eighty black-and-white images featured Sherman posing in suspenseful, Hitchcock-like scenes. A proposed commission by the magazine *ArtForum* inspired her 1981 *Centerfold* (or *Horizontals*) series, in which she posed as the lovelorn girl. From the mid-1980s to the mid-1990s she incorporated carnivalesque and grotesque imagery into such series as *Fairy Tales*,

Disasters, and *Horror Pictures*. Widely exhibited, Sherman's oeuvre has become an influential force in contemporary art.

YINKA SHONIBARE

Born in London, 1962. Photographer, painter, sculptor, and installation artist, Yinka Shonibare was born in London but grew up in his parents' homeland of Nigeria. On his return to London at age eighteen, he became immersed in the heady 1980s art scene. He studied at the Byam Shaw School of Art from 1984 to 1989 and then at Goldsmiths College. Shonibare began exhibiting his work in 1988, and by the early 1990s was using African-style print cloth (made in the Netherlands) to illustrate themes of colonialism, imperialism, and social mobility. His 1998 series *Diary of a Victorian Dandy* was commissioned by London Underground as a public art project. The staged images of Shonibare himself interacting with white actors invert the traditional roles of blacks and whites found in European art. Shonibare has participated in dozens of international exhibitions, including the Venice Biennale in 2001 and Documenta (Kassel) in 2002. The winner of many awards, he was shortlisted for the 2004 Turner Prize.

MICHAEL SNOW

Born in Toronto, 1929. One of Canada's foremost artists, Michael Snow is a painter, sculptor, filmmaker, photographer, and musician. After graduating from the Ontario College of Art in 1952, Snow worked for a year in a commercial art firm. From 1963 to 1970 he and his first wife, the artist Joyce Wieland, lived in New York, where they became immersed in the avant-garde art scene. It was at this time that Snow began making photographs. His 1967 film *Wave Length* is considered a key work in the history of North American avant-garde cinema. Snow has been the subject of numerous international exhibitions, including ones in Toronto, Tokyo, and Paris. A 1999 retrospective of his photographic works was shown in Brussels, Paris, and Geneva. Snow is an Officer of the Order of Canada and a Chevalier de l'Ordre des Arts et des Lettres, France.

EVE SUSSMAN

Born in London, 1961. The American artist Eve Sussman grew up in Lexington, Massachussets, but has also lived in India, Israel, Turkey, and New Zealand. She studied printmaking and photography at Bennington College in Vermont, graduating with a BA in fine arts in 1984. During a nine-week residency in 1989 at the Skowhegan School of Painting and Sculpture in Maine she gained experience in sculpture and installation art. Sussman has created works incorporating film, video, sculpture, and architecture. She has collaborated on theatre, dance, and film projects, and has undertaken curatorial activities. In 2003 she founded The Rufus Corporation, a collective of actors, dancers, musicians, and a choreographer. The group's video installation *89 Seconds at Alcázar* premiered to international acclaim at the 2004 Whitney Biennial. The twelve-minute looping video is an imaginative re-creation of Velázquez's painting *Las Meninas*. Sussman lives in New York.

WILLIAM HENRY FOX TALBOT

Melbury, Dorset, England, 1800 – Lacock, Wiltshire, England, 1877. The polymathic inventor of the positive-negative photographic process, William Henry Fox Talbot graduated from Cambridge in mathematics. On an 1833 holiday at Lake Como, Italy, he made sketches of the scenery with the aid of a drawing tool, a *camera lucida*; unsatisfied with the results, he began thinking about how to imprint projected images directly onto paper using a *camera obscura*. In 1835 he made his first successful negative image of a botanical specimen, using the photogenic drawing technique. Not until 1839 did he reveal his process to the public. Talbot developed the calotype, or Talbotype, in 1840 and patented it in 1841. In 1843 he made a photographic trip to France, and from 1844 to 1846 produced *The Pencil of Nature*, the first commercially published book with photographic illustrations. Talbot was a fellow of the Royal Society.

WARREN THOMPSON

Born in the United States, Warren Thompson was active in Philadelphia from 1840 to 1846, where he obtained a patent for colouring daguerreotypes. By 1847 he had established himself in Paris, working with the Russian photographer Serge Lewitsky. Using unconventionally large half-plates, Thompson soon established a reputation as a fine daguerreotypist, winning a bronze medal at the 1849 Exposition de l'industrie française. In 1851 he photographed the solar eclipse, and in 1852 he was appointed an official photographer at the Champs de Mars military festivities. Thompson was a pioneer of photographic enlargements; at the Exposition universelle of 1855 he and Robert J. Bingham were awarded a first-class medal for their series of life-size portraits. Throughout the 1850s Thompson specialized in stereo-daguerreotypy, a process he used to masterly effect in his series of self-portraits.

BILL VIOLA

Born in New York, 1951. One of the world's most celebrated video artists, Bill Viola obtained his BFA from Syracuse University in 1973. During the 1970s he travelled widely, working in a video art studio in Florence and documenting performing arts in the South Pacific. In 1980–1981 he held an artist residency in Japan and studied Zen Buddhism. Over his career, Viola has created videos, installations, and audio works focusing on the themes of birth, death, time, and consciousness. A number of his recent installation series, including the 1995 *Buried Secrets*, have drawn upon medieval and Renaissance paintings. Viola represented the United States at the 1995 and 2001 Venice Biennales. He has been the subject of numerous exhibitions, including a 1997 travelling retrospective. Viola holds several honorary doctorates, and in 2000 he was elected to the American Academy of Arts and Sciences.

JEFF WALL

Born in Vancouver, 1946. Jeff Wall studied art history and fine arts at the University of British Columbia, obtaining his MA in 1970. Over the next three years he pursued doctoral research in art history at the Courtauld Institute in London, and from 1976 to 1987 was an associate professor at Simon Fraser University's Centre for the Arts. Wall's photographs unite nineteenth-century painting traditions with a cinematic approach. On large colour transparencies, set in light boxes and backlit, he explores contemporary themes relating to violence, alienation, and problems of gender. Actors are posed in elaborately constructed scenes that are often manipulated digitally. Wall's recent work has included large black-and-white prints. A key figure in the Vancouver arts scene, he has received many international honours, including the 2002 Hasselblad Award and the 2003 Roswith Haftmann Prize.

WANG QINGSONG

Born in Hubei Province, China, 1966. Wang Qingsong obtained his BFA in 1991 from the Sichuan Academy of Fine Arts. Trained as a painter, he began making elaborate digital composite photographs in 1996. Using visual wit and satire, Wang documents the extraordinary economic and cultural changes taking place in China. He is linked to Beijing's "Gaudy Art" movement, which employs garish colours and images of popular culture to comment on China's restructuring. In his early work Wang created relatively simple, fantasy-like scenes. Since 2000 his compositions have become more complex, populated with large groups of figures. His 2001 series *Another Battle* borrows images from Chinese action movies to depict the struggle between ancient Chinese civilization and contemporary Western consumerism. *China Mansion* and *Romantique*, both from 2003, make reference to historical European masterpieces of art. Wang lives and works in Beijing. He is widely exhibited, and in recent years has had solo shows in Milan, New York, and Arras, France.

WEEGEE (ARTHUR FELLIG)

Zloczow, Austrian Galicia (now Zolochiv, Ukraine), 1899 – New York, 1968. Along with his family, Weegee immigrated to the United States in 1910, settling in New York's Lower East Side. He left school at age fourteen to earn money as a commercial

photographer's assistant. Starting in the early 1920s he worked as a darkroom technician, first at the *New York Times* and then at Acme Newspictures, where he also began taking late-night press photographs. In 1935 he set out on his own as a freelance photographer. Over the next decade, tabloids and picture magazines displayed his often shocking black-and-white scenes of New York at night – accidents, fires, murders, suicides – and his candid portrayals of the city's social extremes. Weegee's inclusion in several exhibitions at the Museum of Modern Art in the early 1940s and the publication of his book *Naked City* in 1945 brought him wider acclaim. From 1947 to 1952 he lived in Hollywood, where he became involved in filmmaking and photographed movie stars. During his later years he experimented with new photographic techniques while continuing to publish and exhibit his work.

CARRIE MAE WEEMS

Born in Portland, Oregon, 1953. Photographer, installation artist, folklorist, and teacher, Carrie Mae Weems first took an interest in documentary photography in her twenties. She went on to study at the California Institute of the Arts, Valencia, and in 1984 obtained her MFA in photography from the University of California, San Diego. From 1984 to 1987 she studied African American folklore at the University of California, Berkeley. In photographic works that often incorporate text, audio, and sculptural components, Weems explores the African American experience, the legacy of slavery, and issues of identity and gender. Her early series include *Family Pictures and Stories* (1978–1983), *Ain't Jokin'* (1987–1988), and *Coloured People* (1989–1990). In *The Kitchen Table* series (1987–1992) Weems poses in characteristically spare compositions that deal with female identity and relationships. Weems has taught at various colleges and universities. She was awarded an honorary doctorate in 1999 by the California College of Arts and Crafts.

EDWARD WESTON

Highland Park, Illinois, 1886 – Carmel, California, 1958. Edward Weston's work is distinguished by its precise, sculptural images and subtle tones. Weston studied at the Illinois College of Photography and settled in California in 1911. Over the next ten years, he won many awards for his soft-focus, Pictorialist photographs. By 1920, however, he was experimenting with semi-abstractions and hard edges, and within two years had turned in earnest to "straight" images. Weston moved to Mexico in 1923, befriending artists of the Mexican Renaissance and creating sharp-focus studies. Returning to California in 1926, he began a series of abstract-form close-ups featuring nudes and such still-life subjects as seashells and vegetables. A 1941 commission to illustrate Walt Whitman's *Leaves of Grass* was interrupted by the war, and that same year Weston was diagnosed with Parkinson's disease. His subsequent "portraits with backgrounds" demonstrate a dramatically changed approach, connecting the human figure to the environment and also conveying a sense of disillusionment. Weston was a founding member of Group f/64, and was the first recipient of a Guggenheim Fellowship for photography.

MADAME YEVONDE (YEVONDE CUMBERS MIDDLETON)

London, 1893–1975. The Pictorialist photographer Madame Yevonde is recognized for her innovative use of colour and her photographic portraits. The young Yevonde Cumbers became inspired by the suffragette movement while attending boarding school in Belgium. On her return to London she took up photography, apprenticing from 1911 to 1914 with the society photographer Lallie Charles. In 1914 she set up her own portrait studio. Her photographs were published in society magazines, and in 1925 she began to take on advertising work. In the 1930s she experimented with colour cellophane and filters. Her celebrated *Goddesses* series, in which society women pose as Classical deities, demonstrates a characteristically baroque "camp" style and love of artifice. Popular as a lecturer, she was named a fellow of the Royal Photographic Society in 1940.

ANNE ZAHALKA

Born in Sydney, Australia, 1957. Emerging from the Postmodernist movement of the 1980s, Anne Zahalka explores contemporary values, questions of national identity, and the tension between artifice and reality. Zahalka studied visual arts at the Sydney College of the Arts and obtained her MFA in 1994 from the College of Fine Arts, University of New South Wales. In two early series of photographs, *Immigrants* (1985) and *Resemblance* (1987), Zahalka produced staged photographs reminiscent of well-known paintings. The former series was based on early Australian scenes of bush-whacking pioneers. The latter series, created during a twelve-month residency in Berlin, drew on seventeenth-century Dutch genre painting. Later series, such as *Open House* and *Leisureland*, examined modern Australian society. Zahalka's work has been widely exhibited nationally and internationally and has been the subject of numerous articles.

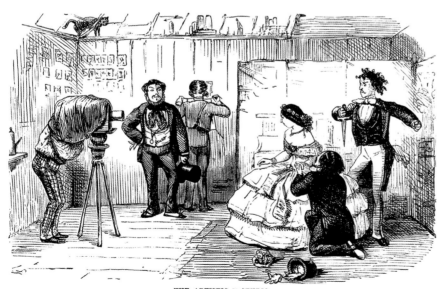

THE ARTISTIC (?) STUDIO.
A Stereoscopic Scene from Fashionable Life.
"*Love, Pride, Revenge.*"—THE GROUP REPRESENTS A YOUNG MINSTREL OF HUMBLE ORIGIN, DECLARING HIS PASSION TO A LADY OF NOBLE PARENTAGE, HER HAUGHTY BROTHER, AS MAY BE SEEN FROM HIS MENACING ATTITUDE, IS ABOUT TO AVENGE THE INSULT OFFERED TO HIS FAMILY!

WORKS IN
THE EXHIBITION

Dimensions given are sheet size unless otherwise specified.

ELEANOR ANTIN
Death of Petronius, from the series
The Last Days of Pompeii, 2001 [fig. 78]
Dye coupler print, 118.4 × 240.4 cm
Courtesy Ronald Feldman Fine Arts, New York

TINA BARNEY
The Son, 1987, printed 1991 [fig. 134]
Dye coupler print, 50.7 × 60.9 cm
National Gallery of Canada, Ottawa, Gift of
Photographers + Friends United Against AIDS,
New York, 1988 (39859.2)

RALPH BARTHOLOMEW, JR.
Untitled, 1954 [fig. 38]
Gelatin silver print, 27.5 × 35.2 cm
Los Angeles County Museum of Art, Gift of the
Bartholomew Family, Courtesy Keith de Lellis Gallery,
New York (AC1998.1.6)

HIPPOLYTE BAYARD
Self-Portrait as a Drowned Man, 1840 [fig. 1]
Dye coupler print, modern reproduction of a
Bayard direct-positive process print, 22 × 22.7 cm
(original print 18.7 × 19.3 cm)
Société française de photographie, Paris

HERBERT BAYER
Knight with Flowers, 1930, printed later [fig. 114]
Gelatin silver print, 23.9 × 30.2 cm
National Gallery of Canada, Ottawa (29158)

ERWIN BLUMENFELD
Untitled, c. 1936–1940 [fig. 35]
Gelatin silver print, 30.1 × 24.4 cm
National Gallery of Canada, Ottawa, Gift of Rodney
and Cozette de Charmoy Grey, Geneva, 1979 (20883)

CLAUDE CAHUN
Self-Portrait, 1920 [fig. 6]
Gelatin silver print, 11.9 × 8.9 cm
Collection of Richard and Ronay Menschel, New York

JULIA MARGARET CAMERON
Pray God Bring Father Safely Home, 1872,
printed 1910 [fig. 63]
Gelatin silver print, 37.8 × 29.5 cm (image)
J. Paul Getty Museum, Los Angeles (84.XM.349.14)

Go Not Yet (The Fisherman's Farewell), 1874 [fig. 62]
Albumen silver print, 34.9 × 27.3 cm (image)
J. Paul Getty Museum, Los Angeles (95.XM.54.1)

Vivien and Merlin, 1874 [fig. 65]
Albumen silver print, 31 × 26.7 cm (image)
J. Paul Getty Museum, Los Angeles (84.XO.732.2.6)

Emily Peacock (Ophelia), 1875, printed 1900 [fig. 64]
Carbon print, 35.3 × 27.6 cm (image)
J. Paul Getty Museum, Los Angeles (84.XM.349.15)

LEWIS CARROLL
Saint George and the Dragon, 1875 [fig. 85]
Albumen silver print, 11.6 × 14.8 cm
The Metropolitan Museum of Art, New York, Gilman
Collection, Purchase, Ann Tenenbaum and Thomas
H. Lee Gift, 2005 (2005.100.21)

CAROLE CONDÉ AND KARL BEVERIDGE
*Oshawa – A History of Local 222, United Auto
Workers of America, CLC 1982–1983 / (Part 2)
1938–1945*, 1982–1983, printed 1989 [fig. 76]
6 azo dye prints (Cibachrome), image dimensions
40 × 50.2 cm (EX-89-86), 39.8 × 50.4 cm (EX-89-87),
40 × 50.5 cm (EX-89-88), 40 × 50.5 cm (EX-89-89),
39.8 × 50.4 cm (EX-89-90), 39.9 × 50.3 cm
(EX-89-91)
Canadian Museum of Contemporary Photography,
Ottawa

GREGORY CREWDSON
Untitled, 2001 [fig. 135]
Dye coupler print from a digital image,
121.9 × 152.4 cm
Courtesy of the artist and Luhring Augustine, New York

Untitled, 2001 [fig. 136]
Dye coupler print from a digital image,
121.9 × 152.4 cm
Courtesy of the artist and Luhring Augustine, New York

F. HOLLAND DAY
The Seven Last Words of Christ, 1898 [fig. 25]
Platinum print, 8.3 × 35.2 cm
Library of Congress, Washington, D.C., Prints and
Photographs Division, The Louise Imogen Guiney
Collection (LC-USZC4-3329)

ROBERT DOISNEAU
*The Kiss at the Hôtel de Ville
(The Kiss on the Sidewalk)*, 1950 [fig. 124]
Gelatin silver print, 24.4 × 30.7 cm
Ackland Art Museum, University of North Carolina
at Chapel Hill, Gift of William A. Hall, III (81.63.1.2)

JAKUB DOLEJŠ
Escape to West Germany, 1972, 2002 [fig. 77]
Dye coupler print, 199 × 122 cm
Courtesy of the artist and Angell Gallery, Toronto

*Caspar David Friedrich Sketching My Homeland,
1810*, 2003 [fig. 46]
Dye coupler print, 122 × 152 cm
Courtesy of the artist and Angell Gallery, Toronto

FREDERICK H. EVANS
F. Holland Day in Algerian Costume, 1901 [fig. 18]
Platinum print, 23.9 × 12.1 cm
George Eastman House, Rochester, Museum
Purchase, ex-collection Gordon Conn
(1981:1198:0083)

F. Holland Day in Arab Costume, 1901 [fig. 19]
Platinum print, 21.6 × 16.5 cm
Los Angeles County Museum of Art, The Audrey
and Sydney Irmas Collection (AC1992.197.40)

EVERGON
Le Pantin, 1985 [fig. 51]
Instant dye print (Polacolor), 244.1 × 113.1 cm
Canadian Museum of Contemporary Photography,
Ottawa (EX-86-372)

ROGER FENTON
Study of Mother and Daughter Mourning over a Deceased Child, 1856–1857, printed 1857 [fig. 69]
Salted paper print, 31.2 × 27.2 cm
George Eastman House, Rochester, Museum Purchase, ex-collection A.E. Marshall (1981:1791:0004)

ANNE FERRAN
Scenes on the Death of Nature, I and II, 1986, printed 1989 [fig. 44]
Gelatin silver prints, 126.9 × 162.9 cm, 124.6 × 143.7 cm
George Eastman House, Rochester, Museum Purchase, Ford Motor Co. Fund (1989:0332:0001 and 1989:0332:0002)

ADAD HANNAH
Cuba Still (Remake), 2005 [fig. 50]
Video installation
Collection of the artist, Montreal

DUANE HANSON
Self-Portrait with Model, 1979 [fig. 11]
3 Instant Prints (Kodak), 6.7 × 9.2 cm each
Courtesy Laurence Miller Gallery, New York

GABRIEL HARRISON
California News, c. 1850 [fig. 71]
Daguerreotype, 14 × 10.5 cm (plate)
The Metropolitan Museum of Art, New York, Gilman Collection, Purchase, The Horace W. Goldsmith Foundation Gift, 2005 (2005.100.334)

ALEXANDER HESLER
Driving a Bargain, 1853 [fig. 70]
Crystalotype copy of a daguerreotype, 20.6 × 15.7 cm
George Eastman House, Rochester (1989:0907:0007)

DAVID OCTAVIUS HILL AND ROBERT ADAMSON
The Morning After ("He, Greatly Daring, Dined"), c. 1845 [fig. 55]
Salted paper print, 20.5 × 15.2 cm
George Eastman House, Rochester, Gift of Alden Scott Boyer (1981:2389.0001)

Mrs. Elizabeth Cockburn Cleghorn and John Henning as Miss Wardour and Eddie Ochiltree from Sir Walter Scott's "The Antiquary," 1846–1847 [fig. 56]
Salted paper print, 20.6 × 15.7 cm (image)
J. Paul Getty Museum, Los Angeles (88.XM.57.21)

LEJAREN A. HILLER
Étienne Gourmelen, from the series *Surgery through the Ages*, c. 1927–1938 [fig. 118]
Gelatin silver print, 45.6 × 37.5 cm
George Eastman House, Rochester (77:0081:0012)

HORST P. HORST
Electric Beauty, 1939, printed later [fig. 122]
Gelatin silver print, 35.3 × 27.7 cm
National Gallery of Canada, Ottawa (41643)

EIKOH HOSOE
Killed by Roses, no. 34, 1962 [fig. 117]
Gelatin silver print, 28.7 × 19.5 cm
National Gallery of Canada, Ottawa (22846.34)

GERTRUDE KÄSEBIER
The Manger (Ideal Motherhood), 1899, printed 1903 [fig. 94]
Photogravure, 21.1 × 14.8 cm
National Gallery of Canada, Ottawa (PSC68:039:2)

HAROLD F. KELLS
Death of Cleopatra, 1934 [fig. 97]
Gelatin silver print, 39.4 × 47.1 cm
National Gallery of Canada, Ottawa (31286)

LES KRIMS
The Nostalgia Miracle Shirt, 1971 [fig. 73]
Gelatin silver print, 16.5 × 22.5 cm
National Gallery of Canada, Ottawa (31310)

MAN RAY
Rrose Sélavy, 1923 [fig. 5]
Gelatin silver print, 22.1 × 17.6 cm (image)
J. Paul Getty Museum, Los Angeles (84.XM.1000.80)

Self-Portrait with Dead Nude, c. 1930 [fig. 36]
Gelatin silver print, modern print from original negative, 2006, 6 × 9 cm
Centre Pompidou, Paris, Musée national d'art moderne / Centre de création industrielle

Les larmes (Tears), work print, 1932 [fig. 109]
Gelatin silver print, 8.5 × 6 cm
Centre Pompidou, Paris, Musée national d'art moderne / Centre de création industrielle (AM 1994-394 [2263])

RALPH EUGENE MEATYARD
Romance (N.) from Ambrose Bierce #3, 1964, printed 1974 [fig. 75]
Gelatin silver print, 16.9 × 17.5 cm
National Gallery of Canada, Ottawa (31641.4)

DUANE MICHALS
The Mirror, 1972 [fig. 74]
6 gelatin silver prints with hand-applied text, 12.1 × 15.9 cm each
Courtesy Pace/MacGill Gallery, New York

YASUMASA MORIMURA
Portrait (Futago), 1988 [fig. 131]
Dye coupler print with acrylic gel medium, 210.2 × 299.7 cm
San Francisco Museum of Modern Art, Collection of Vicki and Kent Logan, Fractional and promised gift to the San Francisco Museum of Modern Art (97.788)

To My Little Sister: For Cindy Sherman, 1998 [fig. 43]
Azo dye print (Ilfochrome), 88.6 × 142.5 cm
National Gallery of Canada, Ottawa (41421)

WILLIAM MORTENSEN
Flemish Maid, c. 1935 [fig. 96]
Gelatin silver print, 18.2 × 14.1 cm
National Gallery of Canada, Ottawa (32109.5)

ADI NES
Untitled, 1999 [fig. 47]
Dye coupler print, 180.7 × 304.8 cm
Museum of Contemporary Art San Diego, Museum Purchase, Joyce R. Strauss Fund (2001.32)

RUTH ORKIN
American Girl in Italy, 1951 [fig. 125]
Gelatin silver print, 11.9 × 35.6 cm
Collection of Alan and Susan Solomont, Newton, Mass.

PAUL OUTERBRIDGE, JR.
The Coffee Drinkers, c. 1939 [fig. 3]
Carbro colour print, 30.9 × 42.1 cm
The Metropolitan Museum of Art, New York, The Ford Motor Company Collection, Gift of Ford Motor Company and John C. Waddell, 1987 (1987.1100.29)

WILLIAM LAKE PRICE
Don Quixote in His Study, 1857 [fig. 57]
Albumen silver print, 31.9 × 28 cm
The Metropolitan Museum of Art, New York, Gift of A. Hyatt Mayor, 1969 (69.635.1)

VICTOR ALBERT PROUT
Mary Queen of Scots Attended by Rizzio: Tableau Featuring the Hon. Lewis Wingfield and Miss G. Moncrieffe, 1863 [fig. 86]
Albumen silver print, 8.5 × 7.5 cm
Scottish National Portrait Gallery, Edinburgh (PGP 162.33)

WILLIAM H. RAU
Mr. and Mrs. Turtledove's New French Cook, 1902 [fig. 72]
12 dye coupler transparencies, modern reproductions of 12 gelatin silver stereographs,
Dimensions for each image within the stereographs:
 Mr. and Mrs. Turtledove's New French Cook, 7.7 × 15.2 cm
 "You Sweet Thing, When Did You Arrive?" 7.8 × 15.3 cm
 "Now Don't Be So Shy!" 7.7 × 15.1 cm
 "Oh My! But You Are Lovely." 7.7 × 15.1 cm
 "Sh! Sh!! I Hear My Wife Coming." 7.7 × 15.2 cm
 "Heavens! What Does She Mean?" 7.6 × 15.2 cm
 "Well, I Am Caught Sure Enough." 7.8 × 15.2 cm
 "She Must Leave This House at Once." 7.7 × 15.2 cm
 Mr. Turtledove Trying to Get Out of the Difficulty, 7.8 × 15.2 cm
 Mr. Turtledove Making Promises to Be Good, 7.8 × 15.2 cm
 "Darling, I Love You More than Ever." 7.7 × 15.2 cm
 Mr. and Mrs. Turtledove's Next "French" Cook, 7.8 × 15.2 cm
National Gallery of Canada, Ottawa (32617.1–12)

OSCAR GUSTAVE REJLANDER
The First Negative, 1857 [fig. 29]
Salted paper print, 22.4 × 15 cm
Hans P. Kraus, Jr., New York

Two Ways of Life, c. 1857 [fig. 2]
Albumen silver print, 21.8 × 40.8 cm
Moderna Museet, Stockholm (FM 1965 001 777)

Head of Saint John the Baptist in a Charger,
c. 1858 [fig. 67]
Albumen silver print, 14 × 18 cm (oval)
George Eastman House, Rochester, Museum
Purchase, ex-collection A.E. Marshall
(1981:1791:0003)

Hard Times, c. 1860 [fig. 68]
Albumen silver print, 13.9 × 19.9 cm
George Eastman House, Rochester, Museum
Purchase, ex-collection A.E. Marshall
(1972:0249:0042)

The Artist Introduces O.G.R. the Volunteer,
c. 1871 [fig. 24]
Albumen silver print, 10 × 11.3 cm
National Museum of Photography, Film and Television,
Bradford, England

Poor Jo, before 1862, printed after 1879 [fig. 138]
Carbon print, 20.3 × 15.7 cm
National Gallery of Canada, Ottawa (37076)

GUIDO REY
Four Figures in Classical Robes, c. 1895 [fig. 34]
Platinum print, 14.9 × 8.9 cm (image)
J. Paul Getty Museum, Los Angeles (94.XM.9.1)

The Letter, 1908 [fig. 33]
Platinum print, 22.2 × 14 cm (image)
J. Paul Getty Museum, Los Angeles (85.XP.314.7)

HENRY PEACH ROBINSON
"She Never Told Her Love" (study for *Fading Away*),
1857 [fig. 82]
Albumen silver print, 18 × 23.2 cm
The Metropolitan Museum of Art, New York, Gilman
Collection, Purchase, Jennifer and Joseph Duke Gift,
2005 (2005.100.18)

Fading Away, 1858 [fig. 81]
Albumen silver print, 23.8 × 37.9 cm
National Museum of Photography, Film and Television,
Bradford, England

Red Riding Hood, 1858 [fig. 58]
4 albumen silver prints, image dimensions
24.5 × 19.4 cm (2003-5001_2_22382),
24.3 × 17.1 cm (2003-5001_2_22383),
24.4 × 19.5 cm (2003-5001_2_22384),
24.9 × 19.1 cm (2003-5001_2_22385)
National Museum of Photography, Film and Television,
Bradford, England

The Lady of Shalott, 1861 [fig. 59]
Albumen silver print, 35 × 52 cm
Harry Ransom Humanities Research Center,
The University of Texas at Austin, Gernsheim
Collection (964:0661:0002)

Dawn and Sunset, 1885 [fig. 61]
Platinum print, 54.3 × 75.7 cm
Harry Ransom Humanities Research Center,
The University of Texas at Austin, Gernsheim
Collection (964:0661:0007)

**HENRY PEACH ROBINSON AND
NELSON KING CHERRILL**
Preparing Spring Flowers for Market, 1873 [fig. 60]
Albumen silver print, with applied colour,
55.9 × 76.2 cm (image)
J. Paul Getty Museum, Los Angeles (86.XM.603)

CINDY SHERMAN
Untitled Film Still #16, 1978 [fig. 129]
Gelatin silver print, 119.8 × 99.7 × 6.2 cm (framed)
Vancouver Art Gallery, Major Purchase and
Acquisitions Funds (VAG 2002.27.17)

Untitled #96, 1981 [fig. 42]
Dye coupler print (Ektacolor), 61 × 121.9 cm
Collection of Robert and Jane Rosenblum

Untitled #223, 1990 [fig. 41]
Dye coupler print, 147.3 × 106.7 cm
The Museum of Contemporary Art, Los Angeles,
Partial and promised gift of Beatrice and Philip Gersh
(97.162)

YINKA SHONIBARE
Diary of a Victorian Dandy, 1998 [fig. 132]
 Diary of a Victorian Dandy: 11:00 hours [fig. 132a]
 Diary of a Victorian Dandy: 14:00 hours [fig. 132b]
 Diary of a Victorian Dandy: 17:00 hours [fig. 132c]
 Diary of a Victorian Dandy: 19:00 hours [fig. 132d]
 Diary of a Victorian Dandy: 3:00 hours [fig. 132e]
5 dye coupler prints, artist's frames,
122 × 183 cm each
Collection of John and Amy Phelan, New York

MICHAEL SNOW
Flash! 20:49, 15/6/2001, 2001 [fig. 49]
Dye coupler print, 121.9 × 181.6 cm
Courtesy of the artist and Jack Shainman Gallery,
New York

EVE SUSSMAN
89 Seconds at Alcázar, 2004 [fig. 48 and p. 2]
Video, 12 min.
The Museum of Modern Art, New York

WILLIAM HENRY FOX TALBOT
The Fruit Sellers, 1845 [fig. 54]
Salted paper print, 18.8 × 22.3 cm
National Gallery of Canada, Ottawa (33487.35)

WARREN THOMPSON
Self-Portrait as an Arab, c. 1855 [fig. 13]
Stereo daguerreotype, 6.7 × 6 cm (each image)
George Eastman House, Rochester, Gift of Eastman
Kodak Company, ex-collection Gabriel Cromer
(1970:0011:0004)

Self-Portrait as a Hunter, c. 1855 [fig. 14]
Stereo daguerreotype, 6.7 × 6 cm (each image)
George Eastman House, Rochester, Gift of Eastman
Kodak Company, ex-collection Gabriel Cromer
(1976:0168:0154)

Self-Portrait as Thinker, c. 1855 [fig. 12]
Stereo daguerreotype, 6.7 × 6 cm (each image)
George Eastman House, Rochester, Gift of Eastman
Kodak Company, ex-collection Gabriel Cromer
(1976:0168:0115)

UNKNOWN PHOTOGRAPHER
Soldiers in a Staged Fight, c. 1863 [fig. 37]
Ambrotype, with applied colour, 7.14 × 8.25 cm
Amon Carter Museum, Fort Worth, Texas (P1989.7.1)

BILL VIOLA
The Greeting, 1995 [fig. 140]
Video/sound installation
The Modern Art Museum of Fort Worth, Texas (95.261)

JEFF WALL
The Vampires' Picnic, 1991 [fig. 144]
Transparency in light box,
248.4 × 353.8 × 20.2 cm (light box)
National Gallery of Canada, Ottawa (36801)

WANG QINGSONG
Number 6, 2001, from the series *Another Battle*,
2001 [fig. 79]
Dye coupler print, 106 × 74 cm
The Farber Collection, New York, Courtesy China
Avant-Garde Inc.

WEEGEE (ARTHUR FELLIG)
The Critic, 1943 [fig. 123]
Gelatin silver print, 28.3 × 35.6 cm
International Center of Photography, New York

CARRIE MAE WEEMS
Untitled, 1990 [fig. 80]
3 gelatin silver prints, 5 text panels,
67.3 × 67.3 cm (each image)
Walker Art Center, Minneapolis, Rollwagen/Cray
Research Photography Fund, 1991 (1991.101.1–8)

EDWARD WESTON
Civilian Defense, 1942, printed before July 1969
[fig. 115]
Gelatin silver print, 19.2 × 24.3 cm
National Gallery of Canada, Ottawa (33671)

MADAME YEVONDE
Lady Malcolm Campbell as Niobe,
from the *Goddesses* series, 1935, printed c. 1999
[fig. 98]
Pigment transfer print, 40.6 × 50.7 cm
Yevonde Portrait Archive, Winchester, England

Mrs. Donald Ross as Europa,
from the *Goddesses* series, 1935, printed c. 1999
[fig. 99]
Pigment transfer print, 50.7 × 40.6 cm
Yevonde Portrait Archive, Winchester, England

Mrs. Meyer as Medusa,
from the *Goddesses* series, 1935, printed c. 1999
[fig. 100]
Pigment transfer print, 50.7 × 40.6 cm
Yevonde Portrait Archive, Winchester, England

ANNE ZAHALKA
The Marriage of Convenience,
from the series *Resemblance I*, 1987 [fig. 45]
Azo dye print (Cibachrome), 82 × 82 cm (image)
Art Gallery of South Australia, Adelaide, South
Australian Government Grant, 1989

ILLUSTRATIONS

FURTHER READING

The following list offers references for those interested in pursuing the topic of artful photography; not all these publications are cited in the book. Additional references may be found in the notes following each essay.

Vince Aletti and Louise Neri. *Settings and Players: Theatrical Ambiguity in American Photography*. London: White Cube, 2001.

Philip Auslander. *Liveness: Performance in a Mediatized Culture*. London and New York: Routledge, 1999.

Quentin Bajac. *Tableaux vivants: Fantaisies photographiques victoriennes* (1840–1880). Paris: RMN, 1999.

Jennifer Blessing. *Rrose Is a Rrose Is a Rrose: Gender Performance in Photography*. New York: Guggenheim Museum Publications, 1997.

Michael R. Booth. *Theatre in the Victorian Age*. Cambridge and New York: Cambridge University Press, 1991.

———. *Victorian Spectacular Theatre, 1850–1910*. Boston and London: Routledge & Kegan Paul, 1981.

France Choinière and Michèle Thériault, eds. *Point and Shoot: Performance and Photography*. Foreword by Chantal Pontbriand, with essays by Diana Nemiroff, Rebecca Schneider, Karen Henry, Doyon/Demers, and Jan Peacock. Montreal: Dazibao, 2005.

A.D. Coleman. "The Directorial Mode: Notes toward a Definition." In *Light Readings: A Photography Critic's Writings, 1968–1978*. Oxford and New York: Oxford University Press, 1979.

David A. Cook. *A History of Narrative Film*. 4th ed. New York: W.W. Norton, 2004.

Penny Cousineau-Levine. *Faking Death: Canadian Art Photography and the Canadian Imagination*. Montreal and Kingston: McGill-Queen's University Press, 2003.

Malcolm Daniel. "Darkroom vs. Greenroom: Victorian Art Photography and Popular Theatrical Entertainment." *Image* 33, no. 1–2 (1990), pp. 13–20.

Elaine K. Dines. *Anxious Interiors: An Exhibition of Tableau Photography and Sculpture*. Laguna Beach, Cal.: Laguna Beach Museum of Art, 1984.

Kathleen Edwards. *Acting Out: Invented Melodrama in Contemporary Photography*. Iowa City: University of Iowa Museum of Art, 2005.

Douglas Fogle. *The Last Picture Show: Artists Using Photography, 1960–1982*. Minneapolis: Walker Art Center, 2003.

Sabine Folie and Michael Glasmeier. *Tableaux Vivants: Lebende Bilder und Attitüden in Fotografie, Film und Video*. Vienna: Kunsthalle, 2002.

Anne H. Hoy. *Fabrications: Staged, Altered, and Appropriated Photographs*. New York: Abbeville Press, 1987.

Michael Köhler, ed. *Constructed Realities: The Art of Staged Photography*. Zurich: Edition Stemmle, 1995.

Max Kozloff. "Through the Narrative Portal." *Artforum* 24, no. 8 (April 1986), pp. 86–97.

Martin Meisel. *Realizations: Narrative, Pictorial, and Theatrical Arts in Nineteenth-Century England*. Princeton, N.J.: Princeton University Press, 1983.

Nissan N. Perez. *Revelation: Representations of Christ in Photography*. London: Merrell, in association with the Israel Museum, Jerusalem, 2003.

Quotation: Re-Presenting History: David Buchan, Sorel Cohen, Evergon, Dany Leriche, Al McWilliams, Yasumasa Morimura, Cindy Sherman. Winnipeg: Winnipeg Art Gallery, 1994.

Carter Ratcliff. "Tableau Photography: From Mayall to Rodan, Its Roots and Its Reasons." *Picture*, no. 18 (1981), pp. 5–19.

CONTRIBUTORS

Lori Pauli is Assistant Curator of Photographs at the National Gallery of Canada and the author of *Manufactured Landscapes: The Photographs of Edward Burtynsky* (2003).

Marta Weiss is a Chester Dale Fellow in the Department of Photographs at the Metropolitan Museum of Art, New York.

Ann Thomas is Curator of Photographs at the National Gallery of Canada and the author of *No Man's Land: The Photographs of Lynne Cohen* (2001), *Beauty of Another Order: Photography in Science* (1997), and *Lisette Model* (1990).

Karen Henry is an independent curator and writer, and the author of *Allyson Clay: Imaginary Standard Distance* (2002).

PHOTOGRAPH CREDITS

Photographs are provided courtesy of the owners or custodians of the works, except as noted.

Fig. 3 © 2003 The Metropolitan Museum of Art

Figs. 4, 5, 17, 33, 34, 56, 60, 62, 63, 64, 65, 110 © The J. Paul Getty Museum

Fig. 6 National Gallery of Canada

Figs. 16, 19, 38 © 2005 Museum Associates / LACMA

Figs. 22, 24, 30, 58, 81 Science and Society Picture Library

Fig. 27 © Christie's Images Limited 2002

Figs. 28, 32 © The National Gallery, London

Fig. 31 V&A Images / Victoria and Albert Museum

Fig. 36 CNAC / MNAM / Dist. Réunion des Musées Nationaux / Art Resource, New York; Photo Georges Meguerditchian

Fig. 40 Archivio Fotografico Soprintendenza Speciale per il Polo Museale Romano

Fig. 42 Courtesy Cindy Sherman and Metro Pictures Gallery

Fig. 45 Courtesy Anne Zahalka

Fig. 48 and p. 2 Courtesy Eve Sussman; Photos Benedikt Partenheimer

Fig. 52 © Manchester Art Gallery

Fig. 53 Tate, London 2005

Fig. 57 © 2004 The Metropolitan Museum of Art

Fig. 71 © 2005 The Metropolitan Museum of Art

Fig. 79 Courtesy Wang Qingsong

Figs. 82, 85 © 1993 The Metropolitan Museum of Art

Figs. 104, 107, 108 Telimage 2006

Fig. 111 © 1993 Museum Associates / LACMA

Fig. 113 Courtesy Fotostiftung Schweiz, Winterthur

Fig. 125 Courtesy Howard Greenberg Gallery, New York

Fig. 126 Courtesy Ian Wallace

Figs. 127, 128, 143 Courtesy Jeff Wall Studio

Fig. 129 Photo Tim Bonham

Fig. 130 Photo Cheryl Bellows

Fig. 131 Photo Ben Blackwell

Fig. 132 Courtesy Stephen Friedman Gallery, London

Fig. 139 Photo Scott Livingstone

Fig. 140 Photo Kira Perov, courtesy Bill Viola Studio

COPYRIGHT NOTICES